DRUMMER OF AEROSMITH

JOEY KRAMER

HIT HARD

A STORY OF HITTING ROCK BOTTOM

AT THE TOP

WITH WILLIAM PATRICK AND KEITH GARDE

HarperOne
An Imprint of HarperCollinsPublishers

DRUMMER OF AEROSMITH

JOEY KRAMER
HIT HARD

HarperOne

HIT HARD: *A Story of Hitting Rock Bottom at the Top.* Copyright © 2009 by Joey Kramer. All rights reserved. Printed in the United States of America. No part of this book may be used or reproduced in any manner whatsoever without written permission except in the case of brief quotations embodied in critical articles and reviews. For information address HarperCollins Publishers, 10 East 53rd Street, New York, NY 10022.

HarperCollins books may be purchased for educational, business, or sales promotional use. For information please write: Special Markets Department, HarperCollins Publishers, 10 East 53rd Street, New York, NY 10022.

HarperCollins Web site: http://www.harpercollins.com
HarperCollins®, 📖 ®, and HarperOne™ are trademarks of HarperCollins Publishers

Design by James L. Iacobelli
Chapter opening illustrations are by courtesy of Joey Kramer.

Library of Congress Cataloging-in-Publication Data is available upon request.

ISBN 978–0–06–156662–2

10 11 12 13 14 RRD(H) 10 9 8 7 6 5 4 3 2 1

FIRST HARPERCOLLINS PAPERBACK EDITION PUBLISHED IN 2010

DEDICATED TO: Doris, Mickey, Annabelle, Amy, and Suzy Kramer

IN MEMORY OF: Mickey Kramer, Torri Wightman,

Ralph Simon, Anne Krouse, John Ramp,

Bob Timmons, Frank Connelly, and Don Bernstine

CONTENTS

ACKNOWLEDGMENTS

To my band mates, my partners, my brothers . . . even at its worst, you're the best. We have stood the greatest test of all—time. It is an incredible honor and my great privilege to play the drums in our band, Aerosmith.

To Steven Tyler for all that you've given me—for the gift of the love of the brother you are to me.

I would like to honor, give thanks, and much gratitude to Keith Garde—his contribution as one of the principal architects and drivers of Aerosmith's career since 1987 has never been rightfully acknowledged. As marketer, co-manager, creative contributor, collaborator, guide and friend, Keith, unlike anyone outside of the five guys in my band, is truly a part of what Aerosmith is today. Without his painstaking understanding

of my struggle, his patience, compassion, and kindness—this book would simply not exist. I love you Keith and thank you.

Thank you to the many Aerosmith fans who reached out to me—when I was in need and who suffer today from depression, anxiety, or the disease of addiction. There is hope.

Thank you Linda Kramer for opening my eyes and helping me to see the light of life once again. "I love you as deep as the ocean and high as the sky."

My thanks to Brad Mindich, whose generous friendship is equaled only by the uncompromising honesty, depth of insight, and skilled, balanced criticism with which he contributed to the editing of this book.

To Jessie Goldbas and Andy Martel for all the hours of organizing (and agonizing), coordinating what would have otherwise been a mess of words and pictures and pages . . .

To my son, Jesse K. a.k.a. J-2—Always keepin' me laughin'.

To Sandy Jossen for forty-six years of undying love and friendship.

To Patty Bourdon for believing in me when no one else would.

With love and thanks to Trudy Green for marshalling the forces as only you know how to do.

To Nikki Sixx, a kindred rock 'n' roll spirit who fought the fight, felt the pain, and has come out the other side—my thanks, respect, and love.

To Jill Kneerim for bringing me to Roger, locking in Harper and all the love along the way.

To Roger Freet for believing in me, for "getting" my story, and for rising to every occasion—keeping it all together when the seams felt like they were going to split.

. . . and to all the angels and demons I've had relationships with along the way—angels for the love and demons for the pain (you all know who you are)—I would never have been able to really see myself without you.

FOREWORD

Sitting in a hotel room in Boston, Joey Kramer's manuscript for this book is in pieces all around me—it looks like a bomb has gone off in my room; and feels like I've been on a roller coaster through hell, page after page. To be perfectly honest, I'm lying here exhausted not only from my own tour (which, ironically, ends today in the very city where Aerosmith began—Boston, MA) but mostly from Joey's book and life. It's funny how life is funny, even when it's not funny.

I don't think you write a foreword as a sales pitch or as a way to make a book look, sound, or feel better. You write a foreword out of respect for the author or respect for the content of the book. In this case it's both, and it's also a warning to the reader: so sit down, buckle up, and hold on tight. You are about to hit warp speeds exceeding reality.

I first met Joey Kramer in 1972 when I stole my first Aerosmith record. They became my favorite band in the world, and Joey Kramer was a major fuckin' reason it had ump, boogie, groove. The band snarled, spit, and vomited attitude. Steven and Joe? Monsters at their machines. Brad? Solid and melodic. Tom? Unstoppable on the bottom end. And Tom and Joey together? The dirtiest, tightest, rhythm section in rock 'n' roll. Mix it all together—It was and is pure sex . . . the kind of sex that's sweaty, dirty, illegal, and probably deadly. It didn't and doesn't get any better than Aerosmith.

But you know what . . . so fucking what . . . 'cause that isn't what this book is about. There are tons of books about America's greatest rock 'n' roll band, and I agree with them all. But this is something that one man, proudly, had the balls to write, to stand on his own, and, through the unraveling of his life, found out how to make life work on life's terms: stop fighting the past, and live in the present. There's an old saying, "It's called the present 'cause it's a gift". . . I agree. But, it too took me, a long time to figure that simple lesson out. So we begin, again . . .

Forewords can be long and boring, and I know you're eager to get to the meat and potatoes so to speak, so let's just cut some of the fat off the bone so we can get straight to the gristle.

The truth is, Joey is open about the confusion between love and abuse. Open . . . open like heart surgery. What became apparent early in this read was that all the while Joey's story breaks your heart, it gives you hope. It touched a lot of raw nerve endings in me, and I hope it does the same for you. As Joey's awareness sets in and he grows through it all, you feel it too . . . self-help? I don't know, but it helped me to look at myself, again, I hope the same for you.

You know the funny thing about humans? We're all the same on a molecular level. But we think we're chemists, psychologists, and gods on an ego level. Joey reveals what's under the skin of these unhealthy theories —and not just the road rash left by years of playing rock 'n' roll. The worst rashes, the ones most likely to leave the ugliest scars, are the ones from our childhoods and families. When you boil it down, it always goes back to that—the family; and until you dig into that wound, you're

destined for a life of agony—the highs are never high enough, and the lows are not unlike the depths of hell.

I love this book; this is an important book, because it's not bullshit. Joey had the balls to see what's underneath the hood, and to fix it. Being a rock star was easy compared to that.

—Nikki Sixx

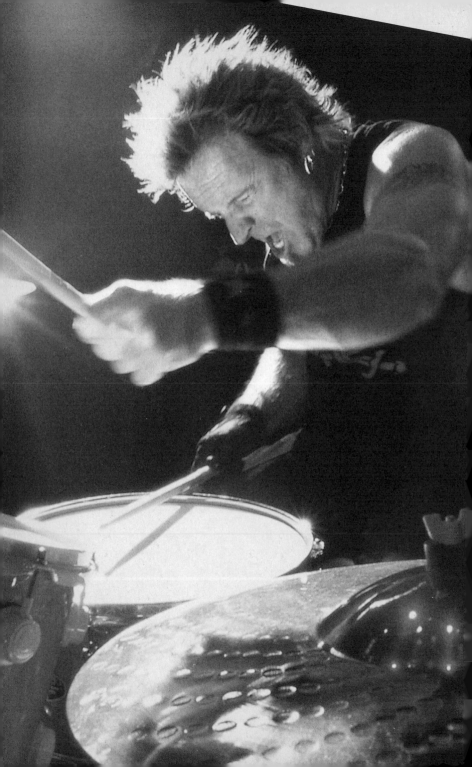

INTRODUCTION:
SCARED SHITLESS

When I stepped into the lobby, I felt my stomach rise up into my throat; tears started streaming down my face.

This was the Marlin Hotel, a jet-set place a couple of blocks off Ocean Drive in South Beach. I was completely losing it. Surrounded by palm trees, Ferraris, halter tops and those exotic drinks with the little umbrellas, and here I was crying so hard I was barely able to stand. All I could think was *What the fuck is going on? It doesn't make sense. We're selling millions of records, playing sold-out concerts. Everyone loves us. Everything is great. But I am losing my mind.*

It was February 1995, and a few weeks earlier the rest of the band had gone down to Florida and were getting ready to record, but I was still at home in a gray, cold, New England winter, so full of anxiety that it was all I could do to get out of bed each day. I was so afraid, and

the anticipation that it would get worse was almost paralyzing. Every waking moment I was filled with dread like I was about to hear a fatal diagnosis. I just wanted to get this feeling over with, but the despair, the emotional weight, and the anticipation of more of this misery had become misery itself.

After a while the pressure got so bad that I drove to the airport and caught the next plane to Miami. I was hoping that throwing myself into my work might pull me out of this funk. I walked through the lobby and straight into the small sound studio inside the hotel when the pain took over. I stared at the drums that were set up for me, but I couldn't even think about playing, so I stepped out of the studio, and a flood of emotion started to overwhelm me—I could barely see through the tears.

Bob Timmins was standing just inside the door, talking to some guys from our crew. Bob was a well-known "rock 'n' roll therapist." Drugs and alcohol, a specialty—a given with his kind of clients. He'd been working with the band to try to protect us from our collective insanity. He could see at a glance that something serious was going on with me, and he came right up and put his arm around my shoulders and sort of guided me away from the gawkers and the reporters. "Let's go upstairs," he said. "There's somebody I think you should talk to. Come on up to my room and we'll give him a call."

A few hours later, Bob and I were on a plane to California. A guy named Dan met us at LAX, and Bob handed me over to him and got on the next flight back to Miami. Then Dan drove me about an hour up the coast. Dan didn't say much, and I had nothing to say anyway, so I just stared out the window, watching the people driving in their cars and going about their lives. I was empty. We had to go up the 405 through L.A. and then the 101 across the Valley, which meant that it was pretty late at night when we reached Oxnard. I checked into the mental-health facility where Bob had arranged to have me admitted. It was called Steps.

One of the first people to greet me was the director of this place, Steve Chatoff. He was the person I'd spoken with on the phone from Bob's room at the hotel. The not exactly technical term he started using to describe what was going on with me was "nervous breakdown." His administrators booked me into a private room—supposedly a courtesy for a rock

star—but I didn't feel like a star, and I sure as hell didn't want to be alone. There's an expression I'd heard in Twelve Step recovery meetings that "my disease wants me dead, but first it wants me alone." I didn't want to go there. For the first forty-eight hours I barely left the nurses' station, sitting in a chair under the fluorescent lights, sobbing.

I had no idea what was happening to me. I was scared shitless, confused and even feeling a little guilty. Everything seemed so good. I was nine years clean and sober, and I was getting to live my dream—again. Even after we, as a band, drank and drugged that dream into a nightmare, we'd gotten a second chance and came roaring back. Our last two albums sold more than ten million copies apiece. Our new deal with Sony was worth over $30 million. We had just won the Billboard Music Award for "Best Rock Band," had more MTV awards and nominations than any other rock band, but here I was so fucking miserable that I could barely make it through the next minute.

The first time I went away for help, I kept asking for explanations, but the counselors told me that understanding was the booby prize, that the goal was just to feel my feelings. So what was I feeling now? I didn't have a clue. Something between everything and nothing. I was an incredibly lucky guy, I had everything I thought I wanted, but it didn't matter. Nothing mattered, and I didn't care. I couldn't shake this cloud of despair surrounding me, and I kept asking what the fuck was wrong with me.

The previous October, Issac Tigrett, the owner of the Hard Rock Cafe, was putting together a journey to India for some people to see Sai Baba, a renowned spiritual leader. My wife, April, wanted to travel to India to see Sai Baba, and with the band's heading back into the studio, to her this was a perfect time to go.

We lived out on the marshes of Boston, and it was snowing and raining when April left. By that time I was feeling so grim and shaky that I had to ask a buddy of mine, Frank Gangi, to come stay with me. He camped out in the guest room, and every morning he'd knock on my door and say, "Hey, man, it's time to get up." I would just pull the covers back over

my head and go back to sleep. If Frank would let me, I'd try to spend the whole day hiding in bed. I just couldn't see the point of anything. I'd lost my ability to experience pleasure. I had no appetite, so I'd forget to eat. Frank had to take me out and force me to down some food. He also took me to AA meetings, but I'd just start crying and we'd have to leave.

The idea of recording this album in Florida was the brainchild of our new producer, Glen Ballard, who'd just done an album for Alanis Morissette. Glen was a Southern guy who liked to work at Criteria, a studio in Miami, and everybody was psyched to be working where the sun was shining and it was eighty degrees. Steven and Joe went down early to do preproduction. Brad, Tom, and I stayed up in Boston and rehearsed for a while, and then Brad and Tom headed down to Florida to join the others; I just wasn't up for making the trip, so I stayed home. As the winter wore on, I started to withdraw. By early February I was almost completely shut down. Just taking a shower became an effort of epic proportions. A shower meant that I had to go into the bathroom, take off all my clothes, turn on the water, warm it up, and then get some soap. . . It felt like too much—I just didn't have it in me. In the same way, it felt like too much of an effort to eat. But then I'd get so weak from hunger that I couldn't get out of bed, and I felt so crappy from lying in bed and not having a shower that it made me feel even more depressed.

Looking back, going to Miami to record with my band as the way to break out of this misery was, well, misguided to say the least. I was in denial about it then, but being in the studio was its own kind of trauma for me. So it made sense that now I was sitting at a nurses' station in California, rocking back and forth in my chair, crying uncontrollably.

Steps is a residential facility in a residential neighborhood, with Spanish mission-hacienda stucco they put on most buildings in California. There was some pink bougainvillea, and they tried to make it look nice, but all in all it had the personality of an office park. I'd left the rock-star luxury of the Marlin for a mental-health Motel 6.

On my third day there they put me in a room with a sliding glass door that opened out onto a patio with picnic tables. As I would soon learn, that's where everybody ate lunch and congregated to smoke and talk between sessions. There was a parking lot beyond the patio, and then

some eucalyptus trees, and if they let you walk a few blocks, eventually you got down to the beach.

For about the first week of group sessions I spent a lot of time staring at the second hand ticking by on the face of my watch. The pain and sadness were brutal. I just had to take it one tick at a time, breathing in . . . breathing out. **I felt like someone was peeling back my skin, ripping off scar tissue.**

Japan, 2004

The first night that I stayed in my room, I lay awake all night praying to anyone, any thing that might listen, concentrating on each breath, begging for strength. I was in California where it was warm, but all the images in my mind were gray and cold and brooding. I could just as easily have been in New England—I almost didn't know the difference. I spent that night in personal darkness and started to think about walking the mile from my room to the Pacific Ocean, sinking under the waves and just getting it over with.

In the morning, when the light came in and I looked around, all the drama of the storms and waves inside my head was gone. I saw a dresser, two single beds, glass doors that looked outside onto the courtyard and a bathroom that I shared with the guys in the next room. The natural wood and soft blue cushioned institutional furniture made sense—after all I was back in an institution.

I got out of bed, stepped over to the glass doors, looked out, and saw my fellow residents sitting around the tables, drinking coffee, having a smoke. I slid back the door a bit, expecting the air that came through to have that soft and misty, coastal California feeling, but it smelled like cigarettes.

I closed the door and got back in bed. I wasn't ready to go out and face even this tiny little part of the world. Back in the eighties, when I first got clean at the Caron Foundation, my therapist talked about being "spring-loaded in a pissed-off position." What he meant was that common characteristics of active addicts could be edginess, irritability, and sometimes paranoia. Here at Steps I didn't have the energy to pounce on anyone, so I don't know how spring-loaded I was. I definitely did not want to be here—back in rehab once again. Not only were these people a lot younger than me, but most of them were here to deal with their addictions for the first time. Even though I had nine years in the program, I was so off that instead of appreciating the power and value of hearing newcomers share their stories and identifying with their pain as a way to help myself, I was thinking this was a fucking waste of my time; I'd moved on in my life, and I didn't need to be sitting in a group talking about drug and alcohol problems anymore.

New Orleans, 2004

After a few days, Steve Chatoff tracked down April in India, but when she and I talked on the phone we decided—or so it seemed at the time—that she would stay on and continue her trip. She'd waited a long time to see Sai Baba, so when we were on the phone, she told me she knew I was in good hands and questioned what she was going to do back in the States anyway? "Okay," I mumbled into the receiver. My own wife seemed distant, distracted, and not particularly concerned about me, but this was hardly the first time, so I didn't think about it much. It would take me another ten years to allow myself to admit that what I really felt was unsupported, unloved, abandoned, and sad, which at the time added far more to the anger I couldn't recognize and didn't know how to express.

Of all the people who saw me in this miserable state, the one who reached out to me first was Steven Tyler. Back in Miami, his room at the

Marlin was just down the hall from mine, and when I first showed up to attempt to settle in and unpack, his door was open. Even before I went down to the studio, I sort of stumbled over to see him and I told him what was going on with me. I can't remember what he said, exactly, but it was one of those times when Steven's compassion and heart of gold really came through. He gave me a hug. This was something I really needed, and at that moment a hug from Steven was more significant than had it come from anyone else.

Steven Tallarico (Tyler); he had been my friend—and truth be told, my hero—since junior high school. Steven was a couple of years older and always cool, the tenth grader with the Beatle boots and the voice that blew people away. The voice—and the attitude—that made him the one guy everybody knew was going to be a rock star even before he started to shave. Steven had music in his bones. He was a drummer before he became a lead singer. As such he became my mentor . . . a mentor I'd always been a little overeager to please. From the earliest days of Aerosmith, I would play something, hoping to impress Steven. He'd look at me and say, "Are you kidding with that?" I valued his opinion, but it always came as criticism. And coming from Steven, the words sounded like my father whacking me in the back of the head. "Stop sniffling!" my father would say, and then the whack! "This report card is unacceptable," and then the whack! "Your behavior is hurting your mother." Whack! Whack!

With Steven it felt like the same thing. He was the dominant force in the band "family" with great expectations for the band that he loved, as well as for everyone in and around it. But Steven could be punishingly critical when those expectations weren't met—"Joey, this sucks; your ideas suck. It should be like this. Why didn't you think of that? You suck." Whack!

Steven Tyler and I had been doing that same love/abuse dance now for a quarter of a century. It flowed right out of the dance between my father and me that contributed to my confusion between love and abuse right from the start. The sense of rejection I felt and had no idea how to "name" or express just collected inside, seeping into every cell in my body. Maybe

that's where some of that spring-loaded stuff came in. All the emotion—anger and humiliation—had been building up, packed in tighter and tighter, pressure building up for years until it had to come gushing out. I'd been stuffing more and more anger, humiliation, sadness, and confusion into the same space for forty years, and now it finally busted loose in the lobby of a Miami hotel.

If April had been there, she'd have been telling me to "talk to Baba." She'd tried earlier to get me on board with her spiritual quest, but I resisted. Now in this state of mind I'd buy into the tooth fairy if I thought it might make me feel better. At this level of misery I had no more resistance, only helpless resignation. I felt a desperate need for some high-powered help, so sitting in my room, I actually muttered a little prayer to Baba . . . sort of a "gimme a sign" prayer. Then I went down to the common room just so I wouldn't be so alone.

For once the place was empty—the TV wasn't even on—so I sat on the couch, and on the coffee table in front of me was a book—a Dean Koontz thriller. I picked it up for no particular reason and started thumbing through it. A bookmark fell out. I looked down at it. A piece of paper—about three by five inches. Then I picked it up and looked again. It was a photograph of Sai Baba. I gotta admit it kind of freaked me out.

I asked around in the cafeteria and found out whose book it was. I told the kid the story of my praying and then finding the picture, and I asked him if I could keep it. He said sure. Sai Baba was not the higher power I needed, but I wanted to keep the picture more as a matter of "why not" than "why?" I needed to believe in a power greater than myself, and for the moment this one would do.

The routine at Steps was breakfast at seven o'clock followed by classes, exercises, lectures, and group therapy. Every day at nine thirty, eight or ten of us drifted into a classroom-like space and sat in a circle and waited for the therapist to show up, this guy Kevin. Jumpy with anxiety, I would cross my legs one way, then cross them the other way. I would scratch my head, then put my hands through my hair, then cross my legs again and shift in my seat because the demons were eating me alive. But then I would look over and see that the guy next to me was doing the same kind of thing. And so was the girl across the circle from him. So here we

New Orleans, 2004

were, ten people in a room—all obviously uncomfortable—doing our own versions of a crazed fidget dance.

I was in my midforties, but most of these other people were somewhere between nineteen and thirty-five. I was the only "inmate" dealing with depression and anxiety as a primary "identifying issue," as the therapist called it, but regardless, a lot of the people there were looking to me for guidance. Sometimes it felt like they wanted to hear from me even more than from the therapist. I guess in some ways they related to me because I'd been through it. They also knew about the band; our downfall in the early eighties was the ugly stuff of rock 'n' roll decadence—infamy. Our climb back to rock royalty—unprecedented. And maybe they were just psyched to be in rehab with one of the guys from Aerosmith. At the time, though, I was feeling so low that I clung to any opportunity to feel valuable.

When Kevin would arrive, we got down to business. He would ask a question, and everyone would sink down in their seats unwilling to contribute, but I was motivated to raise my hand. I'd been through these routines before. I think it was less because I believed I could be of service and more because I knew the process, but probably mostly because I wanted to get the process over with.

Kevin would ask for a volunteer to do some "empty chair" work, and I'd be the one to go first. We were instructed to address someone we had big issues with. I went up in front of the group and pretended my father was sitting in the empty chair across from me. And I talked to him, trying to say things I had never been able to say to him in real life. As much as I'd dreaded this experimental exercise and felt like resisting, I started to see a little window of safety and was open to start getting into it.

Nine years earlier, when I was at the Caron Foundation in treatment for drug and alcohol abuse, having finally decided that snorting $5,000 worth of coke every week was a bad idea—more on that later— my mother came to visit during family week, and she opened up a little, telling me things about my childhood; she left me with some images from my earliest days. One story she told stuck with me in such a big way that it lodged in my soul even if I was too young for the actual experience to be etched into my conscious memory. I was two years old,

she told me, sitting at my dad's desk. "Exploring," is what she called it, only this desk was where my dad sat to do work when he came home. Apparently I wanted to sit at this desk and "do work," to be just like my dad. I pulled out some drawers, and I messed around some papers. I was having a great time, my mother said. But then my dad came into the room. He started shaking me, screaming at me, hitting me.

"What're you doing!? Get the hell out of there!"

As the words left my mother's lips, I could see that little kid, shocked and terrified. I wanted to scream. I wanted to save him. I couldn't say a word, but all of this made such perfect sense to me. Hearing her talk was like watching a photograph come to life in a developing tray, the empty spaces filling in over time. **This feeling of being cowed and beaten was something that was reinforced in me all my life. This was my father; he was supposed to be my protector, and here he was raging, beating me.** This shit was repeated so often when I was a kid that I developed an autoresponse like one of Pavlov's dogs. The scientist rings the bell when he sets out the food, and the dogs salivate. After a while, the scientist doesn't have to show the food anymore—the bell is enough. My dad would yell and then—boom—the fists landed. After a while the pain registered in my body whether he hit me or not. Before long, he didn't need to hit me. And then, he didn't even need to yell. His mere presence was enough to feel like danger. People react differently to different stimuli. I internalized the madness. I went numb. I'd just keep my head down to try to avoid the pain, and when the pain came, I'd find a way to hide to make it go away.

As a little kid, I'd hide in the crawl space in the attic next to my room and play with my cars. As a teenager, I found my drums to hide behind. As an adult, I added drugs and alcohol for refuge, and I could afford a lot of it. After a while, the job of numbing was complete: by numbing myself to the painful emotions, I had become pretty much numb to every emotion. What had happened to me was that I had to hide to experience pleasure, and after a while I became hidden even from myself. But now

the feelings that had been stuffed down inside of me were exploding. The pressure in the cooker was rattling its lid and it was going to keep my guts twisted in knots until it was reckoned with one way or another.

My life had become a series of emotional contradictions. I'd played my drums in front of eighty thousand screaming fans, and passed out in my own puke. I'd toured in private jets, rode in limos, and had just about any girl, at any time, for anything. I had also lived in rat-infested, shithole apartments, got caught in a burning car where I got third-degree burns all over my body, racked up hundreds of thousands of dollars of debt, and watched my father die a slow, agonizing death. But I had never felt anything like this depression that brought me to Steps. All my life, whatever problems or challenges I had to face, there always seemed to be some way out. I could withdraw, hide, or deny, and problems would seem to go away, or someone else would figure out a solution for me so I didn't have to deal. This time there was only me and my personal pain, and I didn't see any way out.

In a real way, Aerosmith had also become an addiction. I needed it. It was another place to hide, but like any addiction, instead of providing me with a safe haven, it was beating the shit out of me. Therapists tell recovering addicts that they can't simply go back to the same crowd they used to get high with—no question, with Aerosmith I had been breaking that rule for decades. The band was my life, but it was also a source of pain, humiliation, and abuse. **I started to think that if I really wanted to get serious about healing myself, I might have to kiss Aerosmith good-bye. I needed to see what the rest of life was like, what people call "real life," without the security blanket of a tour schedule and the drum riser and all the attention.** So I decided I was primed and confident and more than ready when we started our group session that day, ready to face my fears and demons and break away from all my abusive addictions. At that moment I began to realize what I would soon discover was a gift—desperation. So I was ready, that is, until Kevin the therapist pinned me to the wall.

"Who are you, Joey Kramer?" "Who are you without Aerosmith?"

I was forty-five years old, and it was time for me to have an answer. This book is about how I came to grips with that question and how I managed to change the way I saw myself in the world. Through the process of learning and self-discovery, I have managed to transform my relationship with myself and, as a result, transform my closest and most painful relationships—Steven Tyler, my father, April, those people whose judgment I turned into a weapon that I stepped in the way of as if on cue. I no longer have to see myself in that role as victim—a major pattern in my life that I really had to get to the bottom of and take responsibility for.

Obviously, coming from the drummer for one of the biggest rock bands in history, this book, like any good rock 'n' roll memoir, has stories about how we made it and lost it—life on the road of excess. But this book isn't just about living the rock-star life—there are plenty of books around that are just about that. The real point of this book is to say that you don't have to be a rock star to crash and burn. The details of our stories may be different, but as humans, our pain is the same. I've been through the fire and have come out the other side alive. Better than alive. And so, by revealing the details of my story in *Hit Hard*, I tried to convey a story that—while uniquely mine—is so relatable that it serves to deliver a universal message of hope and the process of healing.

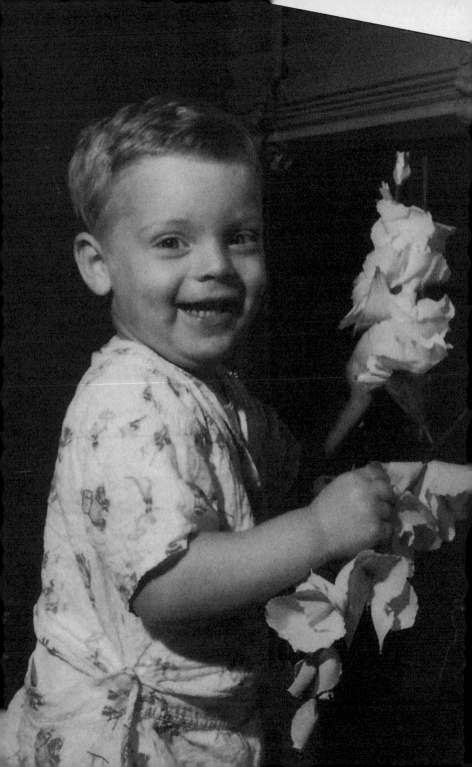

TWO IMPOSTERS—
LOVE AND ABUSE

When I grew up, in the fifties, I lived with my family in the Bronx, and then in Yonkers, New York. It was my mom, my dad, my three little sisters, and little Joey always running around getting into trouble. If that sounds like the setup for a sitcom, there was not much of a laugh track.

My dad, Mickey, was a hustle and bustle businessman, a salesman who started a company called Jumbo Advertising. If you were a contractor and wanted ballpoint pens with your outfit's name on them, my dad would make them for you. Or the calendars that the insurance agents handed out, or the metal frame that went around the license plate that said the name of the car dealership, Mickey was the man! He worked his ass off all week long but on Saturdays he couldn't wait to get the hell out of the house to go play tennis. I remember his skinny legs sticking

out of those white flannel shorts as he passed through the kitchen in his sneakers and matching gym socks.

My mom, Doris, stayed at home and took care of my sisters—Annabelle, Amy, and Suzie—and me. She even wore dress-up dresses during the day, like Harriet Nelson from *Ozzie and Harriet,* and she loved music and Broadway musicals. When she was younger she practically lived at Radio City Music Hall. Around the house she was always singing show tunes from *The Sound of Music* and *South Pacific.* She could even tap dance. She loved the whole idea of show business, the glamour of the world of entertainment, provided that you didn't push it past Gene Kelly or Julie Andrews.

My grandparents on both sides were Jewish immigrants from Eastern Europe, so both my parents were first-generation Americans. My mother's mother was maybe eight when she landed in Pittsburgh, and her father opened a shop repairing watches and guns. My father's father came over from Poland as a kid and found work as a tailor in New York City. My mother used to tell us stories about how her mother scrubbed floors to get through the Depression but set aside quarters so she, little Doris, could take dancing lessons. And how, "of course," all her clothes were hand-me-downs.

This whole immigrant experience shaped my parents and how they tried to raise me. They were all about assimilation and material gain—fitting in—and image meant everything to them and was pretty typical for parents in the fifties, which also helps to explain why we had "the sixties."

My father joined the army during World War II, and the night before he shipped out, he asked my mother for a date. They hit it off, and then my mother joined the army, too, working at an air base in South Carolina. But then my father hit the beaches at Normandy on D-day, and he got shot up all to hell and was hospitalized in England. My mother wrote to him, and my dad wrote back. When he returned to the States, they picked up the romance. After a couple of years they got married, and my dad went into the clothing business which he soon determined was not for him. So he scraped together a little money from friends and, with the help of a GI loan, started Jumbo Advertising. And with another GI loan my parents bought a house at 115 Whitman Road in Yonkers.

My dad was determined to make something out of nothing, and before long, to add to the pressure, he had a lot of mouths to feed. He also suffered from what today we call PTSD—post-traumatic stress disorder. He'd been badly wounded, and many of his buddies were killed. I think

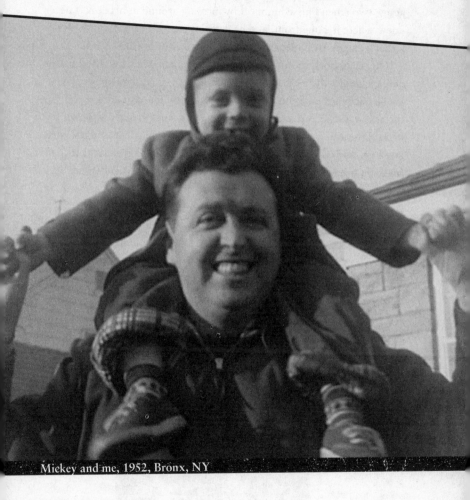

Mickey and me, 1952, Bronx, NY

he spent a lot of time agonizing over *why them and not me?* These were only some of the demons that haunted him. I learned from my mother when I was in treatment the first time that when he was just a little kid,

my dad's own mother told him she wished he had never been born, that she had tried to abort him by jumping off a kitchen chair.

I'm sure knowing that can fuck you up, so maybe all of this shit combined was where some of the rage came from, the rage I first experienced at age two when I pissed him off by messing around at his desk. I never knew where it came from, and he certainly never told me, but I felt my father's anger just under the surface every day of my life.

Our neighbors, the Suozzis, had five kids, and when I was about kindergarten age, their cat had a litter of kittens. I can remember playing in the backyard and finding an arrow lying on the ground. I picked up the arrow, picked up one of the kittens, and stuck the arrow down the back of the kitten's neck. I have no idea why I did that. The kitten started howling, and all the Suozzis came running out into the backyard, all freaking out when they saw what I'd done. They screamed at me like I was an axe murderer: "Joey, what're you doing? My god, you're killing that poor kitten!"

Was I just angry? Or reacting to how I was feeling at home? Maybe I was just a little kid doing the kind of mindlessly cruel things that little kids sometimes do. I don't know. But I do know that I had powerful feelings that I couldn't name, feelings that surely I had no idea how to process.

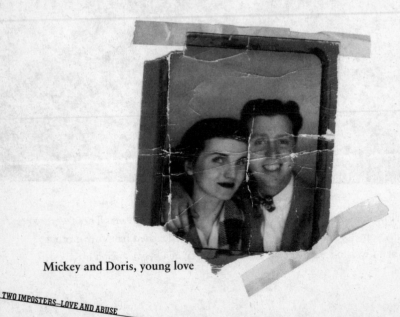

Mickey and Doris, young love

My dad just seemed pissed off at me all the time, and the next thing I knew, my mother was taking care of my baby sister, and then another baby sister, and then one more.

For whatever reason, I definitely got the feeling that I was not exactly what my parents had hoped for. While I had no conscious understanding of that, all I knew was that it felt bad. I was, however, developing an instinct for making bad feelings go away as quickly as possible.

At home in my bedroom there was a crawl space that I could get to through my closet. The entrance was like the portal to that magic kingdom of Narnia in *The Lion, the Witch and the Wardrobe,* except that the only thing behind the door were my slot cars. Whenever some friends of mine, or their parents, got tired of their Aurora racecar sets, they gave them to me. I wound up with what seemed like miles of track, dozens of cars, and extra controls, so every time I felt bad, I could sneak back into the closet and be all by myself. I sat and played with those cars for hours, hiding out. And I would convince myself that nobody knew I was in there, which made me feel safer still. **No one was hitting me or yelling at me. I felt really good, connected and "in the zone." The only problem was that I had to hide in this space—my space—in order to feel that way.**

My dad used to keep a Nestlé Crunch chocolate bar in the refrigerator that was his and his alone, and one night I ate it. He went nuts trying to figure out who took the candy bar. He said that my sisters and I had to stay in and we were going to be punished until somebody confessed. He was pissed. I was freaking out. I headed right up to the crawl space—lots of track, lots of cars. I got lost. My little sister Amy took the blame just to get it over with. She knew she wasn't going to get hit. Somehow, my dad's anger didn't get focused on my sisters the same way it did on me.

When threats were purely physical, like in the neighborhood out in the open, I did a better job of standing up for myself. John Pascucci lived next door, and he was bigger than I was and was always picking on me. One evening in the summertime the Suozzi kids, the Pascucci kids, and the Rosenblatt kids were all out playing in the street, hitting a

tennis ball back and forth with rackets, and when it was my turn, John came at me saying, "Give me that racket, you little animal." He reached out to grab it, and I smashed his hand. He started yelling, "You broke my fingers! You broke my fingers!" I didn't break his fingers, but I did

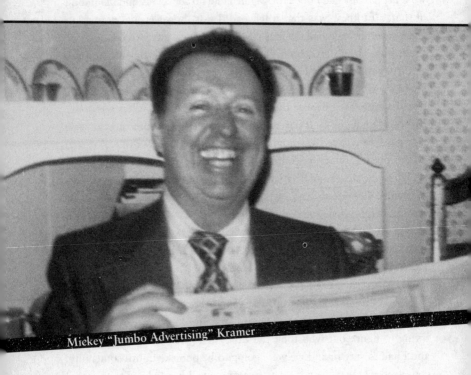

Mickey "Jumbo Advertising" Kramer

hurt him badly enough that he never bullied me again. I was sick of being pushed around every day, and even I knew there were fights I could win—and fights I couldn't.

Whenever my dad wailed into me, he narrated the experience using all the clichés. "I'm doing this for your own good," he would say as he hit me. And even when he wasn't hitting me, he went off at me in such a crazy way that I was sure I was about to die. The tsars back in the old country used to line up troublemakers for fake executions as a way of breaking their spirits. My dad's rage and his size delivered the same

message to every part of me: "I have the power over life and death." And when I couldn't keep back the tears, he made it clear—I'd better stop crying, or else.

I had this sniffle—a nervous habit that I still have to this day—and every time I sniffed, my father smacked me on the back of the head. And each time he smacked me, he'd remind me, saying, "Every time you sniff, I'm going to hit you on the back of the head." Then he'd remind me once more, just in case I could ever forget: "Every time you sniff, I'm going to hit you on the back of the head."

My dad never asked, "So what's with the sniffle? What's going on?" It never seemed to occur to him that my sniffing was a nervous habit and that there might be more to it, that maybe he had something to do with it. He'd just whack me. "Stop sniffling. It drives me crazy. I can't stand your sniffling." Sniffle—whack!

My friends knew about my dad, how afraid I was of him, and so they'd fuck with me. Mickey had a special whistle, and when I heard that whistle, it meant I had to come. Sometimes my buddies would get quiet, look at me, and say, "Did you hear a whistle? Joey, I think your dad's calling you." I'd go pale, and then they'd laugh their asses off. I'd laugh, too, but, secretly, I would always be listening for that whistle.

Tennis on Saturdays

At Jumbo Advertising, Mickey did everything himself—the production, the sales, the bookkeeping—a one-man operation. Sometimes in the summer I went with him to visit clients, and I was always amazed at what a nice, smooth, loveable guy he was with them. He would really charm these people, and they really seemed to like him too. But the Mickey I got was the enforcer: distracted, angry, and generally disappointed and disapproving.

To the extent that our household was pretty miserable for me, school was more of the same: more disappointment, more disapproval, and more physical punishment. Mr. Schwartz, the science teacher, and Mr. Ianocone, the coach, would swat certain kids with these long wooden paddles made from baseball bats split lengthwise, and my ass was always getting blistered. I definitely played the class clown—or the class pain in the ass, depending on how you looked at it. At Walt Whitman Junior High I would screw around in the hall until I was late, and then the teacher would have to send me back to the preceding class to get a late pass. If I could get the pass, I'd come back into the room and make a big production out of it, then sit in the back and start drumming on my desk, certain to be annoying.

For Mr. Hamill's math class I never had my homework. I was never prepared, and I would always lean back on the rear legs of my chair with my legs hooked underneath the desk. I'd rock back and forth, and every once in a while I'd fall over.

Mr. Hamill would give me a little whack with his ruler now and then to keep me in line. But one day I was doing my usual thing, sitting way in the back, tilting my chair, giving him some lip, but something was different. He didn't hit me, but he kept warning me, saying "You'd better watch out." It was weird because warnings never came without rulers before. About three-quarters of the way through the class I happened to glance up and through the glass panels in the wooden doors. Oh shit, I thought. There was my mother looking back at me. She was standing out in the hallway, catching my whole act. So when I got home that day, I caught hell from my father. He may have been the enforcer of the punishment, but my mother was control freak number one. She

wanted things her way, and when she didn't get her way, she talked to my dad. They made quite a team.

The one teacher who sort of "got me" taught ceramics. Mr. Rothenberg must have been six foot six and had a huge hook nose. It seemed like every time I was sent down to the principal's office, he'd somehow show up to put in a good word for me. He always seemed to know when I was in trouble, and he seemed determined to save me from Mr. Ramano, the assistant principal, who had a major broomstick up his ass and preyed on my fears, fed my doubts, and reinforced my insecurities. Maybe it was that Mr. Rothenberg was a hands-on kind of guy and sensed that I was the same. All I know is that, instead of moving around and taking a different shop class each semester the way you were supposed to, I stayed in ceramics for the whole three years. I must have made more salad bowls and ashtrays than any other kid in the history of Yonkers. Mr. Rothenberg taught me everything he knew about throwing pots and curing them, and would pat me on the back after I created some new design or color. After a while he had me making all the glazes for the whole school system—all by myself. For those three years, he was like a really tall guardian angel. At that time he was the only person who reached out to me, and I felt like I had value and purpose and could make a meaningful contribution. Sometimes I wonder what would have happened had Mr. Rothenberg not been so kind to me and had I not been willing to accept his kindness.

With the exception of Mr. Rothenberg's class, I didn't get any (positive) attention, guidance, or support from school authorities—probably because I didn't fit in there, just like I didn't fit in at home. The only place where I felt safe and where I completely belonged was with my buddies in the neighborhood. There were six of us—Robbie Kelly, Jack Conroy, Mickey McCullough, Butch Holland, Ricky Zarameda, and me—and we all lived on Whitman Road. We hung out in one another's houses so much that we knew one another's moms, and everybody knew everyone else's brothers and sisters, and everybody's dog knew everybody else's dog.

A typical Saturday morning was me getting up and walking down to Jack's house, which was ten houses down from mine. He was three or

four years older than the rest of us. Jack had his license and a '61 Ford convertible, white with red interior. I'd never knock on the door. I'd just go inside and call to him upstairs, and then he'd come down, and we'd walk back up toward Kelly's house. After we got Kelly, we'd go across the street and get Butch and then go next-door to get Zarameda, and then we'd all pile into Jack's car.

I remember this one particular Saturday that was like 100 percent Norman Rockwell. We drove up to the Croton Reservoir, up where the dam is, and we all went skinny-dipping. There was even a tire swing hanging from a tree, and I spent hours swinging out over the water on that thing, letting the momentum take me up to the top of the arc, and then letting go. I'd fly through the air in a forward motion like Superman until I splashed down into the water. Ice-cold!

I didn't think about getting yelled at, had no worries about taking a beating. I could just be me, flying through the air. Mostly I felt safe, surrounded by this band of brothers. This gang was like my real family, the first environment where I was accepted for who I was. **This was a good feeling that didn't require that I hide, and the "band of brothers" was a concept that stuck with me.**

With my parents, being accepted—even being tolerated—meant coloring well within the lines. So I think they were pleased when I approached them about taking accordion lessons. I had a couple of friends who played, and I think the nerdiness of the accordion really appealed to my parents' sense of respectability. I mean, good luck getting laid with an accordion strapped to your chest. Every Saturday morning my father drove me down to the Joey Alfidi Accordion Studio in Getty Square in Yonkers. I'd go into this little room with a guy, and he would give me a lesson. When I got home, my dad said I had to practice "while the lesson was fresh on my mind." He'd send me down to the basement, where we had a playroom with a playpen for my baby sister. "Okay, it's now ten o'clock. For the next hour, you're not coming out of that room."

My dad's intentions were good, and he took the time to drive me back and forth, but there was something about the whole routine that was

more like dog training than trying to find out what was inside me and then bringing it out in the best way. As a result, the "forced feeding" method of musical instruction didn't really take.

Down in the basement we kept a record player and an old upright piano. I had a buddy named Jerry Rosenblatt who had turned me on to the heartthrob singers of the day, guys like Paul Anka and Fabian and Bobby Rydell. I was supposed to be practicing the accordion, but instead I'd put "Lonely Boy" by Paul Anka or "Like a Tiger" by Fabian on the turntable. I'd get up on the piano bench and pretend I had a microphone in my hand, singing, " I'm just a lonely boy, lonely and blue. . ." I even put a box in front of the bench to make a step so I could make an entrance onto my little stage. For the hour that I was locked in the basement, I was Paul Anka or Bobby Rydell or Fabian or Joey Dee from the Starliters. I was singing my heart out, imagining that I was in a big club and everybody was digging the shit out of me.

Jerry's brother Allen was trying to make it as a doo-wop singer, and Jerry's father, Phil, was a heavy jazz cat who taught music in school. There seemed to be something musical in the Rosenblatt gene pool, and what really impressed me was Jerry and his violin. He was totally dedicated to it, and he practiced like a maniac. His father and his brother Allen both played the piano, and they all really seemed to love what they were doing. The discipline of practicing didn't seem like it was forced on them from outside by somebody else. It came from inside, because something about the music and the way they presented it reflected who they were. In a sense, they were being free to express themselves and disciplined at the same time. Something about that appealed to me, as did the idea that you could be "in the zone" and away from all your troubles, but also creating something.

Jerry was probably the most musical kid in school, but the coolest kid was Frankie Re. He had a waterfall hairdo and was really good looking, and sometimes he wore a sharkskin suit with a black velvet collar. He even had a go-cart with a McCullough engine on it. All the girls liked him, and he got along with all the guys. Frankie had a little combo. He was the drummer, and for Christmas his father bought him his own set

of drums. I had to see them, so one day I went over to his house to check it out. I went down into his basement, and there before my eyes was this beautiful set of blue sparkle Slingerlands.

Frankie sat down and rolled out some basic patterns, and then he said, "Try it." He got up and said, "Go ahead Joey. Try it out."

This was the first time I'd ever seen a set of drums up close and personal. The blue sparkled, the chrome reflected the light, and there was a little crest on the front of the bass drum with Frankie's initials: FR.

I sat down and picked up the sticks. Frankie showed me where to place my right hand and where to place my left hand, and then I started to tap around the way Frankie'd been doing. I figured out how to bounce one stick and then the other and to take it from drum to drum. Up to that point I guess I was like any other kid who picks up a set of sticks. You watch somebody play, and it looks like a lot of fun, so you bang around and make some noise.

Then I really whacked it, and it was a rush like nothing I'd ever felt before. Right there in Frankie Rae's basement I was thinking, *This is good. This feels really good.*

Frankie took over again, while I sat and watched him play. I watched what he did with his feet, and I dissected it all—took it apart. He let me play again, and I remember it like something out of that movie *Billy Elliot*. They ask the ballet kid what it feels like to dance, and he says it feels like flying. For me, though, the feeling was more like electricity. **Everything I'd experienced up to that point, all the emotions I couldn't articulate or even process or understand, I could feel being channeled through those two wooden sticks and onto the heads of those drums.** The positive and the negative charges just came together and made a full circuit. Pounding on those drums flipped the switch, and the lights came on.

I had some money from odd jobs, and I talked my parents into letting me rent some equipment—a three-piece set of red sparkle Kent drums. I kept them for about three months, and I began to teach myself how to play. When I could accomplish even the smallest thing, like putting a hand and a foot together, it felt the way I had felt on that rope swing up

at Croton when I reached the top of the arc. I was flying, because as I was teaching myself, I was also learning about myself. I was good at this, naturally good, and the more I realized how well I could do it, the more that made me want to be even better. I was a "feel" player right from the start. But when I held the sticks in the traditional grip, the kind that Frankie told me to use, it just didn't feel natural. In the traditional grip you hold the stick in your left hand almost like a pencil sideways to your body, and you rotate your wrist to make the stick go up and down. But I liked to hold the left stick the same way I did the right, straight ahead as if I'd picked it up to throw it, which is called a matched grip. And this let

Joey "Davey Crockett" Kramer—fifth birthday party

me hit the drums with both hands really hard, and the inflection of the power got me off. I was nearly thirteen years old, and I was beginning to make the drums sing.

Hormones were kicking in around this time, and the power and the self-discovery of the drums was really potent stuff for me. But turning thirteen, and especially being Jewish and turning thirteen, presented a few other issues which I had to contend with.

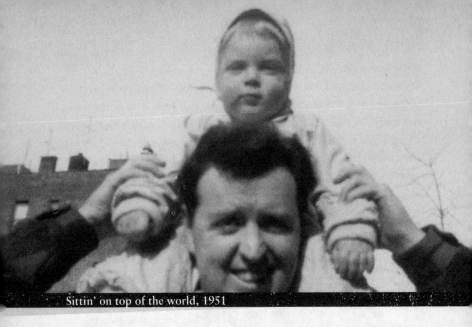

Sittin' on top of the world, 1951

On Tuesdays and Thursdays every week, after six or seven hours goofing off in the classrooms over at Walt Whitman in Yonkers, I had to make my way over to the synagogue and spend another couple of hours in Hebrew school, then another hour or so learning to read from the Torah. I was, if anything, probably less inclined to sit still and absorb this kind of education than I was the regular kind. All I wanted to do was be back in the basement, playing my drums.

I met this kid, Sandy Jossen, in Hebrew school—and we became obsessed with minibikes, so much so that I let my drum rental lapse. That one summer we rode those things everywhere, engines screaming, tormenting the neighborhood—or so we hoped. But by the fall I was ready to reconnect with the drums, only this time I wanted to own my own set.

By selling my minibike, which I'd bought largely with my bar mitzvah money, I was able to buy a three-piece Ludwig kit with single heads and a clamp that held the tom-tom onto the bass drum. This was definitely bottom of the line, but I would lie in bed at night, thinking about them and how I was going to work to get the next piece. I'd take on some little job and make a few bucks, and I'd go out and get a high hat, and then another cymbal, and then a stand. Whereas most guys had pictures of movie stars or cars or baseball players on their walls, I had pictures of

drums. I had found the thing that brought my life into focus, the thing that motivated me and started to give me a sense of identity.

Meanwhile, the music world was just about to explode. A band from England was creating a bigger buzz than Elvis—Brits who looked like little choirboys in their suits and ties, only they were belting out "Dizzy Miss Lizzy" and "Twist and Shout" rock 'n' roll. The stuff they were writing was harmonically way beyond what we were used to. They were really a band, too, not just a heartthrob singer and some anonymous backups—the Crickets, the Belmonts, the Jordanaires. The Beatles were the total package, complete musicians as well as singers. They shared the stage, rotated the lead, then shared the limelight offstage.

Our whole family sat together and watched the *Ed Sullivan Show* every Sunday night. When the Beatles came on American TV that first time in February 1964, the whole country went nuts, and I was no different, sitting on the floor in front of our ratty, old, orange couch. My eyes were glued to Ringo up there on the riser in the center with a smile on his face, occasionally giving his head that signature shake. It was like he was sitting on top of the world, the coolest guy on the planet. His partners were spread out in front of him, and he was the man in the middle. I was mesmerized; I felt it. I imagined it was me at that moment on stage in front of all those screaming fans.

One day my buddy Sandy and I were standing outside the Midchester Jewish Center, and he said, "I'm going to grow my hair long to be like the Beatles."

I said, "I'm not going to be like the Beatles, I'm going to *be* the Beatles." I bought in to the program completely, I mean I knew this was what I was going to do.

No doubt millions of teenage guys in America were saying the same thing that morning. The difference between me and all the other kids was that I was willing to say fuck it, this is where I'm going, no matter what. I was making the commitment. Nothing else mattered as much. All my bets were on playing the drums.

They say that 74 million people watched *Ed Sullivan* that night. The Beatles took America by storm, and when they started doing interviews, their attitude got the kids completely juiced and ready to throw off the

fifties straitjacket. Suddenly, the nightclub kind of entertainment my parents liked was headed for the dumpster, and a new growth industry was being born.

My parents just couldn't see it and certainly couldn't see me as part of it. My mother developed an "auditory condition." She said she couldn't handle having to listen to me play.

"Here's the deal," they told me. "You can play the drums in the basement when you get home from school. That's from three o'clock until five o'clock."

My parents were never going to accept that my playing the drums was worth taking seriously. But the more I played, the more I loved it; and the more they resisted the idea, the more determined I was to prove them wrong. This was what I cared about, what I did really well, and what expressed what I could identify with as who I was. Mostly, it just felt good, and I was going to hang on to that good feeling—no matter what.

I studied the drummers I saw on TV, like Dino Danelli of the Young Rascals and Dave Clark of the Dave Clark Five. I learned which sound of what part of the drum kit was associated with which hand, and then by listening, I could visualize what the drummer on the song was up to. I taught my ears to see, in other words, and once I could see with my ears, then I could pretty much figure out whatever I needed to figure out.

I always worked out what I wanted to play before I sat down at the drums. I'd hum the beat in my head and then play it on my thighs or in the air. That way I was able to translate what I saw and heard to what I was going to do myself, one hand and one foot at a time. Once I had the basics down for whatever song I wanted to learn, I would play to the record. I'd pretend to be in whatever band I had playing on the turntable. Sometimes I was Ringo, sometimes Dave Clark, but mostly I was Dino Danelli.

Dino was really my first drum hero, just like his was Gene Krupa from the Big Band era. Before Krupa, the drummer was just some guy keeping time in the back of the band. Krupa was a matinee idol as much as he was a technical drummer. He had the clothes and the shoes, the trademark of always chewing gum, and his hair always just so. Dino had the same

kind of charisma with the clothes and the hair and everything—only early sixties style.

I didn't want to spend any more time than I had to in my parents' world. When the frustration of living at home just got to be too much, the physical outlet of banging away on those drums helped to keep me going. I could let off steam, and by drilling and drilling, I could enter into a state where my mind was completely elsewhere, completely in tune with the universe, completely happy. Music wasn't only a world that I loved, but one where I could have things my way. Teaching myself felt like I was also discovering myself, and at the same time sort of inventing myself.

Within about six months I was in my first band, the Dynamics. I was only fourteen, so this didn't amount to much, but then I was in the Medallions, a combo that was strictly instrumental. Somehow we wound up playing at the New York pavilion at the 1964 World's Fair out in Queens. There's even some old 8 mm film of me playing "Wipe Out," working up a sweat, only without any sound.

About this time I got to know some guys from the other side of town who were into the English bands, especially the Who. Johnny Ramp was a bass player, and he used to hang out at Jerry Elliot's house, along with Paul and Tom Piscotta, Bobby Mayo, and Barry Schneidman. These guys were willing to really work and drill, which meant that they were into music on a much more serious level than anybody I'd played with before. When we got together, we started a group called the King Bees.

Every Saturday afternoon we played at the bowling alley lounge, called Café Gay Era, and over the sound of pins being knocked down and people cheering, I sang lead on Rascals stuff like "Good Lovin'" and "You Better Run." We wore polka-dot shirts, red or yellow dots on black backgrounds. The owner paid us what he took in at the door plus free lunch in the café. We also played the sweet sixteen parties at the Jewish Center and at a lot of school dances.

Paul and Tom's father, Sal Piscotta, took what we were doing seriously, just like those parents who support their kid on the football team or the debate team. He and Bobby Mayo's dad were kind of our managers at the time, and they looked after things and made sure we got what we were owed. The best my parents could do was to be tolerant.

Then I got a really shitty report card. My father took one look at those Ds and Fs and said, "I'm taking your drums away. I'm taking 'em apart, and I'm locking 'em up in the attic."

I wanted to kill him. He was taking away the thing I cared about most. Looking back now, I know I was crazy with rage, but I had no access to the anger, no way to express it, let alone process it. The pathway from my feelings to my conscious awareness was closing off, and at the same time some survival mechanism in me started taking over, telling me, *you can't win these fights, pal. Better just shut up, put your head down and plow on through the best you can.*

The inability of my parents and me to communicate about this stuff and maybe their embarrassment about who I was and what I wanted to do and their disappointment with what I was not just reinforced their fear and frustration. **I think they had me pretty well sized up as being on the road to wrack and ruin unless I gave up this music shit and got serious about something that made sense to them, like becoming a dentist or a plumber.**

At Walt Whitman Junior High we had a "battle of the bands" coming up. The King Bees were supposed to duke it out with Frankie Rae's band, which was going to be a real chance for me to shine, doing what I cared about and what made me feel like me. Only now I didn't have any drums.

Barry Schneidman, our bass player, had an older brother, Henry, who played guitar in another local band called the Dantes. These guys were all a little older, and they were doing some major gigs around the area, so they were like the varsity to our junior varsity, and every once in a while they'd come over and check out our rehearsals.

One of those afternoons when they dropped by, Barry talked to Henry, his older brother, and Henry arranged for me to borrow a set from their drummer. Then on the day of the contest, Henry came to see us, along with the drummer who'd loaned me his stuff.

Their drummer, this guy named Steven, was already a local legend, the best singer of anybody we'd ever been around. He showed

up wearing plaid pants, zipper boots, and a fur vest, with this gorgeous girl on his arm who was creaming over the fact that the Dantes had just been lined up to open for the Beach Boys. So from our perspective, this dude was The Dude, the man who could walk on water, which made it all the more mind blowing when he agreed to sing lead on a couple of our songs in the contest. I came out-front and sang "Route 66," and then he came out and nailed a couple of Stones songs—"19th Nervous Breakdown" and "Around and Around." This guy could really tear up the vocals, so naturally we won, but then there were all sorts of protests because he was a ringer, this older guy from the Dantes. His name was Steven Tallarico, and over the years that followed, he and I would continue to make music together. What I didn't know back then was that not only would Steven and I—and three other guys—change the face of rock 'n' roll, but Steven himself would become my mentor as well as my hero and (one of) my demons. He would serve as a kind of surrogate father figure for me in a dysfunctional dynamic that continued the pattern of confusion I felt between love and abuse as a child. It would be a central part of our relationship—and it would torment me for years. ★

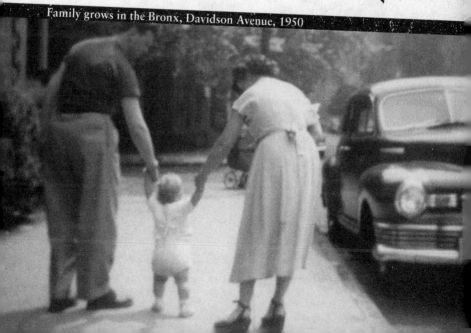

Family grows in the Bronx, Davidson Avenue, 1950

All my love "
Joey

IS THAT A BELT IN YOUR HAND

OR ARE YOU HAPPY

TO SEE ME?

Bands are all about collaboration, and the quality and the commitment of the guys you're with. I've always been lucky to have some great partners, starting with the Piscotta brothers. Their parents were completely open to the whole idea that their sons were going to play music for a living. Their father, Sal, was a stage director at NBC working on *Shindig*, one of the first music shows to take the *American Bandstand* idea and bring it into the sixties, so rock 'n' roll as a career for his kids made perfect sense.

But just as important as their support of our dreams, the Piscottas were open to having everybody hanging out at their place. They had this big, unfinished basement where we could rehearse. So one day after my drums had been locked up in the attic for a while, I simply went up and

sneaked them out of the house and set them up at Paul and Tom's down the street. My parents never even noticed.

At the Piscottas, I had free access in and out of the basement door, and they let me come in and play whenever I wanted to. I can remember us all sitting around the record player upstairs in their family room, listening to songs we were trying to learn. Bobby Mayo was such a natural that he could sit in front of the turntable, listening to a song for the first time, and call out all the chord changes as the music went rolling by.

The fact that my parents never noticed that the drums were gone, that they never even asked, was very much in character. They also never asked me—admittedly, not many parents would—if I wanted to move, which is what we did about this time. With the King Bees I had set up a pretty solid business proposition. We were good, and we were committed, but then all of a sudden there was a new obstacle in my path: we were living in Eastchester instead of Yonkers, almost five miles away, and it was a real pain in the ass to get back and forth to my basement rehearsal space. But it wasn't like I was going to give up easily. When I couldn't get a ride, I walked all the way back to Yonkers, which took about an hour and a half.

"What did I do now?" Eastchester, NY, 1968

Moving also meant that I had to transfer to a new school. For any kid, getting uprooted during your first year of high school can be a social disaster, and for me it was that much worse because I was Jewish, and Eastchester was tightly knit Italian. I caught so much shit that I started skipping out, writing notes to my teachers and signing my mother's name. Mr. and Mrs. Piscotta were pretty relaxed about school and homework and all that, so I was able to make good use of my time. Instead of getting crap at school, I was over in Yonkers with my musical brothers, practicing.

After a few weeks I had so many absences that the school administrators became suspicious. They called my house one day and wanted to know where I was. My mother had to admit she didn't know. "Well, what about all these days where you wrote notes for him?" they asked her. "What notes?" she said.

I thought my mother was going to implode. Her habit was to hold the anger in, but this time she was like a black hole that sucked all the negative energy toward her, tighter and tighter. Given her reaction, I knew I was going to have to face my father on this one and that this might be what finally got me killed. I was ready to kiss my ass good-bye, but for whatever reason, when we had our "little talk," he did not beat the crap out of me. I tried to explain that the kids in Eastchester had all been together since elementary school, maybe since first or second grade, and that I was doing my best to fit in but was getting ridiculed and rejected for being an outsider, and especially for being a Jew. I'm not sure this excuse cut any ice or that it was even necessary. **It seemed as if my parents were simply overwhelmed. Here they were, with all their first-generation American social insecurity, working hard and doing everything right, trying to fit in, and they had a son who cut school and forged signatures?** No matter that this kind of thing was going on in every school in America. I think they were so embarrassed that, for once, my father couldn't even access the rage and the violence that were his first picks from the child-rearing toolkit.

As for any confusion about what to do next, Eastchester made it simple. They suggested that I might do better by getting my education

elsewhere. My parents' solution was New Rochelle Academy—a jacket-and-tie private school that they hoped, I suppose, might support some behavioral modification.

Truth be told, aside from having to wear a tie every day, New Rochelle wasn't all that bad. I met a guitar player named Tom, a bass player named Tony, and a keyboardist named Ray, and we started a band called the Radicals. The headmaster allowed us to bring our instruments to school and set up in the cafeteria and play during lunch.

I'd been forced to let go of the King Bees, so I was no longer hiking back and forth to Yonkers, but now every other morning I hauled all my drums onto the bus and took them with me to school. When I got there, I'd set them up in the cafeteria and just smile, knowing that we were going to get to play. From my first class in the morning until noon, I would work out our set list and go through the drum patterns in my head. Then during lunch, none of us would eat because we just wanted to play. The kids at school loved it, which turned us on to the music that much more. Tom, the guitarist, was also an artist, and taking a hint from the Rascals logo on the front of Dino Danelli's bass drum, he copied the same design onto the front of my bass drum, only instead of Rascals it said Radicals.

I felt more at home sitting in that lunchroom playing music than I'd ever felt in my parents' house. The other kids were digging me because of my music, and I was digging being a part of something that felt like me. The only problem was the hair.

In the mid-sixties it was hard for me to feel like I was really a part of the music scene with a "boy's regular" haircut, paid for by my mother. But in my parents' eyes, any male with long hair had to be a degenerate.

"How come I can't have long hair?" I asked.

The response: "Because I'm your father and I said so." Or, "Because I'm your mother and I said so."

"Just do as I say, no discussion," was not a great technique for winning the heart and mind of this teenager. It was, however, an excellent way to foster rebellion, which was, of course, exactly what it did.

I wasn't conscious of it at the time, but I'm sure the demand for blind obedience made me look even more to my drums for my identity, and it

drove me that much further into the scene I was already slipping into. I might not be able to look the part quite as much as everybody else in the band, so I was determined to be just that much better musically.

To the extent that my going to New Rochelle was about upward mobility and family image, an unintended (and very opposite) consequence was my meeting Irv Goetz, who happened to be the nephew of the headmaster. Irv was from Boston, one year older and a year ahead of me. We became good friends and started hanging out together all the time. He slept at my house, and I slept at his house—his uncle's house, really—**and that is where Irv introduced me to drugs.**

It was summertime, and during the summers I often had to go to school to make up for whatever I had failed during the regular term. This meant that I had to be home by ten o'clock, but I didn't think, or care, about following the rules except to the degree I could slide by.

One night, our keyboard player, Ray, went down to 181st Street to cop nickel bags and to get a little fucked up on the way home. It must have been about eleven on this particular night when Ray dropped me off at my house. All the lights were off inside, and just the one porch light was on out front. So far so good. I walked up to the entrance and opened the door. I knew I was late and, of course, that my father could act like a maniac whenever I was late. But I was sort of having this "looks like it's cool," tension-releasing feeling. I'd made it to home base, and everything felt like it was okay. But, just in case, I took the joints I had in my pocket and rolled them into the elastic inside my pants.

The house seemed quiet. I took a breath and stepped inside.

Behind me the front door seemed to close by itself, and then my father was standing there.

"Summer school's tomorrow," he said. "It's eleven o'clock. You're supposed to be in at ten."

He stepped forward from where he'd been waiting for me behind the door. I looked at him, he looked back at me, and for a second I couldn't breathe. The scariest thing was how he was trying to be so very controlled. I saw the belt in his hand. Then I heard it come swinging past my head.

"Who the hell do you think you are?" he yelled.

He whipped that belt at me again. I ducked and ran across the living room, but he came after me. **I ran around the dining table, and he was right there. I turned one way, and he went the other, and then he had me cornered, whipping me with this heavy leather strap. I tried to hit him back, but the harder I swung at him, the harder the belt came down on me.** I was scrambling for my life, but I kept thinking about the joints rolled up in my pants. If they fell out, I was dead for sure.

In the end I just slumped to the floor and let my father whip me, and he did until he simply wore himself out. By the time he was done, my shirt was ripped, my shoes had fallen off, I was all black and blue, and my arms and my neck were bleeding.

"You get up to your room," he said, breathing hard. "Then you stay there until I say you can come out."

I wiped some of the blood off my face. I got to my feet and went up the stairs. I shut the door, and then I pulled down my pants to look for the joints.

Not there.

Now I was worried.

I listened. I heard my father climb the stairs and head down the hall. I needed to be sure he was in bed and down for the count. I didn't feel like having a replay of what had just gone down. I was seriously afraid one or the other of us was going to wind up dead.

After about five minutes things got very quiet. I figured the coast was clear, so I made my way back down the stairs.

The lights were off, so with one hand brushing against the wall, I felt my way through the living room and then into the dining room. I got down on my hands and knees and started sweeping my hands across the carpets, trying to find the damn joints. Finally, out of desperation, I stood up and flipped on the light.

My mom was standing there looking back at me.

"Jesus . . . Mom, you scared the crap out of me."

"What are you looking for?"

IS THAT A BELT IN YOUR HAND OR ARE YOU HAPPY TO SEE ME?

"The buckle fell off of my shoe. I'm just looking for it."

She stood there for a couple of minutes longer, and I continued to look around in the corners and under the dining table, only now I was desperately trying *not* to find anything. Mostly, I was just going through the motions because I couldn't even think straight.

"It doesn't matter," she said. "Just get to bed."

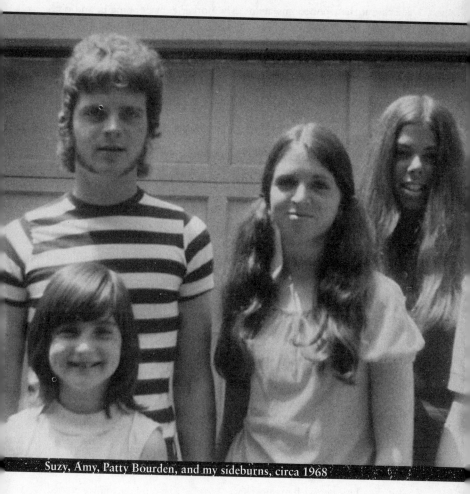

Suzy, Amy, Patty Bourden, and my sideburns, circa 1968

I went up the stairs again, with her following me, and this time I stayed in my room. I took off my jeans and just fell onto the bed, but I don't remember sleeping much that night.

The next day came, and I was still alive. My father hadn't come in to kill me, so I figured they hadn't found the joints. I had to go to summer school, and I got up too late to even take a shower, but I still tried to check out the front rooms again. My mother kept popping in and out, and I was afraid she was getting wise, so after a while I just said fuck it, grabbed my stuff, and took off.

That whole day in school I was miserable, trying to figure out what the hell could have happened to the joints. I couldn't find any trace. I tried to console myself that I'd looked over that room pretty well and hadn't seen them, so it was pretty unlikely that my mother would just stumble across them.

After class I went over to the Fort Hill Country Club to meet up with my friend Jerry whose parents were members. I went into the cabana to change into my bathing suit, and when I took off my pants, down there in the folds of my underwear were the joints. They had been safely tucked in there all night. It was such a relief that I could have lain down and cried. Instead, I sat down right there in that cabana and lit up a J.

I never really questioned the way my parents treated me—I was always too busy just trying to figure out how to get through the next couple of minutes. I did whatever I could to avoid catching shit and getting hit.

My dad was the judge and jury, and my mother was the warden. She would mess with my head by not talking to me for three days just because I didn't agree with her about something.

But the thing that drove me craziest about my mother was the whole status thing she bought in to. I started arguing with her one day about school, and she started yelling back at me. I told her how I felt about having to move to Eastchester and how miserable it made me, and this really pissed her off.

"How can you say such a thing!" she said.

For her, moving to Eastchester was meant to make our lives better. But then I hit her with my best shot. I said, "The only reason we moved to Eastchester was so we could look down on all the people in Yonk-

ers, even though all the people up in Bronxville still look down on us." Pontificating as only a teenager could, I told her that all this keeping up with the Joneses was nothing but horseshit, and then I turned away from her and walked down the hall.

She took one step and yelled, "You ungrateful little brat."

I muttered, "Go to hell," just loud enough for her to hear it. She waited about a beat, and **then she grabbed a mirror off the wall, caught up with me, and smashed it over my head.** It was a round mirror, about the size of a hubcap. When it hit me, the pieces shattered all over the hall. The glass flew into the bathroom and bounced on the tile floor.

I thought I was going to pass out. Not just from the pain of being slammed in the head with a thick piece of glass, but because I was so stunned. It was like someone had thrown ice water all over me, only ice water filled with broken glass.

I ran up the steps to my room and sat there on my bed, thinking, *Holy shit . . .* There was a mean lump on my head, throbbing and getting bigger. *What the fuck? My mother just hit me with a fucking mirror!*

At that moment I knew I had to get out of there, but I really had no place to go. I was in a band, in addition to my lunchtime gig with the Radicals, called Strawberry Ripple, and we were making a little money playing local clubs, but not enough for me to support myself.

A few minutes went by, and then my mother appeared in the doorway.

"Get downstairs and clean it up," she said.

My first thought, my first reaction, was to tell her to go fucking clean it up herself. I bit my lip, though, went downstairs, and swept the glass into the dustpan. I put it in the garbage, and then I came back upstairs, which, just as in our house in Yonkers, was my sanctuary. Being the only boy in our family, at least I had always been allowed my own bedroom. And here in Eastchester it was really big—an attic space that had been finished off. The walls were paneled, but they were short because the ceiling, which was really the eaves of the house, came down at a sharp angle. And that long expanse of sloping ceiling is where I created this massive collage, a kind of ode to teenaged angst. Every time I got sent

to my room, I worked on it, taping up pictures, creating a montage that ultimately covered the length of the room—maybe twenty feet long. The pictures overlapped until you couldn't see any of the wallboard. It took months for me to cover the whole expanse with images I'd cut from magazines, pictures of everything from girls to cars to drums to singers. It was like half the length of the back of the house, and it became like a shrine that all the other kids had to come see.

While my relations with my parents went from bad to worse, my relationship with Irv over at New Rochelle got more and more intense. We smoked pot every chance we got, and because his room was up on the third floor of his uncle's house, also kind of in the attic, those chances came quite often. From the window you could climb right out onto the roof and sit up there in the treetops and listen to the birds and watch the sun go down. Which was nice, but we went out the window and onto the roof mostly so we wouldn't smell up the place when we were getting high. And up on the roof is where the headmaster, caught us right then and there, toking away with not a care in the world.

Time for me to find another school once again. I was allowed to finish the term, but I was not invited to come back in the fall.

I was blowing through my educational opportunities at a pretty rapid pace, so it's good I was paying my dues in the music business. Strawberry Ripple consisted of me, Vinnie the keyboard player, Whitey the singer, and Jack Wizner the guitar player. We all got along really well, and we stayed busy working clubs and the college campuses, doing a lot of Young Rascals covers. But I had bigger ambitions. One day I said to Vinnie, "We've got to start writing our own songs." As a cover band, we were going to be stuck in the frat houses and the bars forever.

But Vinnie was older than we were, in his early to mid-twenties and married—and as long as we had gigs, he didn't have to have a day job, so he and the other guys were happy to do what we were doing. But I wanted to take it to the next level. If all I was doing was making pocket money, there were faster ways.

When I turned sixteen, it was time to start driving the car, but my father told me that if I wanted to drive, I'd have to pay the additional

insurance. I got a gig working at Eastchester Music, a hole in the wall store in the center of town owned by two brothers, Sal and Mike Tardella. Sal was a guitar player, and Mike was a drummer, and they both gave lessons. At first I was just the errand boy, but after a while I started working behind the counter.

Coiff by Bobby Rydell, mid-'60s

One Saturday morning Sal and Mike were both downstairs teaching. I was taking care of the store upstairs by myself, and business was slow that day, so I completely rearranged the whole place. When Sal and Mike came upstairs, they flipped out, but in a good way—they loved what I'd done. So they began to have more confidence in me. But more than that, because I was playing in local bands, they started asking my advice about guitars and amplifiers and other equipment. So I started helping Sal and Mike with inventory. They began stocking Marshall amps and Gibson guitars and the other stuff that the younger guys wanted.

The new equipment sold, so Sal and Mike thought I was the shit, and they started to take me out to dinner to ask me more about what I thought about this or that. After about eight months I was managing the store. So I started buying clothes and dressing the part—there was a haberdashery just down the street—and now that I had money to buy insurance, I was a big dude on wheels—driving my mother's station wagon.

At that point my parents instituted something that, to this day, still baffles me. Moving to Eastchester had been all about moving up and appearances, and that extended—at least for a while—to our having a live-in maid, a not unattractive young lady from Haiti, maybe twenty-five years old. In this case, my mother's obsession with order and control worked in my favor. I mean here I was a horny teenager, and they put our young, female help in the next room? All that separated me from her was a set of louvered doors. But in my mother's mind, this particular room next to mine was simply where the maid should go, and moving the kids around was just not going to happen.

So I spent hours staring at this young woman through the slats in those doors, watching her change clothes or get ready for bed. One night, while I was watching, she started sort of touching herself. It was so hot I could hardly believe it. All the other times, watching her change, taking off her clothes, it would be way too much of a turn-on for me to just watch so I'd always play with myself. But this time she was running her hands over her breasts and slowly, what seemed like teasingly, over her belly and down into her underpants. I was kind of freaking out and thought, maybe, just maybe she knows I'm watching and she's putting on a little show for me. So, and I have no idea where I got the balls, I

walked around and knocked on her door. She opened up, let me in, and then she opened up and let me in. . .

Unfortunately, this was a one-shot deal, but over the next couple of years I spent many a happy night reliving that scene—in my mind. Just about then, however, I was discovering another form of female companionship that turned out to mean a lot more to me in the long run.

Thornton-Donovan was the next lateral step on my way through high school, and there I met a girl named Patty Yellin. We were both in tenth grade, but I was a year older because I had to repeat a year. Her parents were very wealthy and never home, so we had the run of this huge mansion they lived in over in Scarsdale. I used to hang out there all the time after school, with Patty and this other girl, a friend of hers named Gretchen. We were like the three musketeers, but Patty and I were really like brother and sister. We ate, smoked pot, and watched movies. Patty's dad was the chairman of the board of P. Lorillard, a big tobacco company. They made Kent cigarettes and Tabby cat food and Reed's candies. Day to day, Patty was looked after by servants, a couple who took care of the house. Their names were Cledo and Singh, and every day when I got to Patty's house and went into the TV room, they would have it all set up for us. There would be a plate piled high with a little mountain of tuna sandwiches, cut in quarters, with all the crusts cut off, like tea sandwiches, very neatly piled in a circle, with probably twenty sandwiches around the bottom, and then eighteen, and then fifteen. And right next to that mountain of food there was always a tin filled with fresh chocolate-chip cookies just the way I liked them—still warm from the oven and soft in the middle. So being over at Patty's was like heaven. **There were no parents to fuck with us at Patty's house, no authority figures smacking me in the head.** Instead, Cledo and Singh were at our beck and call. If I wanted something to eat, I could have it whenever I wanted. If I needed to spend the night there, no problem. I would be in class in Thornton-Donovan, bored, totally not into it, but the thing that would keep me going was knowing that after school I was going to go over to Patty's house to listen to music and eat tuna sandwiches and chocolate-chip cookies.

Eventually, I started bringing my friends over. We all hung out at Patty's and listened to music. As it turned out, her brother Burt was in the rock 'n' roll business—he used to manage the Remains and the Barbarians, a couple of bands from Boston, so Patty had a main line to what was going on in the business. She turned me on to bands like Nazz, Todd Rundgren's group, and artists like Harry Nilsson.

We listened to music in her room, sitting under this print she had on the wall of van Gogh's *Starry Night*. This was the first time I ever saw it, the last painting he did before he killed himself, and it really stuck with me; I wondered, *Do you really have to be so tortured to be creative?* And even now, every time I hear certain cuts off the first Blood, Sweat and Tears record, *Child Is Father to the Man*, or Buffalo Springfield, I think of *Starry Night* and van Gogh.

I especially loved listening to Nazz, because it was no bullshit rock 'n' roll with sweet vocals over the top of it. They might have been just a bit too far ahead of their time, so not a lot of people knew about them, but the fact that they had only a cult following made them seem that much cooler, and us that much cooler for liking them. Which got me to talking about how I was going to put my band together and make it and be big and famous. And Patty asked me, "What would you name your band?" I said I didn't know. So we started kicking around ideas. And then one day we were listening to *Aerial Ballet* by Harry Nilsson. *Aerial* inspired us to come up with Aero. And then we started matching Aero with other concepts: **Aerocross, Aerofish, Aerocandle, Aerophone . . . Aerosmith! And I said, "Yeah, that's it. Aerosmith. Aerosmith. Aerosmith."** A "smith" is a master craftsman. Aerosmith would be the masters at getting you off the ground, getting you up, getting you high. I wrote it all over my books in school, and from then on, that was the name that stuck with me.

Patty took me seriously. She supported me, even though I can't say how much emotional support she got from me in return. I think she was lonely with her parents never being around, so she reached out to my parents to fill what was missing in her life. Patty spent time at my house just hanging out and, unlike me, she was able to connect with my parents. Patty became especially close with my mom and would try

to explain to my parents what it was that music meant to me and how important it was for me to be in a band. I loved having Patty in my life, having her support me the way she did, and it felt good to me thinking that, because my parents seemed to respect her, she might be able to get through to them and get them to see me and what was important to me with some respect. But the way my parents looked at the world, there was no room in their eyes for my life to be about me. I was an embarrassment to them. I failed to support the image of the successful, middle-class American family they worked so hard to be and to project. Their image of the Kramer family did not include having a son who was a long-haired rock musician.

Johnny Ramp, a friend of mine who also played in bands, had a '67 Plymouth Barracuda, green with black leather, four-speed on the floor. Johnny loved to drive, and I loved his car. We spent a lot of time just cruising around the neighborhood. We checked out the selection of girls and hot cars up and down Central Avenue, up and down Roxbury Drive, up behind Nathan's on Patton Drive, and on Eisenhower Drive. And sometimes we went over to Ray Tabano's. Ray was always the "go to" guy for getting high because he always had the best hash, which we called "chunko."

One day we went over to Raymond's place on Mountain Dale Road. His mother let us in and said, "They're upstairs." We made our way up to Raymond's room, and there he was with his sister Dottie, his brother Les, and a couple of the local neighborhood guys, Pip and Guy Gillette. They were all kind of lying around the bedroom, smoking a hash pipe, getting high and just sort of groovin' out.

We told Raymond that we wanted a "weekend kit." This was Raymond's brilliant marketing concept, a survival kit that consisted of a little piece of hash, a couple of downs, some speed, and some acid. Johnny and I both immediately went for the speed. Then we started smoking the hash to smooth out the speed-head. When the drugs kicked in, we looked at each other and said, "Time to ride."

Just then the door opened, and in walked the cool, slightly older guy who had loaned me the drums for the battle of the bands, Steven Tallarico. He was already a local hero because he was the best musician

around, with bands like the Dantes, and William Proud, and Fox Chase. On this particular day at Raymond's, he was also way ahead of the rest of us when it came to experience with drugs. Steven drifted in completely stoned with an album in his hands. High as a kite, he told Raymond, "You gotta hear this record. You gotta hear this record."

So Raymond put it on the turntable, and we all started listening. Steven had more sophisticated musical tastes and had his finger on the pulse. What he introduced us to this day was Jimi Hendrix's third album, *Electric Ladyland*. Steven sat himself down on a drum stool in the corner of the room and just went off into this groove.

It took all of sixty seconds for me to completely forget about cruising with Johnny. All of a sudden I couldn't wait to go out and get that record and start learning all that shit. I was completely blown away by Hendrix, and especially by Hendrix's drummer, Mitch Mitchell. That dude was from another planet as far as I was concerned. The songs were great, and Hendrix's singing was great, and the sound of his guitar was simply miles and miles beyond anything I'd ever heard before. The whole thing made me feel higher than the drugs, and even if I'd been clean and sober, it would have sent me flying.

I left Raymond's, went out, bought the record, and took it back to my room. I listened to every track over and over and over again, and I learned every lick and every beat. I listened to it all the time, day and night, night and day, and by the time I'd worn that vinyl out, I knew every bit of it backward and forward.

And then came the next album, *Axis: Bold as Love*, which completely sealed the deal for me with Hendrix and Mitch Mitchell. It didn't take long before I could play every beat on every song on that album too. It was unusual then for the drum sounds to be so powerful. This was actually one of the first recordings where I could hear the drums distinctly enough to really tell exactly what the drummer was doing. Mitch was just playing so much, and that's what I was getting into—his adding all those fills and chops in addition to timekeeping.

I was ready to apply this new understanding of what was possible with a set of drums. The first chance I had to really try it out was with a band I got into after Strawberry Ripple called Nino's Magic Show.

IS THAT A BELT IN YOUR HAND OR ARE YOU HAPPY TO SEE ME?

Jack Wizner, who came from Strawberry Ripple with me, was the guitar player, and he used to pick me up and drive me out to rehearsals at the keyboard player, Larry's, house in New Jersey.

This was 1968, and things at home sucked so bad that I was going out of my mind, but here with these guys I could be myself. More than that, I could be myself making something happen musically. **I picked up the phone, called my parents, and told them I wasn't coming back.**

My mother started crying. "How can you treat us this way?"

Then my dad got on the line, but instead of tearing me a new asshole, he tried to sound like the guy on *Father Knows Best*. "Son, you really need to come home. Your mother's hurt. You've made your mother and me . . ."

He told me everything would be okay, but everything wasn't okay, and it wasn't going to be—I knew that, and he probably knew that too. My dad was the muscle that enabled my mother's need to control. If I made her feel bad, he was the one to make me pay by beating the crap out of me. I was sick of this shit, and I decided I had to do something about it.

"I'm not coming home," I repeated.

"How long can you stay there? You don't have any money."

"I'll be fine. I'm just not coming home."

I stayed out there for most of the summer, living on Spam at Larry's parents' house and playing rock 'n' roll. And I think it really drove my parents nuts that, for the first time, they really had no say. They didn't even know exactly where I was.

By the time the summer was over, I'd pretty much worn out my welcome in New Jersey, and I was pretty sick of Spam, so I finally relented and came back home. I think my parents where sufficiently glad to see me that they stayed fairly cool for a while. I lived at home, did my senior year at Thornton-Donovan, and, miracle of miracles, in June I actually got my diploma.

Around that time not much was happening for me musically. Nino's Magic Show had sort of faded, so I spent the summer after graduation indulging my other passion—drugs.

It was 1969. The parents of another friend of ours, Steve Dwyer, were going to put their house on the market in the fall, and they gave us the run of the place for the summer—Steve, my buddy Richard Guberti

Father and son "lookin' good"; Eastchester, NY

from New Rochelle Academy and me. So here I was, living in a big house with a pool in Harrison, New York, and my summer job was dealing, and I was doing pretty well. Steve's mother was the owner of the Sabrett

Hot Dog empire, and there were cases of hot dogs all over the place. We must have eaten tons of hot dogs, and owing to the influence of chemical enhancement, we got very creative. We tried every imaginable combination of hot dogs: hot dogs with peanut butter, hot dog Hostess Twinkie sandwiches, hot dog and tuna casserole, a la mode. . . I can't, and don't really want to remember much more, but suffice it to say, our summer was, among a few other things, a veritable drug-assisted, hot-dog extravaganza.

Richard Guberti and I based out of the house in Harrison that summer. His parents bought him a 1969 MG-C for graduating high school and we would drive it up to Boston to cop a couple of pounds of weed, then drive it down to New York City. We would sell it in Manhattan, pick up a couple of thousand caps of mescaline, then ferry that back up to Boston. The mescaline caps were camouflaged, stuffed in large candle canisters, with a couple of dozen candles to a case. We'd pack the goods into the MG, drop a hit of mesc for the road, and then count out the number of joints we calculated it would take us to smoke our way back to Boston. Very scientific. Once home, we would only sell what we had to in order to cover the cost of what we would give away to our friends and what we would eat ourselves. We did everything we could to consume whatever "extra" merchandise was on hand at any given moment.

Next to the pool cabana there was a shed, and inside the shed was diving gear: tanks and flippers and wetsuits. One day we had a big gang over, and we were tripping; I decided to enhance the experience by putting on all that SCUBA shit, then getting into the pool.

Everybody else was just hanging around outside on the lounge chairs, staring at leaves or counting their toes, but I had this tank on my back, and I was fiddling with the regulator, teaching myself how to breathe through the mouthpiece. Then I was under the water, watching the bubbles rise, totally tripping all by myself. I felt like I was in one of those sensory deprivation chambers, only with the thing set to serious fucking overload. The water was going from orange to purple and back to blue green, and the tile walls kept expanding and closing in and then rotating up over my head into the sunlight.

Because I was under the water—not to mention completely tripped out—I didn't notice when it clouded over, when the lightning started, or even when it started to rain. But by the time I surfaced, everybody else had run up to the house. I stood up out of the water, looked around, and thought, *What happened? Where'd everybody go?*

So I came out of the pool and started walking toward the house, the rain pelting me, thunder pounding, wearing these flippers and a mask and the big tank on my back. I'm not sure I had a clear concept of whether I was still in the pool or on dry land. It was a fairly steep hill to get to the house, and the lawn was slippery, and I was wearing flippers, so I kept falling down. And when I looked up, I could see everybody else, warm and dry in the living room, huddled at this big picture window, watching me, pointing at me, and laughing their asses off. I'm sure I must have looked pretty funny, but still it sent a chill right through me. I felt like the outcast. I hated that feeling but it came rushing back to me, so what I did was my classic "hide" response. I turned around and went back down to the pool and lowered myself back under the water.

My grades all through school had been crap. I had no interest in academic pursuits, but even so, my parents insisted that I go to college. Their son had to be a college graduate. If for no other reason than to keep the peace, I signed up for the fall at Chamberlain Junior College in Boston. The school meant nothing to me, but I was pretty psyched that in just a few weeks I was finally going to be away from all the bullshit at home.

In August as a kind of freshman orientation to the freedom to come, some buddies and I decided to attend this concert upstate. Word had spread that there were going to be maybe thirty bands—and big name bands at that—out in some farmer's pasture. The posters all over New York said, 3 Days of Peace & Music. All I needed to hear was that the Who was going to be playing there, and there was no way that I wouldn't be there too.

On the 14th of August, 1969, I was barreling up the New York State Thruway in a red Oldsmobile convertible, totally stoned, with my friends Howie Brooks, Jerry Elliot, and Joel Van Blake. From the looks of the

building traffic, this event was going to be an even bigger deal than we'd thought. It was turning into some kind of mass migration, with every freaky, Age of Aquarius, longhaired kid in the Northeast hanging out a car window, flashing me the peace sign. For that one moment in time we were all heading in the same direction.

We got to the Yasgurs' farm early, before the cops closed off the thruway, so we actually made it onto this farm in Bethel, New York, where the "3 Days" was all supposed to happen. Tickets were eighteen bucks, six dollars for each day. We figured we'd buy these when we got there, but they were for sale only back in the city, so we bribed a couple of the gate guys with Quaaludes and some weed, and they let us in.

Later that day the number of humans converging on the scene was so huge that the state police had to shut down the thruway. The makeshift fences came down, and anyone who wanted to just walked on in. There were half a million people there. It was amazing—our world was changing, and Woodstock was the soundtrack of this great cultural shift.

We drove across the pasture and set up our little camp at the crest of the hill overlooking the stage.

I could see these huge towers with speakers on top going all the way up the slope. As the crowd kept coming onto the grounds and settling in, it was like the gathering of the tribes, or maybe some kind of costume party, with feathers and face paint, and chicks in granny dresses, and guys with beards and hats that made them look like the Union Army on maneuvers, not a bunch of hippies getting ready to fuck their brains out listening to Country Joe & the Fish.

Joel had brought this big blue tent, and we had Howie's Oldsmobile right next to it, and the four of us inside. It was maybe ten-foot square, and it had a floor, and you could even stand up in it. More and more of these beat-up psychedelic school buses appeared all around as the hippie pioneers circled their wagons. Then some mangy-looking guy suddenly showed up at our door. I have no idea where he came from, but he had that tanned, dirt-encrusted look like he'd been on the road for about twelve years. He asked if he could stay with us. We were pretty dubious, but when he pulled out this hunk of hash the size of a softball, we all

said, "Sure. That's your corner." We let him stay in the tent, and he kept us high on Red Lebanese hash—moist with cannabis resin—you could almost get off just looking at it. We ate it, and we smoked it, and then I spent the next forty-eight hours lying down on the floor of the tent, looking down through the rain toward the stage. My head was propped up on my arm, and the hash pipe was in my mouth. I'd light the pipe and take a hit, and then I'd nod out. Then I'd open my eyes again, stuff the pipe back in my mouth, and light it up again. Between the Tuenols, Seconals, the blotter acid, and the hash, it just went on and on.

By the time the Who made it to the stage, which was 4 a.m. Sunday, I was so out of it that Howie and Jerry had to hold me up, with one of my arms over each of their shoulders. I had taken Tuenols to kind of mellow me out and bring me down off the acid, but all they did was make everything slow to a crawl. When somebody spoke to me, I could see the words coming out of his mouth like in a cartoon, with the alphabet floating by in slow motion.

The Who played twenty-five songs in a two-hour set that lasted until the sun was just about up. When Grace Slick and Jefferson Airplane took over, I decided to go for a swim. There was a pond on the other side of the woods, the woods into which everyone was running off to take a shit because there weren't enough toilets. I passed through this big muddy quagmire—I hope it was mud—and who should I bump into but Raymond Tabano, the king of chunko, the "weekend-kit" entrepreneur.

This encounter with Raymond diverted me from my mission of a sunrise splash. We decided to head over to where his tent was set up, which was near the hog farm. He was carrying these Lebanese Temple Balls, which got me even more fucked up, and I was feeling truly transcendental when, walking across this field, I saw somebody in the distance, sort of gliding toward me in slow motion.

I really liked the image of his arms moving back and forth and his legs going up, down, up, down, and I kept walking, while this other person kept gliding toward me, and as we got closer, I realized it was, once again, Steven Tallarico.

I shit you not. They say that when the student is ready, the master will appear. All I know is that Steven Tallarico kept popping up all over the place. It would be another year or so before he and I started getting together on a more regular basis, but when we did, we and a few other guys I would soon meet made a little bit of music history.

BROWN RICE AND CARROTS

In September 1969, only a couple of weeks after Woodstock, I was out of my parents' house and living in Boston, a freshman at Chamberlain Junior College. The first thing I did was grow my hair, but instead of "down to there," it was more "out to here" in a big frizzy mop. With the crowd I hung with in high school, I was the only guy without long hair; here I was the only guy with it. So I was thinking this was not going to be such a great match, Chamberlain and me.

But then I met my first real sweetheart, a girl named Gracie Schwartz, and I fell head over heels in love. Her best friend, Margorie, was hooked up with my roommate, Jerry Notaire; the girls were a little older than us and well connected and able to get us really high-quality drugs. Mostly, they really liked to fuck. So, at a second look, college was not too bad.

Gracie and I spent most of the fall semester in our dorm room, fucking and stoned out of our minds. Life was excellent. But then Jerry and I decided that it could be even better so we launched a campaign to fight the school's policy of gender segregation. In other words, we wanted to be able to fuck and suck and get stoned with our girlfriends, in our dorm rooms, anytime we wanted, without having to go to all the trouble of sneaking the girls past the dorm counselors. To listen to us rant and rave, you'd have thought it was the My Lai massacre that had us all worked up. We printed up a bunch of flyers and distributed them all over campus. We stood in front of the buildings, yelling, "Don't go to class! Boycott your classes!" And boom—we had an actual strike on our hands.

Before the fall semester was over, we had attracted a lot more attention to ourselves from the administration watchdogs than to our cause, and we got caught with the girls in our room. Over Christmas vacation I was at Gracie's house in New Jersey when I called home to speak to my mom. Even for my mother her voice was pretty cold, contained, and controlled. She told me about the letter they received from Chamberlain saying I was not to come back.

Then my dad got on the phone, and he'd pretty much blown a gasket. "This is the last straw. From now on, you're on your own."

"Fine," I said. I was nineteen years old, and the calendar was just about to roll over to a new decade.

My days at home were over, and so were the sixties. Platform shoes and disco were just around the bend, and the "Peace and Love" message had taken a pretty good hit from the Manson Family murders and the Stones concert at Altamont where the guy got knifed on camera. Richard Nixon—not Bobby Kennedy or Gene McCarthy—was in the White House, and the Moral Majority was primed and ready to pull the country back to a right–wing conforming status quo. In just a few more months the Beatles would be breaking up. A few months after that Hendrix would overdose, followed by Janis Joplin, and then Jim Morrison. My response at the time was to make the most of sex, drugs, and rock 'n' roll . . .

When Jerry and I came back to Boston as "former students," we proceeded to get an apartment together at 855 Beacon Street. This was in the Fenway area just out of Kenmore Square, about a bong's throw from Boston University. Mrs. Shapiro, our landlady, was always bugging us for the rent and also to take down the peace sign hanging in our front window.

I got a job at the Prudential Insurance Company, making $56 a week, running an A. B. Dick machine in the duplicating department. To subsidize the slave wages, I picked up some cash dealing in weed and mescaline.

The head of my department at Prudential was a big black guy who stood about six foot eight and went by the name "Tiny." We got to talking one day, and he told me he sang baritone in a soul group called the Unique Four. When I mentioned that I played the drums, he said, "You gotta come check us out." The Unique Four had a backup band, and it so happened they were looking for a drummer.

A few days later, Tiny was outside my door in a van, waiting to take me and my drums over to this place in Roxbury where he and the group rehearsed. I had no idea where I was going. I didn't really know Boston, and I had no clue that Roxbury was a neighborhood where I was going to be the only white man within about two miles. It made no difference to me, but I think I must have been slightly conspicuous with my white-fro hair and my Captain America shirt.

I went into this sort of grungy apartment and set up my drums in the living room. I was diddling around and warming up as the other musicians started wandering in. I definitely got the feeling that some of the band members weren't real happy I was there. I could almost hear them asking,

"Who the fuck is this white-assed, blue-eyed mother fucker who not only wants to play with us, but wants to play the drums?"

They unpacked their instruments—it was a six-piece combo—and tuned up a bit. Then we started jamming. It became apparent pretty quickly that I knew what I was doing, and I think one or two of the hard cases almost held it against me because they didn't want me to be any good. But then we got into the spirit of the thing. One of the guys would ask me, "You know this song?" or, "You know that song?" Mostly they were

into Kool & The Gang and Solomon Burke and Percy Sledge, whereas I'd grown up on the Kinks and the Rascals and the Beatles. So we had a little cross-cultural exchange to get started on, which was great for me, because these brothers started turning me on to soul in a big way.

This is where I began to come into my own as a "feel" player. Whenever you hear a drum track, even all by itself, it has to make you feel a certain way. It was when I was working with the Unique Four that I learned to project a feeling onto the other musicians, as well as onto the audience. It was then that I truly experienced and realized that the drums have to provide the right groove so that the other players and singers can lay down their thing on top. It's like a roadbed, all the gravel and shit they lay the railroad tracks across. The drum track is the roadbed that the song is built on. If it doesn't feel good—even if it's technically perfect—it's wrong. A drum track has to make you want to move your hips. Music is really all about fucking and a great groove has to drive the rhythm for a great fuck.

Tiny and the other singers and musicians decided that, as a drummer, I had possibilities, so before I knew it, I was buying myself some bib overalls—red polyester with rhinestones all over them—and platform shoes, because everybody in a soul band, they told me, had to "put on the dog."

Tiny and the band wanted to mold me further, so to advance my education, my new partners, (my band members) took me to this place called the Sugar Shack, which used to be down on Boylston Street, in the Combat Zone. "The Zone" was a nondescript, rundown part of the city squeezed in between Chinatown and Boston Common. It was mostly winos and strip clubs, and the name came from your likelihood of getting knifed on the sidewalk on any given evening. The Sugar Shack was a soul club down in a dingy basement, but once you got downstairs—if you could see through all the cigarette and reefer smoke— on any given night you could catch the O'Jays and even the Temptations.

Our bass player sat me down and said, "Watch the drummer." The drummers in these bands played to accentuate the singer's dance steps. This was a whole new concept for me, and to back up the Unique Four, I had to get familiar with the choreography for each song, then work out drumming accents for each step. Later on, this made it much easier for

me to incorporate off beats into the context of a regular beat of straight time and then add stuff in, because I had learned my chops from soul and from working with the dancers.

Like all these kinds of acts, the Unique Four really worked up a sweat, and whenever they'd take breaks, the band had to be ready to fill in with instrumentals. This meant that I also had to get up to speed on some Booker T. & the M.G.s shit like "Green Onions" and "Behave Yourself."

We played a couple of gigs at the Prudential employee office parties and so on. But even after that I spent a lot of rehearsal time with just me and my drums and the singers. They would show me different spots in the songs where they wanted me to accent their steps, and I learned from them how to be the funky backbone of a band.

As the ultimate training mission, the guys took me down to Harlem to the Apollo Theater to see the "Godfather of Soul," James Brown. His band, the Famous Flames, had two drummers—Clyde Stubblefield and a dude who went by the name of Jabo—and they would alternate. One would play and one would rest, and then the other would play and the other one would rest, and I never saw that much sweat and that much shouting and that much spectacle in all my life. But the most amazing thing was the big finale and the encores that would go on forever. James had a guy on the payroll who apparently performed only two functions: one was to announce the show, and the other was to throw this cape over James' shoulders as he was leaving the stage. James would sing his heart out for a couple of hours, growling and screaming and shouting until it looked like he was about to collapse. The audience would be on their feet clapping and stomping and going nuts, and then the announcer guy would come out with the cape. The show was winding down, and it looked like it was time to go, maybe time to get James to the hospital. The announcer would gently lay the cape over the poor man's shoulders, and James would sort of creep off to the side of the stage as if he'd truly given it his all. There just wasn't anymore to give. Then the music would pump and pulse, James would fling back his arms, throw the cape to the floor, and race back to center stage. He'd grab the microphone like he was going to wring its neck, then blast out another song, and then

another, until it appeared that once again he'd screamed and growled and shouted his lungs completely out of commission. Once again he'd drop his shoulders, and the guy would come over with the cape. They'd do it all over again—the whole bit about slinking off to the side of the stage, looking like an invalid, and then the miraculous recovery, and then another amazing encore. They must have done it twelve times.

Once I started playing soul, I got heavy into Earth, Wind & Fire. I loved the combination of the music and the singing, instead of the usual rock 'n' roll thing of just one guy out front as the vocalist. There was another thing I loved about the Unique Four: the drugs—serious dope. These guys could get high and then just sit around for hours, singing. Sometimes they would be working out specifics of the vocal parts, and I'd sit there getting a little bit bored and not wanting to be "not part of," so I'd get high, too, on these little monsters they called bug balls—a little bit of coke and a little bit of heroin. But the Unique Four never ever got so stoned that they couldn't sing.

Getting back into the music scene, and getting deeper and deeper into the drug scene, I started showing up for work at the insurance company later and later. Eventually they fired my ass, but it hardly mattered because this whole routine was about to come to a screeching halt anyway. Staying up all night and not eating right, not to mention consuming vast quantities of drugs, I ended up in the hospital with hepatitis and mononucleosis, and jaundice to boot.

I was flat on my back in a charity ward when my father came to see me. He said, "You have to come back home to recuperate." But even as he was reaching out to the prodigal son, he still had to lay down the law. "In order for you to come back to my house and stay there, you have to get a haircut."

It was really kind of laughable—as in, "you've been doing coke and heroin, hanging out with pimps and junkies in Harlem and fucking everything that moves, but in order to maintain your place in Eastchester society, the hair has gotta go."

Early '70s

But the truth was I had no choice—I needed a place to stay where I'd be taken care of. So I cut my hair and went home to recuperate. Then when the big moment of reconciliation arrived, my parents and my sisters immediately took off for Europe for two months. I got left behind in the house all summer with my grandmother and some Saltine crackers.

By the middle of July my energy was coming back to the point that I started going batshit with boredom. I came upon this guitar player named Bob Schuster, who we called Schroeder, and Tom, a bass player, and another guy named Jeff who played electric saxophone. I don't think this band ever really had a name—it was so short-lived—but I remember being in Schroeder's basement, rehearsing, when I started feeling sick again. I realized that I'd jumped the gun on this return to normal activities shit, so I had to stop playing. I went back and rested up for a few more weeks at the house with my grandmother, Anne Krouse, and the Saltines. By the time I was done with that, September had rolled around, and I decided that I wanted to go back to Boston, only now as a student at the Berklee College of Music.

By this time, I guess my parents had given up on my ever amounting to anything, but any kind of school must have seemed better than living on the streets. So my father agreed to loan me the money, but it was clear that I was going to have to pay him back. I went up to Boston

with Schroeder, who already had an apartment on Hemenway Street, just around the corner from Berklee.

Because we were living in the same apartment, it only made sense that we start up a band. We had a saxophone player living with us and a bass player and Schroeder and me, and we set up all our shit in the living room as our rehearsal space. We jammed our brains out, but it was pretty clear to me that we weren't going anywhere. Meanwhile, Berklee was nothing but frustration because I was self-taught, and I used a matched grip, and they wanted me to basically start over and relearn with a conventional grip.

Oddly enough, Raymond Tabano, my old buddy from Yonkers had also moved to Boston. He and his girlfriend, Susan, had opened a leather store on Newbury Street called The Yellow Cow. I used to go visit on a regular basis, and I told Raymond to let me know if he heard of anybody looking to put a band together. Eventually, he told me about **these two guys from New Hampshire named Tom Hamilton and Joe Perry who were asking around. They were bass and guitar; they had a keyboardist and were looking for a drummer.** Eventually, they came over to the apartment where I was living on Hemenway Street.

I remember when they walked into the living room—Joe with his horn-rimmed glasses, bell-bottoms that only reached down to his ankles, cowboy boots, and a long shag haircut with a blond streak in it, and I was thinking, *who the fuck is this guy?* But once I started playing, I could see him and Tom smiling ear to ear. All of a sudden they were saying, "When can we rehearse? When can we do this? When can we do that?"

Tom and Joe had just moved to town with the single objective of putting a band together. They had already scored rehearsal space in the basement of 500 Commonwealth Avenue, which was a girls' dormitory at BU. They knew a guy named Jeff Green, who was the president of the student union or some such thing, and they'd made a deal with him that in return for playing mixers for the students, he would let them use the space. This seemed to be where all the musicians at BU left their shit, so the entire room was full of drums and amps.

We jammed a bit, and these guys had a lot of balls when they played, but they were a little raw. After a while I was wondering once again if this was going to go anywhere. And at just about the same time they called me up and said, "You know, we don't think we're going to be able to use you because a friend of ours from New York is coming up. He's a singer as well as a drummer, and we've been talking about playing in a band with him like forever."

I was kind of surprised, and there was what they call an awkward silence.

"So thanks for coming around," they said, "but now we're going to use this other guy."

"I'm from New York," I said. "Who is it? Maybe I know the guy."

"Steven Tallarico," they said.

"You gotta be fuckin' kidding me," I said. "I've known Steven since junior high."

So Joe and Tom told Steven about me, and that the three of us had been jamming. "That's fuckin' great!" Steven said. "Joey can play the drums, and I can get out front and sing."

At the time, I didn't fully appreciate just how much whoever was going to be the drummer in this band was going to be in the hot seat. Steven had a reputation for being a perfectionist, and the drummer was going to be a lightening rod for every obsessive-compulsive bone in the man's body. At the time, though, as far as I was concerned, to have the opportunity to play music with Steven along with Joe and Tom in a band was just what I was looking for.

Steven's only other condition was that we would have Raymond playing the second guitar. So this new lineup really was like Yonkers all over again, with a little bit of New Hampshire thrown in for good measure.

Joe and Tom had an apartment farther out at 1325 Commonwealth Avenue, in the low-rent district of Allston. Steven came up and moved in, and I left school and moved in too.

The apartment was on the second floor, and in the basement lived Gary Cabozzi, the building superintendent, and his wife, Millie. Gary

was a greaser, supposedly an ex-marine, and he sort of looked out after us, in exchange for which we paid him in beer. Meanwhile, we were living on brown rice, peanut butter, and occasional meals scored at a BU dorm. (We were also not above walking past the checkout at the Stop & Shop with T-bones stuffed in our pants.)

The only money coming in was from pissant day jobs. Steven worked in a bagel factory. Joe was a janitor, sweeping floors in a temple over in Brookline. Tom finagled his way into some federal program that paid him to study to become a draftsman at Raytheon, designing bombs or rockets or some shit. My job was to lay low and completely recuperate from hepatitis.

One day I was coming home, and I was standing on the corner when I saw a taxi pull up, a guy lean out, put a suitcase down on the curb, and then ride away. I don't think he saw me. So I stood there for a minute looking at the suitcase, then looking to the left and looking to the right. Then I went over to it and opened it up and looked inside. There was nothing in there but a bunch of dirty old clothes, so I closed it up and left it on the corner where I'd found it and went on up into the apartment.

A few minutes later, Steven walks in, suitcase in hand. He opened it up in the living room, rummaged through it just like I had, then closed it, took it back downstairs and put it on the corner where he'd found it.

A few minutes later there was some heavy-fisted banging on the door. We opened up to find these two fairly intense looking dudes, one of whom had a pistol pressed against his thigh.

"Hand it over," they said.

"We put it back on the corner," we said.

At which point the pistol came into full view, aimed right at some of the jewelry hanging down onto Steven's chest.

"Don't fuck with me," said the guy with the gun.

For a minute there, all we could think about was the business end of that gun, but then from out of nowhere comes Gary Cabozzi, running up the steps, screaming, "I'm going to kill you mother fuckers."

Our greaser/ex-marine/building superintendent was swinging this sword around his head, coming on like he's storming the beach at Iwo Jima. These bad guys took one look at crazy Gary and made for the exits.

The only thing I could figure was that there was something mighty valuable in that suitcase that I had missed when I poked around inside. The important thing was that we lived to tell the tale. Years later, Steven finally came clean, supposedly, and said that, yeah, there was money and dope inside and that he took it. I always thought he was full of shit, but as is typical when dealing with Steven—I'll never know.

This living arrangement was set up to be rock 'n' roll boot camp, with Steven as the drill instructor. There were songs that Tom and Joe were doing that Steven loved and wanted to do, and there was stuff that Steven had done that Tom and Joe wanted to pick up. In New Hampshire, they had grown up seeing Steven's bands at this roadhouse on Lake Sunapee, and they'd said to themselves the same thing I'd always said: "Wow, I'd give my left nut to play in a band with that guy. That guy is the shit."

With this band we all knew we had a real shot, and we were all determined to make it work, but first we each had to prove that we deserved to be in the lineup. What we meant by "making it" had very little to do with fame and fortune. That would come along later, but that was not really what we were striving for. Making it in a band at the time meant being able to play good-sized places for a lot of people, and to get our name around, and to become known for being good musically: both talent-wise, and performance-wise. The fame and the money are nice, but we achieved it because we did what we did from our hearts. It came from a true love of the music we played and a love for bringing it to the people and having other people enjoy it. So first, we had to enjoy it.

One day I walked down the steps to our rehearsal place in the basement of the girls' dorm at BU. I was a little late, and there was the rest of the band, playing and working on a new song called "Movin' Out." It was the first song that Joe and Steven wrote together, and they were really anxious to get it down right and tight.

The song has kind of an odd line to it. And I'm thinking, *Wow, that's a tough one. I don't know what I'm going to play for that.* I sat down

at my drums and I started diddling and fuckin' around while the band was playing the lines of the song. And within two minutes, I came up with a drum line that fit perfectly.

I could feel a big smile coming across my face as I played; I looked at Steven and he was smiling back at me. It was a sense of accomplishment, really joyful, and I could feel my joy being reflected back from Tom and Joe and everybody. We were pulling the whole song together and making it happen, and each of us was living up to his part of the bargain. This whole back and forth, give and take, was like nothing I'd ever experienced before. It felt like home.

The band was the number one thing for each of us, and each of us was willing to sacrifice for it. Except for Raymond, who lived with his girlfriend, we all lived together in a shitty apartment for the band. We all ate crappy, cheap meals together for the band. And I loved it. I loved the camaraderie, the rehearsals, the getting high together. I loved the whole feel of it. I loved learning new things, which I always did when I worked with Steven. He was committed to teaching me everything he knew about drumming, and I was very open to learning. He saw some talent, but he also recognized that I really had no clear direction and that I needed to carve out my own territory. He had a better handle on what I was capable of than I did, and he helped me mold my talent. I was doing Mitch Mitchell, and he wanted more John Bonham, but he also wanted that Bonham sound filtered through something new and unique.

Mitch was very jazzy, with a lot of emphasis on the high hat. Bonham played with the kind of feel that was just so overwhelming that you thought everything was going to explode, but then somehow he kept it right on the edge so that it still held together. He did this by playing behind the beat, which accentuates the "heavy" feeling that gave rise to heavy metal.

A drummer can be exactly right on the beat so that he's perfectly on time. Or he can be in front of it, and it feels like everything's being pushed, which gives it this anxious feeling. Or he can lay back on the beat, which means playing behind it. If you listen to "You Shook Me" or "The Bonton Song" or "Trampled Under Foot" or "The Crunge," you hear Bonham hitting the drum at the last possible millisecond on

every beat. Nobody could do it like him, and that's why when he died, he simply couldn't be replaced. A lot of his genius was also all the stuff that he didn't play, which is to say the places where he left holes, and where he stopped.

Steven was influenced by several different drummers, including some that I didn't care for, but he taught me to appreciate them all for what they were doing. That's how I got hooked on the idea of bringing it all together and reshaping it in my own unique way.

Any musician, to really stand out, has to have his own signature, the distinctive things that mark the way he plays. Otherwise, he's just the same as the next pretty good musician, or the next really accomplished, technically adept musician. Steven helped me find my own signature. One small example of what I mean is this little thing on the high hat that I do, like on every two and four. I raise my left foot a little bit to let the cymbals up, and along with that I make the snare drum pop on every two and four, so the high hat comes up a little bit, and just goes tsch . . . tsch . . . tsch . . . along with the snare drum. Nobody else was doing that kind of stuff.

With my great dane, Tiger, early '70s

By working so closely together, Steven and I created this real, musical synergy. Even today, when we do tracks, because of the way I listen to the vocal and the way he listens to the drums, I can create spaces for a vocal line, giving him places to hang his hat. And if he does the vocal first, he'll give me places where I can go off and do little diddlies that coordinate with the vocal.

Steven was really out to shape all of us, both individually and as a band. He says that when he first heard Joe and Tom, what he loved the most was their intensity. He said he wanted to bottle it and refine it and apply some of his classical training and create something that was both tight and really disciplined, funky and loose at the same time. These guys had raw passion, yet it had to be channeled and molded and he was the one to do it. Steven would do whatever had to be done to get the best out of everyone. With me, one of the things I needed was to strengthen my muscles to work the foot pedal, so I'd hang my foot off the edge of the bed, and he'd help me exercise it, working the side of my leg and the top of my foot until the muscles turned to fire. I kept at it, though, doing this flex, and then letting it relax, and then doing it again, with Steven working with me like a personal trainer. It worked.

Steven and I had been the last to move into the apartment, so the two of us—plus his girlfriend Lisa—were crammed into this tiny back bedroom that was about the size of a sponge. There were two single beds, which barely fit, with no room to move around between them. So for the first nine months the band was together, I used to have to listen to them sloshing around at night, fucking, sucking and doing the mambo. Steven also had his special little ways. For instance, he'd lock all his food in the fridge—private stash, do not touch. And we had to take our shoes off before we went into the bedroom so as not to track in the shit off the streets. He was obsessively clean, and yet he was a real pack rat. He still collects all kinds of shit like skulls and voodoo dolls.

I was over there all alone in my little corner still recuperating from hepatitis and jaundice. I still had many months' worth of taking care of myself to go. So for that first year, at least for me, it was no sex, no pot, no booze, no pills, no speed, no nothing. I would walk down the hall in the apartment, and there were Tom and Terry in Tom's room, smoking joints and getting fucked up. And Joe would have whatever girl he was with. But I had to get my ten hours of sleep every night if I was going to have any hope of shaking this thing.

Because everybody went to bed after me and got up before me in the morning, they used to do all sorts of shit to torment me. One day Raymond was over there, and he had a pack of firecrackers. When you walked into our room, the door was right by my bed, which meant that my head was practically in the hallway. Raymond slipped the firecrackers under the door with a cigarette fuse, and when these little bombs started to explode, so did I. They opened the door to see me jumping around like a maniac.

As soon as my year of recuperation was up, I could really get down to business, so once again I started pushing the limits. I had a cup of water on my nightstand, and when I woke up in the morning, I took two or three hits of speed—small white pills called Crossroads. Then I went back to sleep and let the speed in the pills hit me and wake me up with this wham! Tom and I would take the trolley or hitch down to the rehearsal space at BU. Then the two of us would drill and practice all day on stuff that Steven had shown us, and with all the chemical enhancement we

could really focus. The hard thing was not to simply go with the speed, playing a mile a minute. Tom and I stayed with it, just bass and drums, playing for eight, ten hours a day. Then we'd come home at night, get stoned, and watch *The Three Stooges*.

I had absorbed the influence of Earth, Wind & Fire, and Stubblefield and Jabo from James Brown's Famous Flames, but I wanted to get into more complex patterns like Dave Garibaldi, the drummer in Tower of Power. One thing Steven emphasized was the need to hear the beat, never stopping, endlessly, relentlessly. I realized that what I needed to do was to become part of the music, not something that distracted from the music. When you hear a drummer playing a beat, every time he gets off that beat, no matter how much you like all the little extras he's adding, all you're doing is waiting for him to come back to the beat. That relentless beat is a lot of what Aerosmith music is about.

Eventually, all the rhythm and blues bands I'd listened to, and all the rock bands I'd listened to—Zeppelin and the Rascals; the Beatles and Earth, Wind & Fire; Tower of Power and James Brown—blended into my playing. After a lot of work, I realized that I had created something new, my own sound, even though it was really sort of a mutt.

Steven wasn't the only voice I listened to. One day we were working on "Milk Cow Blues," and I was hitting the accent with my cymbal and my kick drum, the way most any drummer would. But Joe asked me to play the accent of that phrase with my cymbal, but with my foot instead of hitting it along with the cymbal, to keep it going, to keep the beat on time and not having it trip up.

I said to him, "Well, you know, that's not how you play it."

And he said, "Why not?"

I didn't really have an answer for him, and for an instant I was thinking, *Who the hell is this guy, who doesn't know anything about the drums, to suggest things to me, when I'm the drummer?*

But then I realized that the only reason I was resistant was because I couldn't quite nail it right away. As soon as he made the suggestion, I had to sit there and figure it out. And while I was sitting there figuring it out, the rest of the band would be standing around, and I'd feel like I was under

the microscope. I could imagine everyone else standing there saying, "Okay, let's see you do your shit. Let's see how good you really are, Joey."

Then it hit me that what's going to make me a better drummer is to be able to be open to suggestions from other people, including suggestions that don't come from a drummer's point of view. And suddenly Joe's "Why not?" sort of sunk in. Right. Exactly. Why the fuck not?

Being open to suggestions improved my style. Other drummers started complimenting me, and it was a really cool thing. Eventually, I hooked into being able to think differently myself. It just made playing music a lot more interesting for me when I opened up to what my partners had to say. I also started suggesting guitar rhythms, or even licks for Joe on lead, and he would pick it up and run with it. That's how the band became a band, by listening to one another and sharing each other's ideas and throwing the ball back and forth.

I don't know that I was specifically conscious of it at the time, but what I did know was that when I was able to open myself up to it, this kind of exchange felt really liberating. I didn't have to put on any kind

Outside the Boston University student union

of front anymore or feel like I had all the answers. The safety of the collaboration allowed me to be myself.

When I got a suggestion from Joe, it was always in the spirit of "try this," and I could feel that he was saying whatever he was saying strictly because he thought it might make the music better. There was no emotion or feeling attached to it really, on either side. He wasn't trying to intimidate me; he wasn't trying to make me feel one way or the other, which made it really easy for me to be open to his ideas, because there was no sense that I was under the gun. There was no sense that I'd better get it right pretty quick or I was going to look like an asshole.

With Steven, feedback was always different, in part because Steven speaks the drum language. He could say to me, "You know, it's like this . . ." and he would go "ching-ching-kaching," and I could understand what he was saying and try and replicate it on the drums, and it would make the communication really immediate. The trouble was, his suggestions or criticism always came with an edge, a large dose of him telling me how much I sucked and how much I should be able to do this and that I should be thinking of this on my own and that he shouldn't be having to tell me.

"Come on, man. Why can't you do that?" was his comment of choice.

The whole routine felt way too familiar. Here I was again with my dad whacking me in the back of the head and it was very fucked up. I thought I'd escaped the abusive relationship I'd suffered for nearly twenty years, yet here I was in another relationship, very much like the one I left back in Eastchester.

One day Steven lectured me in the backseat of a car all the way to a gig from Boston to New Hampshire because I couldn't do a drum solo. That led to a rant about how I didn't put in enough time practicing and about how everything was distracting me, and on and on. And that was supposed to inspire me?

Even with all the negative blast in my direction, I still had great respect for the musician that Steven was. With that respect also came a lot of affection. I was convinced that he knew better than I did about the drums, about music, and that his suggestions were going to make me better, so I listened to whatever he said, no matter how it came at

me. No matter how harsh and degrading it felt to me. I'd come away from one of those sessions with Steven convincing myself that as shitty as it felt, Steven's intentions were right—that he loved this band, and me, and he just wanted it to be as good as it could be—but it was still really hard to take. I just buried the pain that came with the territory because, I would justify and rationalize that Steven just wanted it all to be as good as it could be—right?

Sometimes when we played, I would get complaints from my partners that they couldn't get in touch with me on stage. I would be so into what I was doing that I was on a totally different planet. As blissful as it is to be in that zone, musicians have to be able to feed off one another.

Anyone who observes us on stage will notice that Joe spends a lot of time around the drum riser. His guitar playing, just in and of itself, is very much about the rhythmic quality of drumming, and so he and I have always maintained a lot of eye contact. We lock up all the time when we're playing, because that's where the musical energy of this band is being generated, from down in the engine room, and that's the space between Joe and me.

Obviously the musical connection is critical, but for me, being in a band is also about the camaraderie and the shared commitment. I need that, and it is what gives me a kind of real joy. But it's not always easy to get that—even if you want it.

One day I was walking down Newbury Street with Joe, and we'd had a great day rehearsing, and I don't know—I was just feeling hopped up on everything. I said, "This is just so fucking great. All my life I've been looking to work with a bunch of guys who are this into it. It's like we're a band of brothers, you know? Friends for life."

Joe looked at me and said, "Why do we have to be friends to play together in a band?"

In that moment it became painfully obvious, that the connection I'd been looking for, that I'd hoped I had with my partners, was not there—not by a long shot. With Joe, especially, it would take another thirty years for the acknowledgment that, more than musically, we were the kind of brothers I always wanted us to be.

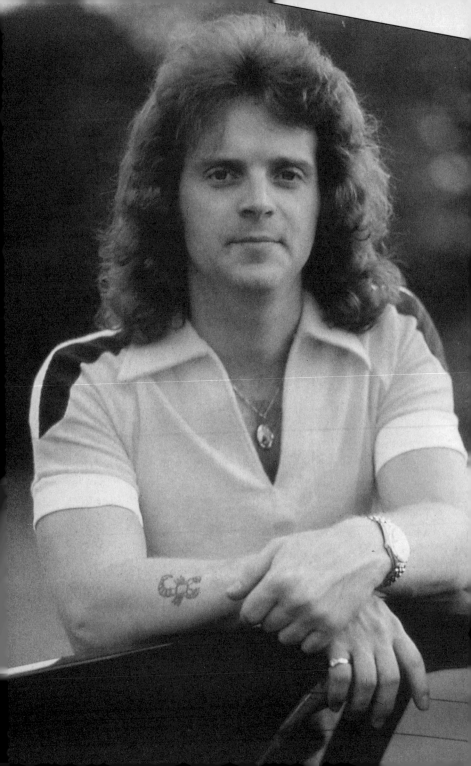

NOTHIN' SO GOOD

THERE AIN'T SOME BAD IN IT

Our first gig as Aerosmith was at Nipmuck High School in Hopkinton, out in the 'burbs west of Boston. We had a maroon fifty-two-seat Ward school bus that we bought from a theater commune, and we'd all pile into it hippie style to get to our gigs. Joe's dad had lent us the money to buy it. There were only a few seats up front—the rest of the space was for all our gear—but it was so big that one of our roadies had to get an ICC license to qualify to drive it. There was a stove inside—the former owners had lived in this thing—and when the engine would overheat in the winter we'd fill a pan with snow and melt it on the burner, then pour the water into the radiator. One of the hippie theater guys kept the thing running his own special way, so underneath the dashboard was like forty-six miles of bizarro wiring. Whenever we'd take this monster in to be serviced, the mechanics

would charge us extra for all the time it took to figure out all the wires and fuses and duct tape.

The first few months, I was the business manager. I kept a notebook of all our expenses—food, what it took to run the bus, what we made from the gig. Then I'd subtract the expenses from the take and divide it five ways. Sometimes each guy's take might be six bucks, so we kept it pretty close to the bone. Whenever we had a big payday—maybe twenty bucks—we'd go down to Ken's Pub in Kenmore Square and have roast beef sandwiches to celebrate.

We were determined, and we were ambitious, which meant not getting hung up on doing club work. **We could have made a lot more money just doing four sets a night at the bars in Allston and Cambridge, but we didn't want to get into the trap of being a cover band.** Doing the freshman mixers and the high-school dances for a lot less money gave us the freedom to practice and grow. "Somebody," "One Way Street," "Walkin' the Dog," "Spaced," "Movin' Out" . . . we were doing our own material right from the beginning. As part of our deal with Jeff Green, the guy from Boston University, we played Sargent Gym, and a couple of times we set up out on Commonwealth Avenue and played for free for the BU students.

During those first few months we still had Raymond playing second guitar, and as long as Raymond was around, there was sort of a buffer between me and Steven. He and Steven fought constantly, and not just about the music. Raymond had his leather store, and his girlfriend who he lived with, and it was pretty obvious that he wasn't placing all his bets on the band the way the rest of us were. That hedge showed in his level of commitment. After all the yelling became relentless and it was obvious that there was a mismatch there, Raymond would set it up that it was "him or me," meaning that we had to choose between him and Steven. Of course that was a ridiculous proposition. Raymond was a great guy, but musically . . . no contest.

He knew the band was going to drop the bomb on him, so he tried to get me to weigh in on his side. We had been friends since way back, and

he thought that maybe I'd speak up for him. Which left me in an awkward position, but I had to put it to him straight. "I'm with them, man."

We all knew that this was our shot at the big time, but not if we hung on to weak links in the chain. It was sort of the flip side of Joe's proposition. Maybe you don't have to be friends to be in a band together, but you can't keep somebody in a band just because you're friends.

Raymond was never one to give up easy, and he always had the entrepreneurial spirit. It occurred to him that, even if he wasn't going to be on stage with us, there was money to be made selling Aerosmith T-shirts and the like, so he started angling to do that. And for a while there he managed our merchandising on shirts and caps and other shit.

With Raymond moving over to marketing, we picked up an incredible guitar player named Brad Whitford, from just up the road in Reading, Massachusetts. Brad had been in a band called Just in Time, in New Hampshire, with a friend of Steven's named Dwight Ferran, also known as Twitty.

When Brad came on, the change in musicianship was like night and day. Brad played rhythm behind Joe's lead, but he was so skilled that now we had, essentially, two lead guitars, with Brad's precision playing off against Joe's raw passion. Brad lived with his girlfriend, but the rest of us, plus our roadie, Mark Lehman, and my Great Dane, Tiger, continued to live at 1325 Commonwealth Avenue.

Through a friend, we got to know this guy named John O'Toole, a tough Irishman who managed the Fenway Theater. During the winter of 1970–1971, he let us rehearse during off hours when the stage wasn't being used, and we kept the curtains closed to keep the heat in. One day we were working out and, during the middle of one song, the curtains opened a bit, and we noticed two men sitting in the audience. We just kept playing, and we did a couple more songs, and then the curtains closed.

The next day John handed us a management contract from Frank Connelly, the Boston impresario who had brought the Beatles to Fenway Park. He had also promoted Chicago's last tour. It was Frank who had

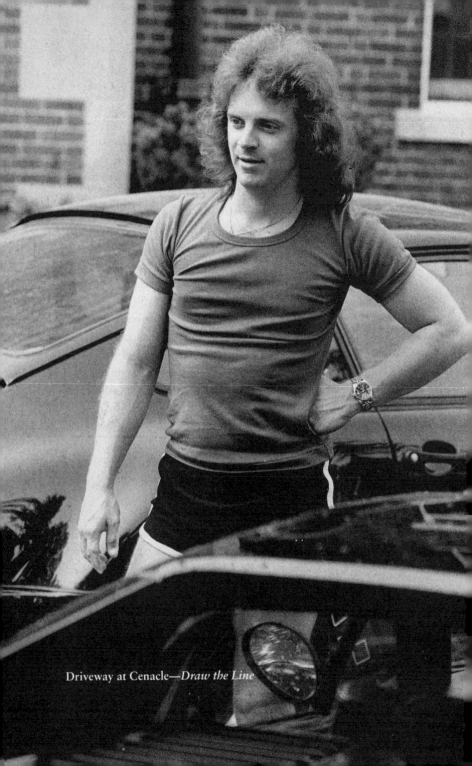

Driveway at Cenacle—*Draw the Line*

been, at John's suggestion, sitting out there listening to us. After that, John became our road manager.

When Frank talked to us for the first time, he said, "We're going to win all the marbles." But for us "all the marbles" just meant being able to make music, to get paid for doing it, and to not have to do anything else. Once we started getting money on a regular basis, the expectations increased, and the reality expanded. Over time we figured out, "Oh, we don't all have to live in the same apartment." And then the expectation grew to, "Oh, I guess I can have a car." And then it reached, "Oh, I guess I can have a nice car." And then, "I guess I can have more than one car . . . and maybe they should all be Ferraris."

Even though money was never the primary motivating factor, it was still a huge thing when Frank started giving us checks. He got bookies and gangsters lined up as investors in the band, and before they all moved down to Providence or into the witness-protection program, they used to come to our shows. One of them ran a ticket agency in Boston, and Frank used to send me down there to pick up packages. Another one of these guys called me once instead of Frank because this package needed to get picked up and Frank had disappeared and this guy didn't know where he was. When he called me I thought, *that's funny, usually it's you guys who make people disappear.*

Frank had us playing some pretty gamy places, some of which he owned, such as a dive called Scarborough Fair, on Revere Beach, which is to Boston sort of what Coney Island is to New York City. **The clientele was mostly bikers, greasers, mobsters, and girls with really big hair. We had a rule that, when you heard gunshots, you didn't go take a peek out front to see what was going on—you just made a beeline out the back door.**

Bob Kelleher, also known as Kelly, was our road manager at the time, and I can't remember where this was, but I do remember his having to go in after a gig somewhere and collect the money at gunpoint because they refused to pay us.

We did a lot of touring around in New Hampshire in our school bus, playing at venues ranging from Dartmouth College mixers to real

bucket-of-blood blues bars. We played a place up there called Savage Beast, where there was a cottage out back for the bands to stay overnight. We nearly rocked that little cottage right off its foundation. It may be true that what happens in Vegas stays in Vegas, but what happened in New Hampshire is that most of the guys came back with the crabs. I was still on my best behavior back then because of the hepatitis, but at the Shaboo Inn in Connecticut they had these really cool, colorful light bulbs, and I got busted for stealing some of them. Trust me—that was the least of our sins at the Shaboo Inn.

After the school bus died, Frank rented a car for us, a Delta 88 about the size of a Greyhound bus, in which we barnstormed the Northeast. One day we had some shitty little gig down in New Jersey, and we were barreling down the Jersey Turnpike in this big Buick, and whoever was driving—I can't remember—was swigging some grape juice out of a bottle, which looked like drinking while driving, so we got stopped by the cops. Next thing we know, we were all being searched and then taken down to the state-trooper barracks and getting booked for possession. Everybody but me. I was the only clean one—again, I was still recuperating—so I was the one who called Frank and got him to bail us out. Even so, the other guys spent several hours chained to some benches while the cops went running out with shotguns to deal with the Camden riots. When we finally got to our gig, there were maybe ten people there. When we got to court, everybody got six months' probation.

The first big show we did was at what used to be called the New York Academy of Music. We were the opening act for Humble Pie and Edgar Winter. From there we went on to opening for everybody from the Kinks to Three Dog Night to the Mahavishnu Orchestra.

We were grounded in kickass blues and hard rock, but it was getting to be 1972, and glam and glitter were coming on strong. The new acts—David Bowie, T. Rex, the New York Dolls—were big on theater, with lots of spangles and spandex. In music, just like in any other competitive field, you can get blown off the road by changes in taste even

before anybody knows who you are. So we kept our eyes on the prize, and we kept refining what we were all about.

Frank was just a local promoter from Boston, but at least after a time he had the foresight and the lack of ego to say, "I've brought you along as far as I can. Now you need to go with somebody bigger." He introduced us to these two big-deal talent management guys from New York, David Krebs and Steven Leber, who had been at the William Morris Agency and had booked the Stones on their 1969 tour. They also controlled the touring company of *Jesus Christ Superstar*. In other words, they had the money, contacts, and other resources to take us all the way—provided that we delivered the goods.

Frank continued to co-manage us, and one of the first things Krebs and Leber delivered was to get us rehearsal space in the visitors' locker room at the Boston Garden. Then they got us a gig at Max's Kansas City, where they arranged for Clive Davis from Columbia Records to come hear us play. Davis offered us a contract, but it was Krebs who signed the agreement, not us. When Columbia paid money, all the money went to Krebs, and then Krebs would distribute it, putting the five of us all the more distanced from the source.

Even so, each of us started pulling down a salary of $125 a week. This was just about the same time that our lease was up at 1325 Commonwealth Avenue. We were about to get the boot, we now had money to live on, and I was ready for a change anyway.

One of the first things I did was to move in with my girlfriend, Nina Lausch. She had her own place a little farther out Commonwealth Avenue, she had a car that she let me borrow, and she had a real job—she was a secretary at an insurance company. This was my first experience of living with a woman, and it was great. I was getting laid all the time, and she had a regular schedule, so when she'd come home, she'd even cook meals for me. I'd had enough of living in one room with Steven. But for Steven, my moving out meant that he was going to have less control over me and this change in how Steven saw the order of things did not help to improve our relationship.

One night at about two in the morning he called me and told me to come pick him up on a street corner somewhere off Huntington Avenue.

When I got to the place he said he'd be, he was standing there with a huge string bass, taller than he was. I was driving a little Vega station wagon at the time, and he had already started putting it in the back before I could get out to say "what the fuck?"

"No questions," he said.

After he loaded up this huge hunk of wood, he got in and we drove off, and right away he started in ragging on me about my girlfriend—the one I had just left in bed in the middle of the night to come pick him up and drive him home. "You gotta concentrate on your work," he said. "You gotta practice harder. No love involvements." I looked over at him like, *you fucking asshole, are you fucking kidding me?* and I told him to shut the fuck up or I was going to put him out on the side of the road. He said, "You wouldn't do that," and then he jumped right back in, telling me all the things that were wrong with me. One more time I told him to shut up or I'd throw him out, and one more time he said, "Nah, you wouldn't do that," and then he went right back to lecturing me about all my shortcomings. After the third time I told him to shut up, and the third time he blew me off, I pulled over to the side of the road and said, "Get out of the car." I got out, pulled the bass out of the back and gave it to him. Then I drove off and left him standing there on Route 9 at about three o'clock in the morning, bass fiddle and all. I kind of couldn't believe I'd done that, and instead of feeling good about standing up for myself, I felt this growing, nagging sense of, "Joey, this isn't good. You'd better apologize." The next day, I did.

You might think that it should have been pretty obvious to me that Steven was simply my father all over again, raging at me, berating me, telling me I had shit for brains and constantly ragging on everything that was wrong with me. But at the time, it was not obvious at all. I was so unconscious in those days that I was like some mouse in a lab experiment.

In other ways, Steven could have been channeling my mother. He shared the same element of fakery or creative manipulation that she'd always used in order to take advantage of my emotions. The pathetic thing was—I accepted that too. The mouse wants to get to the cheese, and I wanted to get the love and the acceptance. For the mouse to get the cheese, he may have to go across this metal plate where he gets an electric

shock, but if he's hungry, he's got to eat, so he just keeps accepting the pain as the price he has to pay. The abuse in so many of my relationships never registered with me because I was so used to it; it was normal for me. Cheese and pain, love and abuse—that's just the way it's always been. I didn't know I had a right to anything better or, really, that anything better between people actually existed. That was a lesson I needed to

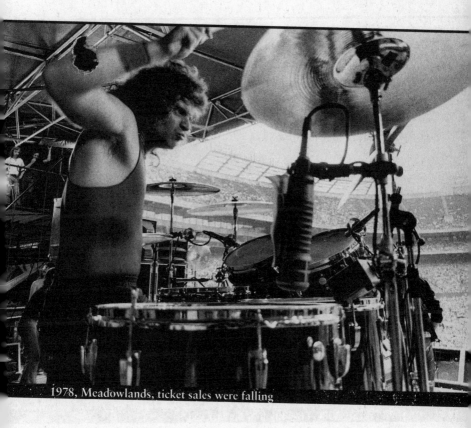

1978, Meadowlands, ticket sales were falling

learn. Even more fundamentally, I needed to learn—and this wouldn't come for years—that I was the one giving these other people permission to fuck with me, as well as the ability to exercise control.

Fortunately, the young women in my life were very different. They were generous and loving, and I was very lucky. One of the great things

about Nina was that she would even take care of my dog, Tiger—a Great Dane—whenever we were on the road.

Like most couples at that age, Nina and I broke up after a while, and when we did, I moved back in with the band. But by that time we had a better apartment in Cleveland Circle, which is in Brookline, farther from the center of town and closer to Boston College.

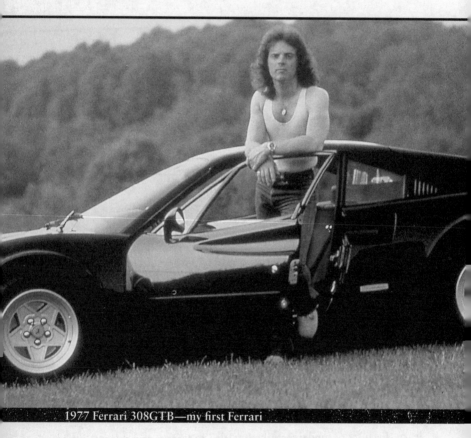

1977 Ferrari 308GTB—my first Ferrari

I dated a lot of other great women during those years, but I never lived with any of them. There was Jane Cowley, who was a friend of Tom's wife, Terry. There was Lucille Aletti, and then there was Cindy Oster, a

Playboy bunny, who I stole from Brad. There was Margie, and a beautiful girl named Andrea Fox who was a BU student and lived upstairs from Tom and Terry. The sweetest thing is that they all took care of Tiger, sometimes for months at a time.

With Aerosmith, right from the start, it was clear that most of the focus on stage and in interviews was going to be on Steven and Joe. I would not have objected to getting some of that attention, and at first I didn't fully understand why I didn't. It took me a long while to understand the reality of the role they played in the lineup and the separate reality of what I contributed.

One day right at the beginning, when we were still rehearsing at the Fenway Theater, our manager, Frank, was talking with Joe and Steven, and Tom and I overheard him telling the front guys that they were the fuckin' stars of the show, and that Brad, Tom, and I were just lucky to be along for the ride. These comments were like a kick in the gut. I was angry and hurt, and my feelings really never got resolved. No one even apologized or said it wasn't so. We were the less important three, the "LI 3." The only way that it got resolved was by my getting to the point of understanding that this is simply the way people are going to look at me as a member of the band, as the drummer. No matter how dedicated you are, or how good you are, and no matter how much your playing contributes to the distinctive experience people associate with a certain band, there's a difference between being a side man and being the front man. If I wanted to do what I was doing, this was the way it was going to happen, and this was the way it was going to be. I just had to accept it.

Our first album came out with Columbia in 1973. The producer was Adrian Barber, and we recorded it in about three weeks at Intermedia Studios on Newbury Street in Boston. Except for "Walkin' the Dog" it was all original songs. Then again, there are only eight songs on the record. It was a good effort, but it was released head-to-head with Springsteen's first album, also for Columbia. We got absolutely no attention, and it seemed like overnight we started

seeing review copies in the used-record bins. We had been allowed onto the bottom rung of the show-biz ladder, but that didn't mean we couldn't be flicked off it like a bug. We knew right away that we were going to have to fight to keep going.

At least that first record allowed us to land a tour with Mott the Hoople. At the time, they had a big hit that Bowie had written for them, "All the Young Dudes." They also had a fan base of teenage boys that we were eager to win over. We were on the road with Mott the Hoople for the better part of two years, which is where we got our first taste of living in hotels, all the while taking lots of drugs and fucking just about every girl that came close. One night, when we were doing some serious drinking with one of the guys from Mott the Hoople in his room at a Holiday Inn, he poured a bottle of booze down the back of the TV. This was our invitation to earn some of our rock 'n' roll pedigree, and we proceeded to go about throwing most everything in the room out the window, but before anything could go out, it had to go through the TV screen. Stupid, yes, but perhaps less so than if we had trashed one of our own rooms.

The guys from Mott were not that great as musicians, but observing them helped me see what a band could be. I never considered Dale Griffin, their drummer, to be all that talented, but what he did suited their sound and contributed to what they were trying to accomplish. **When we toured with the Mahavishnu Orchestra, which was sophisticated jazz fusion—Miles Davis stuff—once or twice, they actually paid us not to play.** Their leader, John McLaughlin, would always ask for a moment of silence before they started in, but after we'd played, nobody could sit still. Their drummer, Billy Cobham, was just fucking amazing. He was the first to use polymetrics, which is to say all the different time signatures at once. We joined the tour in Buffalo, and the first night I walked onto the stage to look around, and sitting on this big Oriental rug was a set of maybe fifteen Fibes drums. They were made out of this Crystalite stuff that you could see right through, and he must have had three or four toms and multiple high hats and a

couple of bass drums. I'd never seen anything like it. I thought, *So this is like the same instrument that I play? Hmmm. Interesting.*

Later on I watched him trade licks with McLaughlin, who was one of the most influential jazz guitarists of the day. They would lock eyes face-to-face and play these abstract, single notes together, going a mile a minute. It was all an improvisation, but it was so tight and so right-on that it sounded as if they'd been rehearsing for years. The rhythms were so complex that I didn't even understand what they were doing. I'd be standing behind them listening, and I couldn't even find the "one."

On the tour, Billy and I compared notes on nitty-gritty shit like how to avoid blisters, but also on techniques for things like doing a simple shuffle. That was something I was really good at and he had a hard time with, so we traded pointers. The tour took a break for about ten days, and when we came back, I'd picked up a set of Fibes just like his, and he'd traded in his Fibes for a set of wooden drums like the ones I'd been using.

We toured next with the Kinks, which bumped our fee from $300 to $1,500 a night, but it's a funny thing how a band can slide up and down the hierarchy, sort of like when the Beatles opened for Roy Orbison, but then after a few weeks the lineup was reversed, and Orbison was opening for them. Some of the acts we opened for treated us with respect; other times I think they saw us as a threat and tried to keep us under wraps, like the Mahavishnu Orchestra cutting back our time and the Kinks cutting back our space on stage.

Now and then it felt like we were getting somewhere; at other times it wasn't so clear. And it's not like you get lifetime security as a rock 'n' roll band just because you have a record deal. Clive Davis was given the boot shortly after signing us, and word was going around that Columbia was cutting back, so we had plenty to be nervous about.

Fortunately, we started getting major radio play in Boston, where WBCN would host "battles of the bands." They set us up against Peter Wolf and J. Geils, the other local band that was big at the time. In May 1973 "Dream On," a song off our first album, was the number one single in Boston. We were still getting no airplay nationally, so we worked with what we had and made the most of our opportunity to be the local rock 'n' roll heroes. We did free concerts in the parks all through that summer,

drawing maybe two thousand people each time. In August, we opened for Sha Na Na at the Suffolk Downs Racetrack, and thirty-five thousand people showed up. That made the local Columbia Records promo guys take notice, and the label started to kick in on our behalf. Ten months after its release, *Aerosmith*, our first album, hit the charts at number 166.

After we built up that strong base in and around Boston, we went to the Midwest and started building a base there, too, city by city. They loved us in Detroit, because we had a gritty, blue-collar sound. Jack Douglas, when he came on as our producer, was ready to take that sound and punch it up to a higher level. We would always choke in the studio when the red recording light came on, so he had them put tape over it so we couldn't see it. **Jack wanted Aerosmith harder, louder, more kickass. I already held my sticks backward, hitting hard with the thick end to get more volume. I was hitting so hard that I started using tape and Band-Aids and wearing gloves, but he still wanted more.**

In March 1974 we released *Get Your Wings,* and we knew this was do or die. We also gave the record company a little more option time to continue our contract with no extra payment. We toured all of 1974 and nearly killed ourselves, but the album hit the charts and was on all year. We were like a drugged-out circus act, going from town to town with two tons of gear in a forty-foot tractor-trailer. Except in Boston and Detroit where we headlined, we were still opening for other bands. **We toured so much that when I got home, I'd pick up the phone and try to order from room service.** But even with all that, *Get Your Wings* peaked at number 100. Still, that represented half a million copies, which made it a gold record.

In the summer of 1974 we did the Schaefer Music Festival in Central Park. The crowd wanted more Rory Gallagher, the blues guitar hero, and everybody started booing and throwing bottles. Somebody threw a beer bottle up onto the stage, and it landed right on my drums. It cut my arms just as I was about to do the barehanded part for "Train Kept

A Rollin'." I spoke into the mike on my drums and said, "This is for the asshole who just hit me with the broken glass." And then I played my heart out. The crowd loved it.

More and more, blood and broken glass seemed to be the kind of excitement the fans were looking for. One of the new bands on the scene was KISS, with the makeup and the costumes and the fire swallowing. When Aerosmith and KISS played together, our roadies and their roadies wound up pulling knives on each other.

In September 1974 we were back in Boston to do sold-out shows at the Orpheum. J. Geils, who had produced a top-ten album in '73, was already sailing into the doldrums, which left us free to take over New England. By the winter our crowds were much bigger, with a lot more excitement. We played Boston College Fieldhouse and caused a bona fide riot.

When it was time for us to record our third album, Jack Douglas put us to work out in Framingham, at Andy Pratt's studio. Joe came in one day with this great guitar hook. We played with it for a while, and Steven and I worked out a drum part. I was just playing the beat, really. The foot pattern on the bass drum went right along with the guitar lick, and up on top it was just twos and fours, with eighth notes on the high hat, and twos and fours on the snare drum. This was the same sort of beat we had used for "Lord of the Thighs" off the second record.

None of us was thinking that this was anything special. At the end of the day, we had ourselves a nice little number, and we called it quits. We went out to get something to eat, and then we went to the movies. **We saw Young Frankenstein—there's the part where Igor, the hunchback, does the old Groucho Marx gag: he tells the visitors to the castle to "walk this way," and they follow him with the same limp and lurch that he has. "Walk This Way" became the title of the song we'd been working on.** A few days later, Steven had finished the lyrics, and we knew we had something. The song now had an identity,

and he was using that same rapid-fire singing style he had used on "Sweet Emotion"—very rhythmical—which makes a lot of sense when you remember that Steven was a drummer. Steven and Joe both base a lot of what they do on percussion, and the fact is that all music is actually just drum rudiments applied to other instruments.

Steven and I worked together on a lot of the rhythmic stuff, and a good idea is a good idea—it doesn't matter where it comes from. I worked hard and was very disciplined. I wrote out my own arrangements for how every symbol crash was supposed to be orchestrated.

"Walk This Way" appeared on *Toys in the Attic*, and that album was huge for us. We toured all through 1975, only now, more often than not, we were headlining. As the headline act, you get to have things the way you want them—the lights, the stage setup. But, of course, having too much of what you want can turn you into a crazy person. One day a check came in the mail for $275,000. I went out and bought a red Corvette, which cost just over $8,000—I remember the price of the car because I recall paying for it with eighty $100 bills.

Thanks to Frank, we were blessed with financial obligations that we had to buy our way out of, so we had a lot of Frank's "friends" still hanging around us waiting to collect. But the mobsters brought along a whole new group of dealers with them, so we didn't really mind. **With more money in the pipeline, Aerosmith became the single biggest market for drugs in New England.**

In 1975 we released a reedited version of "Dream On." It made the *Billboard* Top 10. Then we released "Walk This Way" as a single, and it reached number 10. What none of us realized, though, was that we had just reached our early peak. We had two rapid-fire top ten singles, but we wouldn't be having any more for another ten years. Having hit that peak meant that we were already on our way down. Meanwhile, Frank was dying of cancer, and he sold his remaining share in our management to Krebs and Leber.

By now we had picked up an audience of teenage boys in blue jeans, what we called our "blue army." The only problem playing to

this demographic was all the crap they threw onto the stage, including cherry bombs and M-80s. We took over a warehouse just west of Boston, in back of Moe Black's Hardware Store in Waltham. It had a stage to rehearse, and it became our place to hang out, sort of a boys club with room inside to park my Corvette. Like most guys who get a lot of fame and a lot of money before they know what to do with it, we carried on pretty much like the thirteen-year-old boys who came to see us.

For five years my biggest concern was, where's the blow? My entire routine consisted of being on the road and getting high, and I was having the time of my life. I had no sense of our larger career trajectory.

As a drummer, I felt I had proven myself. I had become comfortable holding up my corner, keeping us moving with the rhythm, and I accepted not being in the center of the spotlight. But the guys started bugging me that I should do a drum solo. Raymond, who was still doing marketing for us at the time, started working with me. He laid it out this way: "You have to do a solo the same as if you were writing a song. It's got to have a beginning, a middle, and an end. And it's got to make sense. And just when you got them, you don't keep playing—you stop. You leave them begging for more." So I put together all my best licks and shaped it the way he suggested.

At the Pontiac Silverdome, in Michigan, it all came together for me when we headlined at our first stadium show, and I did my first solo in front of eighty thousand people. No drug has a rush like that. When the audience responded to me, I could feel the joy in every cell in my body. So being me, I got hooked on that high, and I did a solo every night for the next eighteen years, until drum solos became kind of passé.

Overall, though, my job never involves being the center of attention. Up on stage, we're five guys each doing his part. Steven's job—and it ain't an easy one—is to be the electric focal point every second, exploding with energy. The guy busts his ass like a professional athlete, running

from here to there, jumping off of things for hours every night. Joe's got his assignment as well. He's got to be a kickass musician, but there's also a lot of theater, being the sex symbol and playing off Steven on stage and all that.

For the rest of us, we hold it together and keep it running. We're the linemen, not the quarterback calling the shots, or the wide receivers dancing in the end zone. When Steven and Joe do their "sit down" at the other end of the runway, a hundred feet away from me, I'm doing my job keeping a steady beat and just playing the way I play.

Years ago I had a psychic do my chart, and when she came to see the band, the way that she described it was that we were like a traffic jam and I was a filling station. Everybody is driving around and around, and every once in a while they will come over, fill up, and take off again. I like that role, being almost like the mother hen, so to speak, or, maybe better to think of myself as the mothership.

Even though my real home was on the road, I still needed a place to hang my hat in Boston, so I kept an apartment at 21 James Street, near Coolidge Corner. My landlord was Mr. Chin, who used to come by every month and bang on the door. "Joe Kramah! You pay rent today?!" This was a huge first-floor space with stained-glass windows and high ceilings and enough mahogany for about a dozen cabin cruisers. It was so big that, part of the time I was living there, Raymond and his wife, Susan, lived with me. My girlfriend Cindy Oster, the Playboy bunny, was there, too, and there were a lot of parties with so much constant drug intake that we were really living right on the edge every day. I remember, we had a dentist friend who used to let us use coke in his chair. One day he came to my apartment, and it was all I could do to drag myself to the door. I had been taking Quaaludes and God knows what else, and I could barely move. He saw that I was all but down for the count, so he stuffed some coke up my nose to keep me from going comatose. If he hadn't shown up . . . hard to say what would have happened. All I know is that it's a fucking miracle that none of the five of us are dead.

Once while I was on tour, a friend of mine named Scott Sobel was doing some work on the place, and Cindy was there sort of supervising and painting some of the walls. Cindy was epileptic and had to take medication

to control it. She and Scott were, of course, also consuming quite a bit of blow, and Cindy had forgotten to take her pills. Scott described to me how he heard this crash, ran into the next room, and there was gorgeous Cindy, lying on the floor frothing at the mouth, her eyes rolled back in her head. Scott immediately called 911, but then when the medics and the cops arrived, he remembered the huge pile of blow sitting on the coffee table, lines all laid out. So he left Cindy shaking on the floor and the cops banging on the door while he ran around the apartment and hid all the coke.

By the midseventies, the drugs, which had started out as a way to cut loose after a lot of hard work, had taken over. Back then, my idea of a Friday night was to hook up with somebody along with an ounce of cocaine, and a nice big quart bottle of Stoli that I kept in the freezer. We would sit, and we would snort, and we would drink, and then we would snort some more. Friday night would turn into Saturday morning, and Saturday morning would turn into Saturday afternoon, and we would still be drinking and snorting—another shot, another line. Saturday afternoon turned into Saturday night, and Saturday night turned into Sunday morning, and before I knew it, three days of my life had gone

Pontiac Silverdome

by. **I was sitting in the same fucking spot on Monday morning as I was on Friday night.**

My wake-up call with drugs—at least in terms of the music—came when we played Boston College in 1984. For the three or four nights prior to that, I had been swallowing Tuenols and putting cocaine up my nose and not sleeping at all. By the time I got out to BC, I was fucking blotto. My drum tech, Nils, had to help me take my street clothes off, put my stage clothes on me, tape my hands, prop me up behind my drums, and wrap my fingers around the sticks. "Joey, this is all I can do," he told me. "The rest is up to you."

Drums and drugs really don't mix—the timing, the physicality—so I didn't play well that night, and my partners weren't very happy about it. I took heed of that experience, though, and I never again took drugs directly before a performance. On the other hand, I was always able to make up for lost time afterward. As soon as the last note was hit, I would be off stage and catching up to wherever I might have been if I had been snorting like a maniac all along.

After a while it should have been clear that the drugs had become obsessive, addictive, and destructive. But when you're doing drugs, nothing is clear—that's the whole point. Looking back now, I realize that even just thinking about doing lines had become an obsession. I enjoyed simply the thought of drugs, relishing the anticipation, then feeling the actual sensations. There was pleasure in all of it, from the first moment the coke burned into my sinuses, as the chemicals slammed into my brain cells, and until I was racing along all grandiose and invincible. I loved the way it made me feel holier-than-thou and how I could sit and talk with anyone about anything as if I really knew it all. And then there was the sort of connection whenever I found somebody else who liked coke as much as I did. Trouble was, while there was pleasure, there was no real joy in it. After a while, drugging became as empty and gross as stuffing my face with cheeseburgers and greasy french fries, eating out of gluttony instead of hunger for nourishment. Eventually feelings of waste, excess, and anxiety crowded out all the feelings of pleasure, but by this time, I had no choice. I was no longer doing the drugs for a good

time—I was doing them because I had to. And then the drugs started pulling the band apart.

Krebs and Leber managed a lot of bands, including the New York Dolls, and the Dolls were becoming more and more a part of our scene. Their whole act meant nothing to me, because I was into being a musician and being serious about playing my instrument, and for these guys rock 'n' roll was all just a freak show. But suddenly we had David Johannsen, their front man—later known as Buster Poindexter—hanging around. Then Steven took up with Johannsen's girlfriend, Cyrinda, and then Steven and Cyrinda started doing dope with Joe and his girlfriend Elyssa. They were shooting up in New York, and I was putting coke up my nose and booze down my throat in a different space and time, and that separation started to matter. Then Steven started getting weird because Joe was always with Elyssa—a relationship that is a whole bizarre story by itself. So my little surrogate family, this band of brothers that I deluded myself into believing we were, that I thought I had, was really starting to slip away from me.

DRUG ADDICTS

DABBLING IN MUSIC

For a couple of years I had been kind of out of touch with my actual family, but now for the first time I could put my hands on some serious money, so for Father's Day I went down to see them in Eastchester. I brought along a new car for my father, a brand new Cadillac Seville. I handed him the keys and said, "Happy Father's Day."

He said, "How much money do you have?"

I said, "Fifteen thousand."

"How much did this car cost?"

"Fifteen thousand."

"So how can you go and spend all your money on a car?"

This wasn't like, "Ah, you shouldn't have," with a hug and a smile. This really was, "You're a stupid bastard for wasting your money." All I could see in his reaction was that he and my mother had such a fixed

sense of the way things should be that they couldn't see anything else in this gesture—least of all me. Then I watched as he got in the car and went off to show all his friends.

Obviously, his calling me a stupid bastard was not exactly the reaction I'd been hoping for. Still, one thing my father had any respect for was the dollar, so at least maybe I had registered something with him.

Looking back from my perspective now, it's pretty obvious that what I was up to was, "Dad, I'm a success. Dad, I have money. Look at what I can do—what I am doing for you." It was the classic pattern of trying to please the abuser. His reaction was a total letdown, but I handled it the same way I handled everything at the time—I just put my head down and stuffed the emotion. Whenever a feeling reached the surface, I made sure I numbed it out with drugs and alcohol. But now that I had some cash, it became very comfortable to also numb it out with stuff.

I bought a Mercedes so big that it would always get stuck in the driveway of Joe's place in Newton. The next time I came down to Eastchester to visit my parents, my mother wouldn't let me park it in her driveway. Being Jewish, my mother couldn't understand how I could possibly even think of buying a German-made car. Especially a Mercedes Benz. After all, it was the Benz family that made the ovens the Nazis used to murder millions of Jewish men, women, and children.

In 1976 *Rocks* shipped platinum, meaning one million copies, and we were floating along in the luxury bubble with the women, the jets, and the blow. We hardly blinked when one of our dealers in New York was killed. No big deal. The downside of the drug life had no hold on us. We were invincible. Which meant that we really didn't notice as everything became more of a blur and the faces all around me starting to look melted like those drawings in an R. Crumb comic book.

Arena rock was all about putting on a spectacle, but with us the over-the-top show on stage wasn't just the lights and ramps and fireworks. There was Jack Daniels and rum on the drum riser and coke lines on the amps, and God help a roadie who brushed it off or put his flashlight there. Joe and Steven would snort lines between songs—during songs. The rum was

150 proof, and Steven would pass it out to the kids in the front row who'd drink it until they puked. We had girls climbing all over us, but, truth is, a lot of the time we were too focused on the drugs to really care.

On the Fourth of July we could not get a permit for Foxboro because our last two Boston gigs had nearly caused riots, so we missed that opportunity but were earning our reputation as the "bad boys of Boston." On July 10 we were supposed to play Comiskey Park in Chicago before 65,000 fans when the place caught on fire. Jeff Beck was onstage, and we were waiting in the wings; and our manager freaked out because he wanted us to get started performing so we would be sure to get paid. Problem was that the whole place was on fire, which made it a little difficult to actually play. All the news reports commented on how calm the audience was. Fact is, they were too stoned to react.

About this time *Rolling Stone* was talking to us about a cover, but then they only wanted Steven, which led to a big fight. The agreement we all had was for Steven to avoid photographers, so they couldn't get a solo picture of him. But Annie Leibovitz showed up at his room at the Beverly Hills Hotel at six in the morning, banged on the door, barged in, and snapped a picture of him lying in bed. The image that appeared on the newsstands made him look like he'd just (barely) come back from the dead.

When we played the Cow Palace in San Francisco, I wanted to get the crowd all hyped up, so I started throwing sticks out to the audience during my solo. It worked—they went crazy. We played the Kingdome in Seattle before 110,000 kids, but to us the whole show sounded like a remote hookup. The venue was simply too big. Regardless, we were playing some of the largest venues in the world; we had come a long way from the Savage Beast in Vermont.

The only way I can keep the years straight is by remembering which car I was driving at the time, and 1976 was the year that Tom and Brad and I all bought Ferraris. Mine was a black 308 GTB. Even after I placed the order, it still took almost twelve months for it to arrive. I think I paid $29,000 for it, which was serious money at the time.

In 1976 we were also nominated as Best New Group at Don Kirshner's rock awards, which was a pretty good joke since we had been around since 1970. The winners were Hall & Oates. Joe's Elyssa—by now his wife—said they sounded like a breakfast cereal.

My entire adult life had been about playing music, then getting high, then sitting around with the guys bullshitting and wasting big chunks of my time. But by now we'd reached a tipping point that Joe Perry summed up this way: **we'd became drug addicts dabbling in music, as opposed to musicians dabbling in drugs.**

Joe liked me to provide drum rhythms while he worked out guitar riffs, so I used to go over to his house to work—just the two of us. This was when he lived in Chestnut Hill, out by Boston College, and I can remember being up until two or three o'clock in the morning getting high before we ever went downstairs to start playing. I don't know that anything useful ever got done in those sessions. Which is sort of the larger tragedy in a nutshell. We were really committed to being musicians, but the commitment to drugs just flushed that down the toilet. Sometimes I wonder how many more great songs we could have written back then if we had been clean and sober.

Even if I never did drugs on a show night, I was never completely clean. It made no difference what I'd do on the eleventh day; if I'd been doing drugs for ten days and drinking for ten days, I was still going to be fucked up.

My drug use was making my life, and all of our lives, unmanageable, but I never questioned it. I never asked myself why I was behaving this way or thought that there was even a question to be asked at all. I would just put my head down and plow on through—only now it was through mountains of coke and everything and anything else I could find to cut that edge.

All in all, I still carried, and was driven by, a certain pride in musicianship. In '76, we opened for the Faces, with Jeff Beck as the "special

guest." He had just come out with his first instrumental album, *Wired*, and his band on that tour was Max Middleton playing piano, Wilbur Bascomb playing bass, and Bernard Purdie playing drums.

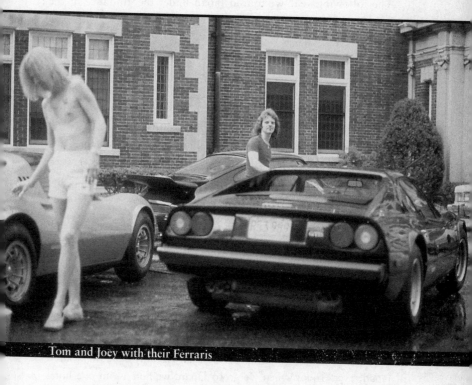

Tom and Joey with their Ferraris

Bernard Purdie—everybody called him Pretty Purdie—was a studio guy, the drummer who originated the fatback beat. He played on Supremes records and all the Motown stuff, and I used to sit and watch him every night and study him. He used to come out and watch me, too, which used to make me really uptight. But one night he came back to the dressing room before the show and asked me if I could get him an Aerosmith T-shirt.

I said, "You want to wear an Aerosmith T-shirt?"

He goes, "Yeah, because I like you, man. You play like a black man." Later, I came to find out that he had a thing about not liking white

people, so those words from him were really a high compliment. And that kind of high lasted for me. It made me feel better later whenever I'd remember it.

The following year we toured Japan under the guidance of the legendary promoter Mr. Udo. We did seven sold-out shows with Bow Wow as the opening act.

Back in those earlier days we took the train, lugging all our equipment from town to town. It was hard to get drugs over there, which may be the reason that we did such good shows. Japan was still very uptight in those days, the kind of place where you couldn't get into the bathhouses if you had tattoos because only gangsters had tattoos.

I went to Asia with a suitcase and a shoulder bag, and I came back with half a dozen suitcases and a couple of lockers. The promoters used to give us stuff like robes and shoes, and I bought clothes and incense and sake. I even bought a Japanese wedding dress just as a decoration for my house. I also bought a couple of silk baseball jackets with embroidered tigers on the back.

Years later, the Rolling Stones would dis Mr. Udo by cutting him out as promoter and doing business directly with the Domes (indoor stadiums where Japanese major-league baseball games are played). To prove no one fares better without Mr. Udo, he used our next tour after the Stones had dissed him to get his revenge by showing them just how big he could make a band. Mr. Udo promoted us with a vengeance. We broke every attendance and ticket-price record for any band that toured in Japan, ever. Today when we go to Japan, we hole up in one hotel and fly to the eight or so biggest stadiums in the country for each of the shows on the tour.

Once we returned to the States, we were on the line to produce another record, so we rented a mansion up in Westchester called the Cenacle. It had been built by the Broadway showman Billy Rose, then turned into a retreat house for an order of nuns called the Congregation of Our Lady of the Retreat in the Cenacle. We turned it into a playpen and recording studio where we were going to work on the album that would be called *Draw the Line*.

At the Cenacle there was the big open room that had been the chapel; only now it had all the pews taken out. There was still the stained-glass windows and the high ceiling, and because of the natural echo, we set up my drums right on the altar. Steven was on the second floor. Brad was in the living room. Joe was in a huge walk-in fireplace. Jack Douglas, the producer, set up his controls in another room with video monitors so he could see us, only we couldn't see him. Trouble was, by that time the band was falling apart at the seams. The only thing connecting us was the headphones, and that's the way everything sounded when we played it back. We had really made it now, but we had no idea how to handle that success. It had been such a long fight, and in our mirror we had won, but now what? We'd rented out this fancy place, but we didn't have a plan. We also didn't have enough new material, so we wound up doing covers of "All Your Love" and "Milk Cow Blues." Basically, we spent six months and half a million dollars to make a record that everybody was going to hate.

We had been on the road for two years, and we had all gone insane. Joe showed up in a Porsche and carrying a Tommy gun. He and Steven had always been into guns and knives in a way that was probably a little too intense. At the Cenacle we even had a firing range in the basement and Steven and Joe would blast shit down there for hours.

Given how out of control everyone was, there was a lot of down time. I would wash all the cars just to keep busy, or we'd have water balloon fights. When we got bored, Tom and Brad and I would race up and down the Merritt Parkway in our Ferraris. Then we would come back and decide that driving 130 in traffic wasn't enough of a release to deal with our frustrations, so we took my cymbals out and shot at them with shotguns. Meanwhile, Joe was firing pistols in the attic and drinking White Russians for breakfast.

One time Steven and I were up all night on coke and Tuenols. About 10 a.m. he decided he wanted some outdoor target practice. We went down the hill to the other end of the property, and Steven lay down on his chest in a sniper position with the .22. I started setting up beer cans as targets, but I was so wasted I never noticed that I was setting them up so that we were firing toward the house. After I was done, I stood back

and said, "Let 'er rip." Steven was aiming . . . and aiming, but he was taking so long I began to wonder what was going on. "So shoot already!" I said. Then I walked a little closer. That's when I heard the snoring. He'd fallen asleep lying on the ground with the rifle in his hands.

Jack was like the den mother for our little troop of bad boys. I'd come downstairs in the morning, and he would say, "We changed the figure for this song. We want you to do it this way. Go in the room and learn it. You have two hours." Then he'd hand me a two-gram vial of coke. "Here's your medicine." So I'd go off to the room with just me, my drums, and the stay-awake.

Brad and Tom and I were drilling to stay tight, but Steven and Joe wouldn't even show till midnight. Joe, when he did show, was usually too fucked up to play. Jack would chew him out, so then Joe would go back to his room and disappear for days. He didn't even play on all the songs we recorded. He just didn't care anymore, and neither did Steven. We were pissing away everything we had worked for all those years, and yet everybody was yukking it up like we were nine years old at a summer camp that would never end.

We had these caterer chicks cooking for us who had worked with the Grateful Dead. For dessert one night they made us brownies and milk, and after they put dinner away, they put this little treat on the big long table that was between the chapel where my drums were and the main living room. The hallway with the big long table connected to the room where Jack was set up with his recording equipment. It was a schlep, so every time I walked back and forth between the chapel and Jack's location, it was very easy to just pick up one of those little brownies and chuck it down. So every time I walked back and forth, that's what I would do. And we must have done six or seven takes, and after each take I'd walk back to the control room to listen, and I'd grab a brownie on the way. Then I'd walk back to my drums to do the next take, and I'd grab a brownie on the way back. Around the sixth or seventh take I looked up at the monitor and said, "Jack, I don't feel so good. I feel kind of strange."

I couldn't hear what Jack was saying back to me because of all the background noise, which was the rest of the band cackling their asses

off. Then it occurred to me, *why is everybody in the playback room, and I'm the only one sitting out here ready to play?* Fact was, Jack had filed away the take he needed hours ago. He had just been replaying the same thing over and over, getting me to play to it again and again, so he could get me to go back and forth eating those fuckin' brownies on my way to the studio. They were laced with so much pot. This must have been what Tiger, my Great Dane, felt like the day he got on top of the fridge and ate a whole pan of hash brownies. He was just about comatose. We had to carry him outside to pee.

The last day at the Cenacle, we tried to film a commercial. They were trying to shoot a scene of Joe riding his motorcycle up a ramp into a trailer, but he was so fucked up, we had to shove some coke up his nose so he could stand. He drove the bike up the ramp and right off into the bushes. The video was never used.

That last day had been a long one under the lights, and that last evening we drank a lot of Jack Daniels. I was really anxious to get home, however, and I was looking forward to the ride in my Ferrari. There was no way I was going to stay over till morning. Brad offered me some stay-awake, but I turned it down because I didn't like to do that stuff while I was driving.

Around eleven o'clock I started heading north, and in front of me was about 150 miles of freeway. I cruised up through Connecticut, crossed into Massachusetts, and then with just about forty miles left to go, I hit the 3000 mile mark on my Ferrari. This meant that it was officially broken in and I could now open it up. This was at two o'clock in the morning on the Massachusetts Turnpike somewhere near Framingham, with nobody around. All the lanes were clear, so this was definitely the time to see what this car would do. So I eased it up to about 130 . . . 135 . . . then . . . and the rush I felt—like flying—was definitely part of what you pay for. It was especially sweet at that time of the morning, being all alone, but I told myself, *Okay, don't push your luck.* So I eased over into the right lane, and I was just kind of cruising along; I came up behind a truck that was going a lot slower than I was, which is just about when I noticed that I was once again not feeling too great. All of a sudden I felt really, really tired.

Smashed and crushed metal woke me up.

I'd rammed into the back of this guy. The Ferrari was so low to the ground that I actually slid under the truck, which crushed the windshield. Fortunately, the impact lunged me forward into the steering wheel just enough to get my attention. Still, it was all I could do to steer off to the side of the road. I slid into the guardrail, and when I stopped, the impact banged my head against what was left of the glass up front.

I just sat there for a second and caught my breath. There was blood all over the place. Thick, dark blood was oozing all over the silk baseball jacket I had just brought back from Japan. It was all over my pants—all over the car.

I was still sort of stunned, so I sat there for another minute. Then a state trooper came along and asked me if I was okay. He got me to get out of the car and stand up. I turned off the lights, and then I stood there for a second looking at the Ferrari, holding my hand up to my head. Which was when I realized that, wow, I couldn't see out of my left eye. I thought I'd gone blind in that eye, which totally freaked me out. I was half muttering, standing there at 4 a.m. fumbling through my wallet, pulling out nine registrations for nine different cars, and the trooper thought I was out of my mind. Then I realized how much blood there was, as well as all the glass stuck into my forehead. And when I felt all the blood, I realized that was what was keeping me from seeing. But then the loss of blood started making me woozy, and I thought I was going to check out. I managed to lock up the car, and then the trooper took me to the hospital in his cruiser, bleeding all over the seat.

At the emergency room in Framingham they spent a lot of time picking glass out of my forehead, then sewing it up. They told me the cut was bad enough to sever a main artery. About an hour later, Tom came cruising down the highway in his Ferrari and saw mine smashed into the guardrail. He told me afterward that he really didn't even want to call the police because from the look of it, he thought I was dead. But he did call, and they told him what had happened and where I was, so it was Tom who came over to the hospital, picked me up, and took me back to his house where I spent the night.

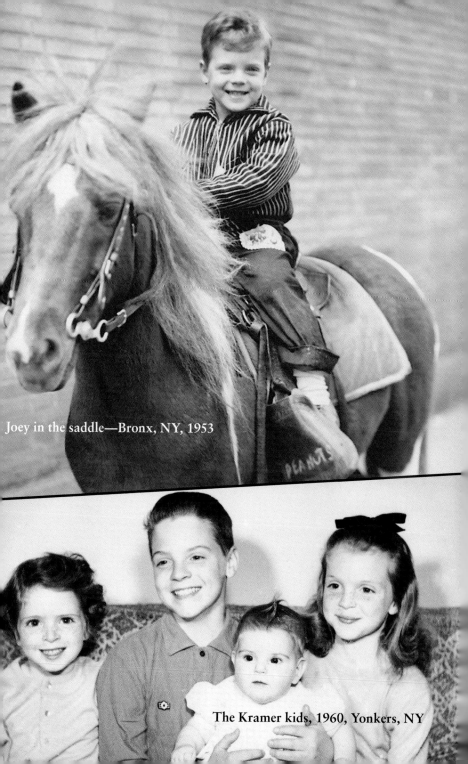

Joey in the saddle—Bronx, NY, 1953

The Kramer kids, 1960, Yonkers, NY

Rik Tinory Studio, Cohasset, MA, 1975

Three generations of Kramer—Marshfield, MA on Pudding Hill Lane

Having fun

Spacemen

Nothing like playing live

Obligatory publicity photo session

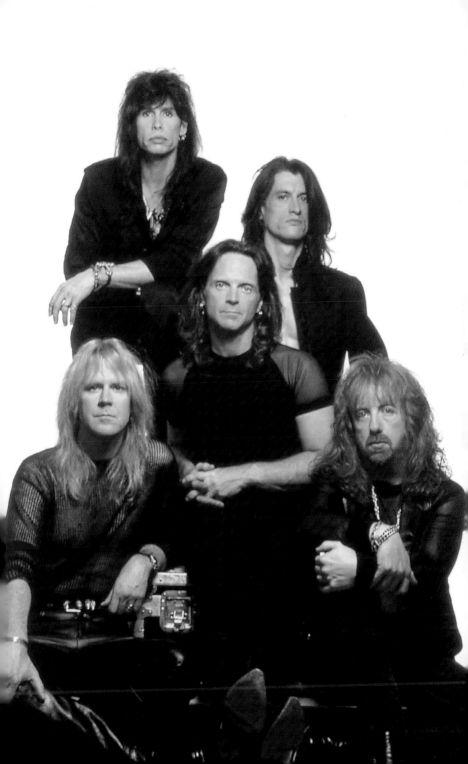

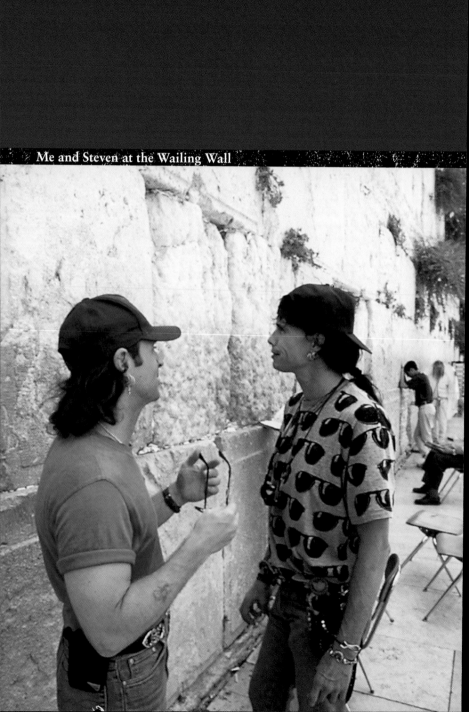
Me and Steven at the Wailing Wall

On the set of the *Rugrats*

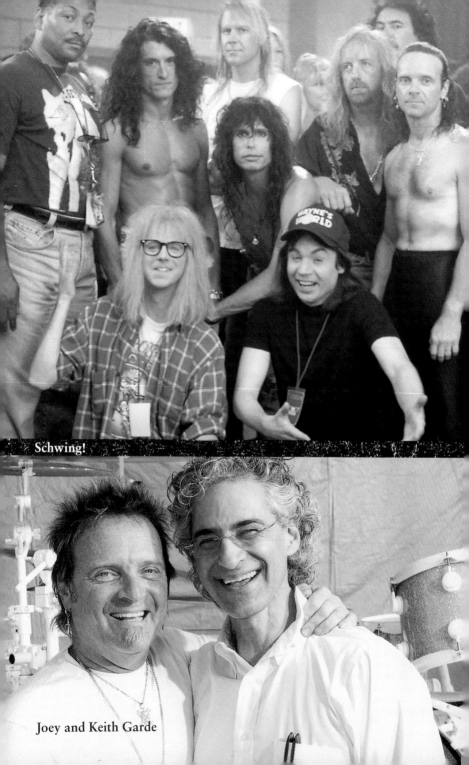

Schwing!

Joey and Keith Garde

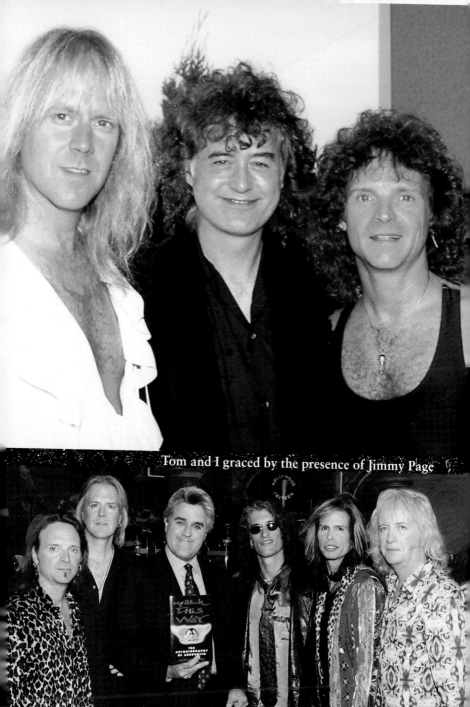

Tom and I graced by the presence of Jimmy Page

Book promotion
on the Leno show

Cemetery, Japan, 2002

The Kramer kids today

The creamsicle drums, *Honkin' on Bobo* tour

We had to cancel some gigs because of this damage I'd done to myself. But to get the story straight, our managers, Steve Leber and David Krebs, wanted to talk to the doctor who was taking care of me. So they came up to Boston. My father insisted on being there too.

The four of us—me, Krebs, Leber, and my father—went to the doctor's office, and my father sat to my left, Steve Leber sat to my right, and David Krebs sat to Leber's right. It was a little strange for me that my father wanted to be there, but I was pretty fucked up from the accident so, as unusual as his offer of support may have seemed, I appreciated it. The doctor started in explaining all about heart rate and blood pressure and how, if I played gigs and my heart rate went up, it was going to blow out the artery above my eye, where the stitches were, and that I would bleed, and that it would just keep opening up, which could be seriously dangerous.

Steve Leber looked at the doctor and said, "Isn't there some kind of IV or something you could hook him up to on stage so he can play?"

I thought my father was going to leap over me and try to choke the bastard. I pushed my dad back into his chair and told him to calm down. It meant a lot to me that my father was sticking up for me, but I remember having this strange, mixed reaction. While it felt good to get his support, I saw in my dad's demonstration of anger at my manager a glaring reminder that for so much of my life, this same guy, acting that same way, was what I needed to be protected from.

I replaced the smashed-up red Ferrari with a silver one. Somebody told me later that Clint Eastwood bought the wrecked car and had it refurbished. I wasn't into reclamation projects. At least not yet. Instead, I just kept snorting the lines, and everything kept going downhill.

Draw the Line was still not finished when we left the Cenacle, but we went ahead and toured that summer anyway—the Aerosmith Express Tour—doing God-awful shows. Rumors went around that we were breaking up, and by all rights we should have quit, because we had totally lost it musically.

This was when the press started calling Joe and Steven "the toxic twins." Steven would do something to piss off Joe who would play too loud and ignore his backing vocals just to piss off Steven. When we went to Europe, they started fighting on stage, even down to Steven's pulling Joe's amp cord out of the socket for playing too loud. In Belgium it was like World War I with the fans up to their knees in mud, surrounded by barbed wire. The caterers had tied a goat to a table and you had to milk it yourself to get cream for your coffee, so the crew shit on the desk in the promoter's trailer.

We were in Munich when Elvis died. At the Lorelei Festival, Steven passed out on stage after three songs, and near Frankfurt he started spitting up blood. The Scandinavian part of our tour was canceled, and we still hadn't finished *Draw the Line*. I wanted nothing but to go home. This would be our last show outside North America for ten years.

Still, it could have been worse. Zunk Buker was a childhood friend of Joe's, and his dad, Harold, was in charge of our air travel. The managers sent him down to Dallas to check out a low-budget Conair plane that had come on sale. He looked it over and said no way—he would not fly in it and would not allow us to. Three months later, the plane crashed in Mississippi with Lynyrd Skynyrd on board, killing half of them. There were so many different ways we could have, should have, died.

Our crew had a rule that if you didn't see one of us for twenty-four hours, you were supposed to break down the door. Aerosmith was still the main customer for drugs in Boston, and there was always a lot of activity outside Joe's house. Where we were in the drug food chain, we were always just one level away from getting killed. That is, if our fans didn't get us first.

The blue army was still well represented in our fan base, and their antics continued. At the Spectrum in Philadelphia in October an M-80 went off in a stairwell and hit Steven in the face, burning his cornea. I'm not sure how, but Joe ripped open an artery in his hand and had to be taken to the hospital with a police escort.

We were such a big deal that year that we bumped Springsteen from the schedule at the plant where they actually pressed the records, but when

it was time to manufacture it, *Draw the Line* still wasn't ready. Finally, in December 1977, when the record was released, there was no single. It was our fastest-selling album—1.5 million copies in six weeks—but then it disappeared because there was no touring, and because it sucked. The critics hated it—they called it dysfunctional and chaotic, just like us. **We had become as self-indulgent in our music as we had become in our lives.**

On March 18, 1978, at Cal Jam at the Ontario Motor Speedway, we had 350,000 kids—the Woodstock of the seventies. Steven was out of coke, so he sent a kid in a Learjet back to Boston to get his stash.

It's hard to imagine things getting much worse, but then we agreed to be part of maybe the biggest piece-of-shit movie ever made—*Sgt. Pepper's Lonely Hearts Club Band*. When the Rolling Stones turned down the roles, we signed on to play the Future Villain Band. Our job was to put on Nazi-style uniforms, give shit to Peter Frampton and the Bee Gees, then try to turn pretty little Strawberry Fields into a groupie.

We went out to Hollywood and stayed at L'Hermitage. We were living large, so much so that we got thrown off the set for being drunk and obnoxious. Later, back at our "Warehouse" outside Boston, George Martin, this nice English gentleman in a shirt and tie who had produced the Beatles, had the task of getting us to record a cover of "Come Together." He had heard that we were insane in the studio and that we took forever, but he had also heard that we were big Jeff Beck fans. He told us there was a Jeff Beck concert that night, so we managed to nail the recording in two takes. He disappeared with the tape, and we raced over to Trax to hear Jeff Beck. Sir George had lied to us—no Jeff Beck. But he did get us to focus and finish the job.

The album shipped platinum, but the joke was that it was returned double platinum. The movie was a huge embarrassment, and everybody hated it.

During the time we'd been filming, I spoke to my dad over the phone, and he made this little offhand comment to me about how easy I had it now. I suggested that he come out to L.A. and see for himself. I appreciated how he had gone to bat for me when I'd been in the hospital, and

Blue army

I was thinking that maybe this was a time for us to mend a few fences. I rented a Rolls-Royce convertible for him, but when he showed up at LAX, he refused to drive it. He traded it in for a Mercedes.

He had been out there four or five days with us when he walked into the room where I was sitting with some of my friends, smoking hash. My dad just came in and sat down—I forget who it was that he sat next to—but this friend of mine just handed him the pipe, and we lit him up. He got high with us. He got a little loose and started having the

best fucking time! But then he looked at me and said, "Make sure your mother doesn't find out about this!"

This was as close to my father as I ever felt. Another day he sat with us when somebody started passing around a plate with lines of coke. He didn't know what to do with this, so he asked me. I explained that you take the straw and you suck it up through your nose. So he did. About twenty minutes later, he looked at me and said, "So, Joey, how am I supposed to feel now?"

I said, "You're supposed to feel good."

He said, "I feel like . . . I have to go to the bathroom. I'll be right back."

So he went to the bathroom, and he was yakking a mile a minute. Then he came back, saying, "How am I supposed to feel now? How am I supposed to feel now?" He was asking me how he was supposed to feel so much that he didn't seem to ever feel what he was feeling. I don't think he'd ever really allowed himself to experience anything just in the moment, so he really didn't know how.

He liked the hash, though. A couple of times after that, when I'd come home like for Thanksgiving, he would pull me aside and ask if we could get high.

I think the truth of the matter is that for the first time, my father was seeing my world from *within* my world and not from his familiar setting in Eastchester where he was the king and he made the rules and where, for twenty years, I was an embarrassment to him. Out on the road my world was impressive—it was a very big deal to have a backstage VIP All-Access laminated pass, and Mickey had one because I was his son. It made him feel good—successful, I think. I'd made it big, and in my world, because of me, Mickey could rub shoulders with the "important." In this world it was Mickey who had to fit in, and getting high with the guys was part of the deal. At this point in my life he was no longer judging me. Of course, he had no sense of my being an addict. I had some major money, I was making a movie, and he was loving it!

During that same stint in L.A., Jack Douglas's new secretary came out from New York to see what was going on. Her name was April; she was a jazz fan and really didn't know who the hell Aerosmith was. I fell in love with her immediately. She told me she had a little girl named Asia who was four years old, and somehow that made me love her even more. This was her first time in L.A., and I took her to Chianti on Melrose, and we sat up talking until they closed the place.

As we talked, I had this amazing feeling, a kind of joy I had never felt before. All I wanted to do was to be with this woman from morning till night, and then sleep together, and then be together again and again. Up to that point, it was the most joyous evening of my life. I didn't even know I was falling in love because I was too busy doing it.

I had been building a house in New Hampshire that I'd designed myself, and I invited her to visit. A few months later she agreed to come, but on the day of her arrival I was too gakked to remember to drive to the airport and pick her up. She pulled into my driveway in a taxi just as my ex-girlfriend, Kay Rhodes, was leaving, driving off in my Jeep. I met Kay at a show in Dallas, and I almost married her, but she was way too young. To say the least, this driveway overlap was a very bad scene, which required a great deal of repair work, meaning that it was a long time before April would even speak to me again.

After I tracked April down, I asked her, "What do you want?"

She said, "Love, honesty, stability." She'd been married before and made it pretty clear she was tired of the same old bullshit.

I said, "Okay."

She said, "Okay what?"

I said, "I want the same thing."

So from that time on, it was me and April.

On July 4, 1978, Aerosmith played Texxas Jam at the Cotton Bowl. It was 120 degrees, and kids had to be doused with fire hoses. Ted Nugent passed out and had to be carried offstage. Steven had to be carried *onto* the stage. Our tech, Henry Smith, carried him out piggyback, pretending it was a joke, but the fact was our front man couldn't walk.

That summer, five alleged coke dealers were murdered in a Boston pub called Blackfriars. Once again, the drugs and death thing was hitting a little too close to home.

We were back to touring, and for the East Coast segment we worked out of Boston. **My hands were black and blue from playing so much and hitting so hard.** When we were back in Philadelphia, which had been the scene of the M-80 attack, someone threw a beer bottle onto the stage that shattered right in Steven's face. He wanted to go on with blood all over him, but he got out-voted and we left.

In November, the band headlined in Madison Square Garden for the first time. My mother's "auditory condition" was nowhere to be found. She sat in the first row with all her friends and her cousins and seemed to be eating it up. April sat on the side of the stage holding Asia, who

The boys of bad

fell asleep. I remember carrying this tiny little kid home and up the six flights of stairs to April's apartment. I was being offered this sweet little taste of what it was like to be a dad, but I was too stoned to feel it.

This was the year Joe's house burned down, Sid Vicious murdered his girlfriend, and Keith Moon went out with his overdose. Columbia Records was just about done with us after the fiasco with *Draw the Line*, but we went on the Bootleg Tour with AC/DC as our opening act anyway. We were based at the Whitehall Hotel in Chicago for a month,

fanning out in a Learjet to do shows in the Midwest. At the Fort Wayne Coliseum, we were threatened with incitement to riot.

At a show in Hartford, when Joe was drunk on stage and falling down, the crowd almost rioted again, not because we got them so excited, but because we were so bad. Cyrinda and Elyssa were still going at each other, which was like having two Yoko Onos traveling with the same band.

Elyssa provoked a lot of shit between Joe and Steven that accelerated the downward spiral. She was in Joe's ear saying, "You don't need these guys, you can do it yourself, yackity, yak, yak." So, he started holding back music for a solo album.

In May we had one last recording session for *Night in the Ruts*, but that was Joe's finale with us in the studio. April and I got married in June 1979, and our wedding turned out to be the last time the whole band would be even slightly "together" for several years.

Night in the Ruts was *still* not ready, but we went back on tour again. At the World Series of Rock, fans camped out all around Cleveland Stadium the night before. There were several robberies and shootings, and one guy was killed. Backstage, Elyssa threw a glass of milk at Tom's wife, Terry, which started a fight that proved to be the last straw for all of us. Joe walked out. In August we canceled a world tour.

We had been living in a bubble called rich and famous. Nobody could tell us anything, which meant that we had completely lost touch with reality. But now reality was going to come back and bite us in the ass.

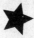

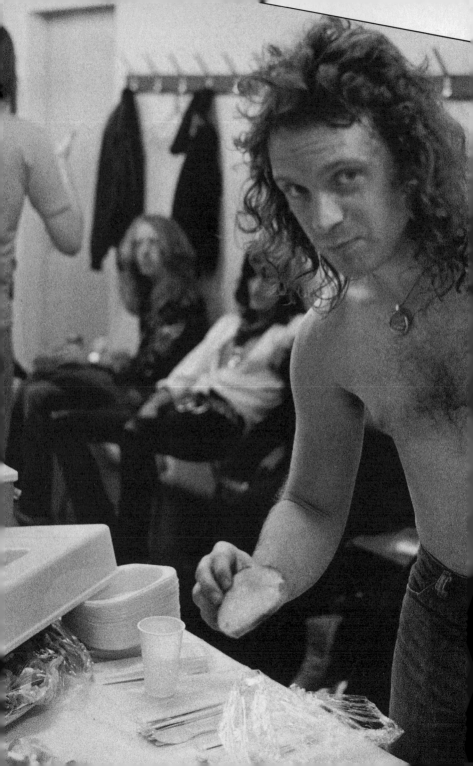

I NEVER MET A DRUG I DIDN'T LIKE: HAS ANYONE SEEN MY CAREER LATELY?

The band was on the road. I was out in California, staying with Sandy Jossen—my old buddy from Hebrew school—and we'd been drugging pretty heavily and then went to bed. A few hours later I got up and walked out the front door and down the street, only I was sound asleep. I sleep in the buff, so here I was sleepwalking through a luxury beach town, buck-naked. That's a pretty good image for this whole period in my life.

The whole wedding when April and I got married was a blur. Sandy was my best man, and we had a rabbi for the service in the backyard of my parents' house in Eastchester. We had the reception at the New Rochelle Beach Club, but it was like they had booked two different parties at the same place on the same afternoon. My parents' friends were at the bar or out on the dance floor, doing the hora, and the people from the

music business were buzzing back and forth to the john, snorting coke. At least I had the good sense to spend some time with April's little girl, Asia, who was five years old at the time. She stood on the tops of my feet as we danced. That was the best part of the whole affair.

One of the few things that registered clearly was a shitload of lobster tail and filet mignon going back to the kitchen, uneaten. The big appetite for blow did a very good job of replacing any appetite there may have been for food. We did a lot of that—passing up some of the good things in life in order to jam the pleasure chemicals directly into the brain. They say lab mice will keep pressing the little bar that gives them a dose of coke until they die. If the drug's freely available, the mice won't bother to eat. Looking back, we were hardly different from mice.

All the guys at the reception were coming up to me handing me envelopes, small ones, uniquely folded with no checks in them. These were single-gram envelopes of coke. By the time we left, I must have had a good half ounce on me. We stayed at a hotel in New York the first night, coked up and awake all night. We then headed to the Bahamas for our honeymoon, which just shows how out of it we were—who the hell goes to the Bahamas in June?

When we came back, it was to the fiasco of our summer tour—bickering on stage and the "milk in the face" cat fight at Cleveland Stadium—and I was about as sick and tired of the same old bullshit as Joe was sick and tired of it. When he asked me to leave the band and sign on with the Joe Perry Project, I told him that I would . . . but only if he got David Hull to play bass. David was a friend of mine who at the time was playing with the Buddy Miles Express. Joe went after him and got him, but by then I had changed my mind. I had sussed it out and realized where my true loyalty was.

In November the Project played Boston College and at the Paradise, with David Hull on bass and Ronnie Stewart as the drummer. That same month Aerosmith released *Night in the Ruts*. It had a few tracks from Joe, but the rest of the leads were filled in by Jimmy Crespo and Richie Supa.

Steven continued to spiral further and further out of control, but we tried to keep Aerosmith alive. We continued to tour, bringing in Jimmy to replace Joe, and as usual, I just kept on keeping on. I was living in my

own little state of oblivion—sort of an adult version of hiding in the attic with my slot cars. If I'd been lucky, my downward slide would have felt clearly scary and humiliating, making a conscious impact, but I don't

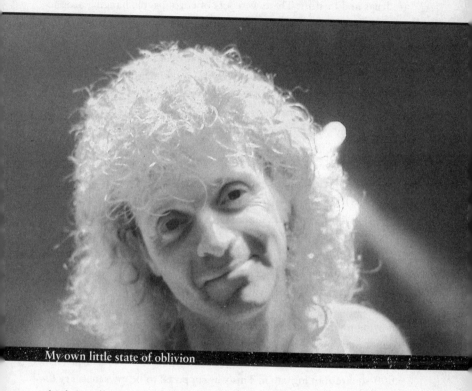

My own little state of oblivion

think I really processed any of it. I know I was puzzled, but the way I chose to avoid feeling shitty or insecure wasn't slot cars anymore—it was coke and Stoli. I had a schedule of when to party and when to get straightened out enough in order to be able to play a gig, and that was about as conscious and deliberate as I could manage, and because I could do that, I thought I was doing fine.

But even if the stresses and resentments, anger and fears I'd experienced all my life weren't clear in my mind, they were there building up inside of me. None of these things had a channel for expression, so they all turned inward. Looking back now, I realize how pissed I should

have been. I was a professional and had reached a high level of success. I wanted to do my job and keep it going, but everybody was fucking it up—including me, and we couldn't stop. We had almost unlimited access to drugs and to stuff. There were lots of crazy people hanging around stirring the pot and reinforcing the message that said indulging in it all was the thing to do—after all, we were rock stars. But we can't blame anyone else for that. Those were the choices we made. We were the ones who took the drugs and decided who to spend our time with. We just weren't minding the store, and the irony is that our old hometown rivals, J. Geil's Band, chose that moment to come back from the dead with a vengeance, by which I mean a #1 album and a #1 single. The best we could do was to issue *Greatest Hits* to fill the gap. We had nothing else to offer. We were done.

April and I rented space in this big house in Newton, Massachusetts, and in 1981 she got pregnant. Even the thought of having another kid didn't slow down the drug intake for me. Actually, it became just one more excuse to get high.

By the time our son, Jesse, was born, we had moved up to the place I'd been building in New Hampshire. Tom and Steven had turned me on to the Sunapee, New London area where Steven's family had always kept a summer place. Our tech, Henry Smith—we called him "Henry Smith, the living myth"—had a log cabin up there, and I wanted a house just like his, only huge. I bought thirty acres in the little town of New London and designed the house that I was having built when I met April—a 6,000-square-foot log cabin. This was supposed to be my sanctuary to get away from the road and from my partners and from the rock 'n' roll lifestyle, but I never had all that much time to enjoy it. April moved in with me, and for a while everything was cool. Little Asia went to school up there, and nobody bothered us while we walked the dog in the woods and had a great time.

But really what was happening was that the anger I couldn't express for all those years and from so many different areas was crushing me inside and getting me so fucked up that, more and more, I just started to shut down. If I was sitting around with someone and we'd just shared a gram, I'd probably be a blabbermouth, yakking as if I'd just downed

about a half dozen cups of coffee. I'd start out very social, but then I'd keep pushing it with the drugs, and I would quickly get to the point where I ceased to be good company. I was always ready to do some lines. There was never enough for me, and the stronger the coke was, the more I liked it. If you had enough to keep me up for three days, then I was right there with you. But you do enough coke and you get paranoid. The bogeyman's out the window and the monster's under the bed.

When I was high, I never liked to be outside or driving or public in any way. I always liked to be cloistered in a hotel room, in my bedroom, in my house, in a dressing room. **Just like back when I was a kid, I always liked to be in some little nook or cranny, some kind of safe spot, a hiding place. But really, my hiding place was inside the cocaine, among other chemicals and behaviors that separated me. Hiding from the world, hiding from my own feelings.**

Drug use and all the behaviors that went along with it provided a place for me to deny the real pain and the depths of depression I was entering. It became more and more my permanent way of life. As time went on and I continued to do more drugs, I didn't have to think about any pain or anger or the frustration and fear that came with having success drift away from me. Drugs and alcohol became the all-purpose response to every emotional stimulation. If it was something as fucked up as the state of Aerosmith—drugs and alcohol. If it was something great, like the birth of my son—drugs and alcohol.

Richard Guberti, one of the guys I spent the summer of '69 with at that big house in Harrison, New York, was up at my place during the last few weeks before Jesse was due. He and I had had a falling out shortly after our summer of dealing drugs, but then he showed up at my wedding, and we reconnected. I'd been getting high and snorting cocaine the whole time that April was pregnant, and Richard and I were up all night, totally blotto, just before I had to drive April down to Newton-Wellesley Hospital for the birth. She had a cesarean, and I went through all that with her, and then I spent the night there, and I spent the next day there, and I loved the fact that I had a new son. On the other hand,

I couldn't handle it emotionally. I left April and Jesse resting up in the hospital, and I drove back up to my house in New Hampshire, where Richard and I sat down and proceeded to get high for two days. That's how I welcomed my son into the world.

After our two-day celebration, Richard and I drove down to see April in the hospital. As soon as we walked into the room, she could tell what we'd been doing, and she was not real happy about it. I should have been down there with her—even I knew that. But at the same time, I didn't know how to do the right thing, and the shame of being absent made me want to get high and be somewhere else even more.

If it was a rainy day, it was a reason to get high. If the sun was shining, it was a reason to get high. I wanted to get high all the time. I was also a binger. I would get high for three, four, five days in a row. I would so overdo it that, by the fourth or fifth day, I would be sick of the shit and say that was it. No more. Then I'd go for a week or so without doing any drugs at all.

But then after the week, even though I said I wouldn't, I'd do it again, and I'd be off to the races. Because I was abstinent before shows, I rationalized that I could do that much more and made up for lost time the minute I got off stage. As soon as I was done, those "make up for lost time" lines would be sitting there waiting for me, and as soon as I got back to that dressing room, I would snort my way right out of town. Still sweating like a pig, even before I could get out of my stage clothes, I would snort up a gram and down a few shots with two, maybe three beers to even me out.

Everything sucked at this point during my career, everything was falling apart, and I would get seriously bored on stage. We were just going through the motions musically—and not even doing that very well. I'd look over at the set list and think, *Ah, five songs to go. Only five songs to go. Ah, only three more songs to go.* All I wanted to do was start getting high again. So I would just count down the minutes before I could climb back into my little coke cocoon. There was plenty of time to do a couple of lines between the last song and the first encore, but after that shit at Boston College where they had to prop me up behind my drums, I never crossed that line again.

Now, of course, I realize that giving myself points for exercising some self-restraint was total bullshit, self-serving active addict doubletalk. That's like justifying the greasy cheeseburger and french fries with ketchup and an ice cream sundae, because, "Hey, I only drink *Diet* Coke."

Even if I limited my intake to after the shows, once I got started, I couldn't stop. When I stayed up all night, that affected the next show. I'd start out staying up the night of a show, but the next night was free—a normal night to get some sleep and get ready for the next gig. But after a while I'd end up getting high both nights. Way too often I'd just stay up all night into the next morning, into that day, into that night, right up to the show time. The first high, the first line off the stage, and the shots and the beers and the whole atmosphere of letting go and getting into that kind of head was fun. Everybody around me was doing the same thing. But then the hours would go by, and the other people would peel off to go do their own thing. Nobody else was around. Then the sun would start coming up, and the birds would start chirping, and I hated the daylight and resented the birds' songs, and I wouldn't have had any sleep at all. But it would be time to deal with the day, so I'd chop out another line and somehow do the do all over again.

Sometimes I'd binge so long and hard that it would seem like I'd hit a state of straight again. The cocaine high would quickly have too hard an edge for me, so I'd have more booze; if the booze brought me down too far . . . more coke. I was self-medicating up and down, trying to find some kind of equilibrium. I'd become so disconnected that the natural way of finding a happy medium just wasn't available to me. I balanced coke with Tuenols, Seconals, and Quaalude, and the Tuenols, Seconals, and Quaaludes with coke and whatever to drink. Sometimes I would crush up Quaaludes and coke together, which was sort of like throwing all your chips randomly across the roulette table, just to see what would happen. Three or four days would go by, and too often I would wake up thinking, *Where am I? What am I doing?*

All in all, I suppose I was lucky just to keep waking up.

As long as my stash held out, I could continue through the day, and by the time it was four or five in the afternoon I'd be completely fuckin'

delirious. I would not have slept. I would not have eaten because I had no appetite. I couldn't wash my face—I wasn't even sure when I had to piss. I could barely sit up, but as long as I was still conscious, I could sure as hell stick another line up my nose. So I would, and then I'd remember that I had a show to do that night, and so I was in big fuckin' trouble. And by then the stash would have just about run out, so I'd really get serious about connecting, scoring, copping. But until that would all go down, alcohol would do just fine.

I can remember nights going to a show after having maybe ten days off, meeting Tom and Brad on the plane. We'd snort the whole way, getting shitfaced out of our brains.

April always felt guilty about using with Asia around, so she would rein it in a little and try to get some sleep so she could be a good mom in the morning. My philosophy was that if you were not going to enjoy it, don't do it and if you're going to do it, enjoy it.

Asia was a very smart little girl. She would get up early, and I would have been up all night. So at six in the morning, we used to sit and talk. I was gakked out of my skull, but we'd have Cheerios together and watch cartoons while April slept.

Asia had a very deep voice for a little girl, so even at seven years old she seemed very old and wise. We'd talk about how her mom and I got together and how it was fun that we'd gotten together, and we'd talk about her dad and how come her mom and her dad had split up.

This little kid taught me how to be open to and accepting of who she was—which was the exact opposite of the situation when I was little. I'd never been around young children since becoming an adult, but when I got married, I got instant family. I had to wonder how this sweet little kid felt about all the craziness. But the conversations with her over those Cheerios taught me that in her child's eyes everybody was good unless there were clear indications to the contrary. Whatever came down, it was cool, and she would deal with it. Being seven years old, she didn't know anything about the band, and she didn't look at me as being any different than any other dad, which was terrific, because

most of the time people figured they knew the whole story about me the minute they knew what I did for a living. So Asia and I got along right from the get-go. I helped bring her up as if she were my own, and I love her as if she were my daughter. As a family man, however, I had to take care of business, and my business—Aerosmith—was slipping seriously off the rails. There was less and less going on, but I still needed the steady income. I owned a piece of a rehearsal studio called Top Cat, and I started trying to write, doing production work, anything to try to keep the ball rolling. I even tried to start a band called Renegade. We had Tom and my friend from New York, Bobby Mayo, who had played with Peter Frampton, and Jimmy Crespo, and Marge Raymond, who had been the singer in a band called Flame. We did a showcase at S.I.R. and started to cut a record. We lined up a record deal, but then Steven suddenly decided he was ready to do another Aerosmith record. Jimmy and Tom and I all belonged in Aerosmith, so that was that. We dropped Renegade and started back to work.

Steven had moved to New York, and we were going to record at the Power Station there, so Tom and I commuted down every week. Monday through Friday we were in the studio, and then on Friday night we drove back, snorting all the way. When we got home, we just snorted more coke and started doing shots, and next thing you know, it was Monday morning and time to get back on the road to New York.

They would call sessions at 6 a.m., and I would come in after being up all night getting high. I would get there and people would be all stuffed into the bathroom free basing. We didn't call it crack back then, but they were smoking coke all the same. Then I'd go into the studio, and on the console would be the white lines. At first I thought it was more cocaine, but these were lines of heroin. Fucked up like that, it would take us twelve hours to do twenty minutes worth of work. Brad did some tracks with us, but then he got disgusted and walked out. He put together one album with Derek St. Holmes from Ted Nugent's band, and then he moved to L.A. and started touring with Joe.

I think it was mostly the sense of waste that got to Brad. We'd be so high that we'd get into a thing and become distracted by all the tiny details that don't really matter. Doing drugs sort of melds people together,

which is part of the reason that I did it in the first place, but this means that you start yakking and start trying to solve the world's problems, and you can talk all night repeating yourself a hundred times with only slight variations. The next day you wake up, and if you remember any of the bullshit, you say to yourself, *well shit . . . sounded good last night*. It was all just a fucking waste of time like some freshman dorm room bull session . . . only with the meter running.

We were paying through the nose for every hour we sat there dicking around in that recording studio. The Power Station was brilliant in its day, and our producer, Tony Bongiovi who owned the place, was pulling what little hair he had left out of his head. Tony was the consummate professional, and he just couldn't deal with the nonsense that was going on among us. After a while he gave up, and they brought Jack Douglas in, because he was just as much into the drugs as we were. Jack got it finished and mixed, and the record is what it is. After we'd dropped $1.5 million on studio time, *Rock in a Hard Place* was released in September 1982 and hit number 32 on the charts. We also did a pretty primitive-looking video of lightning strikes to promote it.

The record doesn't suck. There's some really good stuff on it. But it's not a real Aerosmith record because it's just me, Steven, and Tom—with a fill-in guitar player. Brad played rhythm on "Lightning Strikes," the single; otherwise, it's Jimmy doing all the guitar work.

Our lineup on stage was now Jimmy Crespo in place of Joe, Rick Dufay instead of Brad, and Bobby Mayo as a sideman on keyboard, but the sound and the chemistry just wasn't there. By the time we started touring again, we had slipped further down the food chain. We played the smaller venues, and definitely no more Lear jets. When we played the Tangerine Bowl in Miami, it was second billing to Journey. People wanted the real-deal Aerosmith or nothing at all.

The problem wasn't just the lineup—it was the drugs. At the Civic Center in Portland, Maine, Steven collapsed on stage, and the show was canceled. Then he had a motorcycle accident and ripped off his heel and spent two months in the hospital. We thought some of these New England gigs would be like a homecoming. Instead, everybody was yelling out from the crowd, "Where's Joe?"

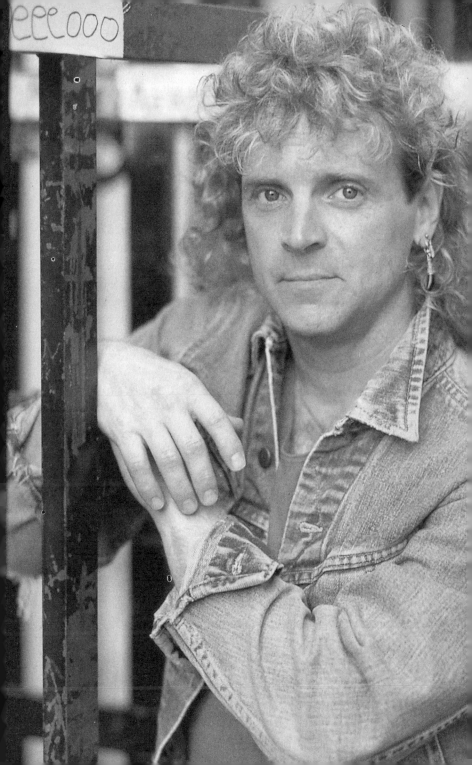

About the same time the record came out, Steven went to see the Joe Perry Project at the Bottom Line in New York. It was supposed to be a fence-mending deal, but nothing came of it.

By this time my own cash flow had gone from bad to worse, so eventually I sold the New Hampshire place, and we moved to a rented house in White Plains, New York. I had to keep borrowing money just to stay afloat. Still, even when everything bottomed out for me, it was still a "high bottom." Tom was also okay—he took a sublet in Manhattan—and I think Brad was okay, although he had to sell all his classic guitars for a song. Steven and Joe were the ones who were really banging against the bottom of the tank, because they were the ones with the most expensive habits. Steven had royalty income that should have kept him going, but he also had huge expenses and huge debts. He was reduced to living at the Gorham Hotel in New York, subsisting on cash doled out by Krebs. That fact, combined with Steven's addictions, just meant that Krebs had that much more control over him. Joe at this point had a new manager, Tim Collins, who was dedicated to turning things around for Joe. When the IRS put a padlock on his house, Joe wound up sleeping on Tim's couch.

Collins started out managing the Joe Perry Project, saying he was going to bring Joe Perry back to life, but it didn't go so well. Joe was touring in a van and playing small clubs.

In the spring of 1983 Aerosmith played the Worcester Centrum. Joe showed up backstage, and he and Steven disappeared into the dressing room to snort some smack. This show was meant to be a big local homecoming for the band, but Steven passed out on stage and once again we had to cancel. I had a big fight with Steven afterward because he came onstage and made a fucking fool of himself. I was insulted and embarrassed, and I wanted to tell him; I grabbed him, but he pulled away and I ripped his shirt. The only difference between him and me, in this regard, was that I did my drugging offstage.

For years these guys had convinced themselves that they could perform fucked up and get away with it. Everyone used to catch a buzz before going on. Brad used to drink beer, and Tom used to throw back Jack Daniels, and it was okay. Until it wasn't. Now it was totally out of control, and the results were fucking humiliating.

In October 1983 Joe released *Once a Rocker, Always a Rocker*. It was his third solo album, and it bombed just like the others. He could no longer afford serious drugs, so he was drinking everything in sight. That winter he bottomed out, playing to empty clubs in L.A. that couldn't have held more than a hundred people, standing room only. Tim started working him over, badgering him to call Steven. Rock 'n' roll had moved on, and there were new bands like U2 and Van Halen and Def Leppard that had taken our place. But maybe Aerosmith could make a comeback. Maybe Joe had learned that a solo career wasn't necessarily all it was cracked up to be. Maybe the place for him to really shine was alongside Steven, with me and Tom and Brad—the original Aerosmith.

Eventually, Joe and Steven sat on the phone together and sort of worked out a deal. One of Joe's conditions was no more using Krebs as the manager. Joe wanted Tim to take over, and the rest of us went along. One of Tim's first jobs would have to be extricating us from Krebs, which was not exactly a slam dunk. Getting us out from under the arrangement with Krebs and Leber would take two more years and lots of legal wrangling.

I had my doubts about Tim, but I was willing to do pretty much anything that would bring Joe back in and get us going again. I even played drums for the Joe Perry Project now and then, helping Joe finish off his commitments, trying to get him freed up so we could revive Aerosmith. Tom was also on board, and eventually we talked Brad back into the fold.

Tim got Steven and his girlfriend Teresa to fly up from New York. Steven arrived at the airport looking like some kind of refugee with all his stuff in a cardboard box. Some reporter described him as looking like the Queen of France, but he was really the Sun King, because everything still revolved around our front man.

We started rehearsing, borrowing more money, not just to live on, but for our tour and to mount our legal battles with Krebs. One guy who really believed in us—putting up a lot of cash—was Jack Boyle of Concerts/Southern. As a promoter, he was to the Southeast what Bill Graham was to the Northwest—a real force and a great guy to do business with.

In May of 1984 we launched our Back in the Saddle Tour, but here's where reality caught up with us. Overcoming our personal differences and

recommitting to the partnership wasn't enough. On stage Steven couldn't remember some of the songs. I don't mean that he couldn't remember the lyrics; I mean he couldn't remember that he ever wrote them or recorded them or had ever heard them before. During one California show he stopped singing and simply sat on the edge of the stage and started telling jokes, but this band on drugs had become the joke. I remember looking over at Tim standing on the edge of the stage and giving him this look like, *Yeh? So what are we supposed to do with this?*

With Back in the Saddle we just wanted to get out in front of an audience again. We did seventy or more shows with no album to promote, which is always going to be a lackluster proposition. On top of that, Leber-Krebs had lawyers at the performances with court orders, attaching the receipts. We set up a different legal entity each night for each concert so we could stay one step ahead of the sheriff. Some nights we were performing under the auspices of Large Penis, Inc. Other nights it was Big Belly Productions. After a while Krebs gave up and left us alone. The Back in the Saddle Tour made some money, and by touring like bastards, we were able to repay Jack Boyle and all our other investors.

Everybody was seeing a profit except me, because I owed what Krebs claimed to be something on the order of $650,000 for past living expenses—and I couldn't prove it wasn't true. Joe and Steven stepped up and allowed me to borrow money on their royalties to get the lump sum to clear the books with Krebs, and then I paid them back over time. I spent the first two years of our being back together just working to get myself out of hock.

Once we had our chops back, we were ready to get back in the studio, and God knows why, given the shape we were in, but John Kalodner, one of the industry's most brilliant and successful A&R men from Geffen Records, was interested in working with us. The one thing he insisted on was that we bring on a song doctor, an outside song-writing expert to help dress up the songs and the tracks. The idea was that our stuff would still be 100 percent Aerosmith, but with a kind of insurance policy for commercial hooks and such. The result was *Done with Mirrors*, produced by Ted Templeman, who pretty much discovered the Doobie Brothers and worked with Van Halen, Van Morrison, Little Feat, and Nicolette Larson. We released the album in November 1985, but

the critics said it sounded unfinished. Even if the songs had been killer, though, the packaging never gave it a chance. There was no Aerosmith logo, so sitting in the record bin it looked like a mistake. All the more so because the type was printed in mirror image—you needed to hold it up to a mirror to read it. The whole concept was like one of those half-assed ideas people come up with when they're fucked up on drugs—which of course we were. **Until we got clean and sober, our effort to resuscitate the band seemed to be just so much pissing into the wind.**

To give him his due, it was Tim who laid down the law. A legendary booking agent named Johnny Podell told him, "Look, you gotta clean these guys up." So Tim came to us and said, "Listen, I can help you guys get back to where you were, but its not gonna happen if you're still doing drugs." The way we saw it then, Steven and Joe were the most extreme, so they had to get clean first. Easier said than done. Joe would go into rehab to dry out, then hit the first liquor store the minute he got out of the tank. Eventually Tim started getting Joe hypnotized to see if that would help. Steven was already a rehab frequent flyer. He had gone away to Hazelden, but Krebs had met him with a limo at the airport and had him smoking a joint on the way home. Steven stayed clean about two seconds. But then his heroin connection got murdered down in the Village, in New York City, and something seemed to register. After Steven himself got mugged, he seemed to have more motivation to clean up his act. But this was not before he wound up hospitalized at McLeans, the highly respected psychiatric hospital just outside Boston. Tim found a doctor to put Steven on methadone, then instituted random drug tests. Steven cheated by storing week-old urine in condoms strapped to his leg.

This reformer streak in Tim was a little suspect at the time, because when we first got together, he was somebody I liked to get high with. But it was a blessing he had enough of his rational brain left that he could see what needed to be done and had the balls and conviction to do it. In 1984 he "encouraged" me to move back to Boston by loaning me $28,000 as a down payment for a house. This was where I moved with April and our two little kids—Pudding Hill Lane in Marshfield, on the south shore.

With Brad and Joe back, we had a huge New Year's Eve celebration at the Orpheum Theatre in Boston. A new light was starting to shine on Aerosmith. We were different, because we had crashed and burned, but now we were coming back. This was the original band from fifteen years earlier, and at first it was mostly we who realized the power of that and the value of what we had. After a while, I think the rest of the world caught on too. One of the critical changes was that Joe realized he was what he was within the context of the band, so there was a little

The way Joey sees it

less ego or frustration and maybe more of a commitment. But even with all that renewed energy, coming back was a long hard climb, just like the first time we'd made the trip.

We struggled for another year and a half, and then some rap group we'd never heard of asked Joe and Steven to be part of a video. They were Run-DMC; we didn't even know who they were, so we felt no big urgency to do this. We sure as hell had no idea how monumental this video and working with Run-DMC was going to be. Although we didn't

know who they were, we figured out how far down we dropped, since these kids had been sampling the riffs from "Walk This Way" for years, and they thought that the name of the band that had done the original song was Toys in the Attic.

On March 9, 1986, Joe and Steven taped this session with them. The play on MTV literally put us on the radar screen of this whole new MTV generation and energized our career like a spike full of adrenalin straight in the heart. Joe and Steven were the only Aerosmith band members on the screen; there was a local New York band called Smashed Gladys backing them up—not Brad and Tom and me, but we had bigger things to worry about.

Unfortunately, not even getting a miracle second chance, like Run-DMC recording "Walk This Way" was going to solve our problems. The first road block to solving our problems was drugs—simple as that. Tom, Brad, and I were still using, but that November Brad joined AA. Steven and Joe were still drinking and doping. Our summer tour that year was so bad that Tim called it off.

It's a big deal to call off an entire tour simply because you're too fucked up to play, so Tim was determined more than ever to get us clean and sober, and he started learning more about Alcoholics Anonymous. Johnny Podell also introduced him to a therapist named Dr. Lou Cox, who directed the process of our formal intervention on Steven. This was huge. Steven was outraged for being singled out. "Why me?" He pushed back. "You're all as fucked up as I am." The irony is that the rest of us *were* fucked up too. But I'm relatively sure Tim believed that if Steven didn't get clean, it wouldn't have really mattered much what the rest of us did. Despite Steven's resistance, in the summer of 1986, he went away to the Caron Foundation in Wernersville, Pennsylvania, a clinic called Chit Chat Farms, and he got clean. Then Joe went to Bournewood Hospital in Brookline, and finally the idea of sobriety "took."

Tom and I had always kept the appearance of it more "under control"—at least we looked that way compared to the "toxic twins"—so we managed to kind of roll along for a while longer. Fortunately most of my drinking and

drugging was on the road, so my little boy, Jesse, didn't see much of that. Asia did, and I regret it. But even where Jesse was concerned, I just wish I could have been more present, more "there" all the time but especially in those once-in-a-lifetime moments like when he took his first steps. Not just there, as in not on the road, but "there" in the sense of having my heart connected to my family, of having my head screwed on straight, of having my own shit sufficiently under control that I could be the grown-up, there to focus on him and let him be the child. Still, Jesse was a great kid, even with a fucked-up dad for the first five or six years of his life.

I never, ever sat him down for instruction, but at about age four he picked up the drum sticks and has never put them down. Jesse learned by osmosis. He sat behind me in the basement and watched. When he first started playing, his legs were too short to reach the ground from the stool, so he'd lean up against it, sort of half standing, so he could push the pedals. Like me, his ears are his eyes and his eyes are his ears. He can look and listen and noodle around until he's got every last detail down pat. When he was around six, I bought him his first set.

In December 1986 I came home one night, and our lovely little house on Pudding Hill Lane was on fire. I had to stand there and watch all our clothes and everything else we owned, right down to the gold records, go up in smoke. **The band had just begun work on Permanent Vacation, which would turn out to be our comeback album, but now—personally—I was faced with another mountain to climb.** The fire had nothing to do with drugs—the inspectors said it was caused by old wiring. But if anything should have been like a sign or a symbol that I needed a big change and a new start, this should have been it. Instead, even that first night after the fire, when April and I moved into a hotel, we did what we figured every couple does after watching their house burn to the ground—we snorted a shitload of coke.

We got Asia back in school, and then it took me maybe a week or ten days to deal with renting a house for us to move into, salvaging what we could from the fire, renting furniture, and putting that whole picture

together. It was like so much in my life—I just put my head down and did whatever I thought needed to be done, but I never really reacted to it emotionally. I never processed it. The fire was just one more big set of feelings that I hid from with blow and Stoli.

We were on even more of a tight budget after that. But we took all the money we got from the insurance company for the house itself and for all these other losses and put it back into building a new place on the same footing as the old one. So we wound up with a decent house, but we still had lots more rebuilding to do in terms of furniture and clothes and our lives.

In January 1987 the band started working in our new rehearsal hall in Somerville, the one with what we called "the wall of shame," decorated with bras and panties that had been thrown onstage. By the spring, John Kalodner had Steven up at Little Mountain Studios in Vancouver, Canada, doing preproduction. John and I didn't get along so well at the beginning, but after a while he became a really good friend of mine. John always had very special ears. And, truth be told, he was the principal architect of Aerosmith's resurgence. He brought in Bruce Fairbairn, who was Jon Bon Jovi's producer and much more disciplined than Jack. Bruce really kicked us up into a higher orbit in terms of our sound. Kalodner also brought in Desmond Child as a song doctor to help Steven and Joe on the creative side. Desmond had a real commercial sensibility, and we needed material that we knew was going to yield hit singles for those three-minutes of airplay on radio and MTV. This was a new way of doing an album for us. It was not just thrashing through to the deadline. Instead, it was thinking it through clearly, planning, and executing. There aren't too many second chances in the music business, and we did not want to blow it.

I remember Steven coming back from the first sessions in Vancouver for the new album. They'd focused on recording the trumpet and sax, and Steven really loved that soul sound, and he knew I did too. So he brought the tracks over for me to listen to, only this time *he* was sober and *I* was high. I remember his looking at me and stating the obvious: "Buddy, you need help."

Tom was still smoking a lot of weed, and I was still into cocaine and vodka, but by this time we were the last two holdouts. Everyone else had gotten into the program. As bass and drums, Tom and I always did the basic tracks first, then they built up the rest on top of that. On the playback I was really psyched, because this was the first record where my drums really got captured well. I was in love with Bruce Fairbairn because he made the drums really big and really present in the mix. The drums were right out front, and I was in heaven.

By starting first, Tom and I also finished first, and we had a tradition of wrapping it up and then saying, "We're fucking done! Let's go party!" Only this time, with everybody else already sober, we had to sneak around to do our celebrating.

Not long after that, I was down in Eastchester visiting my folks. It was clear by this time that my dad had Parkinson's, and each time I saw him, it had gotten a little worse, which was really depressing. I had a lot to say to him, a lot to work out, but I didn't even know where to begin. Or, at least, if I knew, I didn't have the capacity to do anything about it, because I was still hiding out in my addiction.

Down in Eastchester, April and I did some heavy drugging over at Richard Guberti's house, then went back to my parents' place to spend the night. April went upstairs to go to bed, and I went downstairs with a gram of coke in my pocket. Of course, down in the basement, there was also a liquor cabinet well stocked with vodka, so I was down there all night long.

At ten o'clock the next morning, May 20, April came down and looked at me, and I remember the pity in her eyes. **This time it was me who stated the obvious. I looked up at her with bloodshot eyes and said, "April, you gotta help me. Please. I really need some help."**

ONE DISEASE, TWO DISEASE, THREE DISEASE MORE

On July 3, 1987, Tim called to say there was going to be a band meeting at his house in Brookline at eleven o'clock. When I showed up, Steven, Brad, and Joe were sitting around the living room with Lou Cox, the therapist who had facilitated the intervention with Steven. We all started shooting the shit, and then the discussion got around to drugs and alcohol, with Lou doing most of the talking. After a while, I could feel the hairs on the back of my neck start to bristle, because the talk was becoming less and less general, and more and more focused—on me.

Okay, I thought. *I can see what's coming.*

"You need to enter rehab," Lou said.

"Like immediately," Tim said.

I looked at my partners, and they were all sitting there with arms crossed, nodding and looking grim. "That's the deal," they seemed to be saying.

I said, "Look, guys . . . I've been clean and sober for three months already." Since that morning in Eastchester when April found me in my parents' basement, I'd been going to AA meetings at Green Harbor down in Marshfield. Through the Pembroke Hospital I'd even found a shrink, and I'd been seeing him every week.

"Great," Lou said. "The fact that you've already taken the first steps toward sobriety makes this the perfect time to go away for treatment. You won't have to go through detox. You'll be ready to participate from day one."

I could see there was no point resisting the whole group. But still, there were practical problems. I'd been living in a rental since our place burned down, and we were scheduled to move into our new place literally the next day.

"I can't go right now," I said. "I gotta move my family tomorrow. I've got to get everything sorted out. I'll go day after tomorrow. I promise."

Brad and Joe rolled their eyes. ("I'll sober up first thing tomorrow" is like the number one classic dodge of the addict.)

"Well, I don't know if I want to be in a band with you then," Joe said.

But Steven was different. He heard me out, and I could see that he believed me. He said, "I trust you, man. I know you'll go."

And that was it.

The next day came—the Fourth of July—and it was cardboard boxes, moving trucks, pallets, and dollies from dawn till dusk.

We did what we could to settle in, had some dinner and put the kids to bed. April's brother dropped by, and I went upstairs and started unpacking what I needed from the boxes into a suitcase.

An hour or so later, I came downstairs, and April and her brother were snorting lines off the coffee table. I went back upstairs, thinking, *I'm not the only one around here who needs some help.*

The next morning I went away to the same place in Wernersville, Pennsylvania, that Steven had gone to, Chit Chat Farms. I was at Chit Chat for a month, and one of my main influences there, and the guy to whom I owe a huge debt for my sobriety, was a Catholic priest named Bill Hultberg—only

I had no idea he was a priest when I first started working with him. He was just one of the staffers, and he was a very smart, very insightful man.

Father Bill had worked with Steven the summer before. Bill always used to say to me, "You want the same thing that Steven's got. But you have to get it yourself."

He'd say it as a kind of teaser, but he would never explain exactly what he meant. In that respect he was sort of like a Zen master, and I was like the "grasshopper" kid in those Kung Fu shows who needs to figure out the riddle.

Father Bill used to come up to me first thing in the morning and say, "Well, good morning, Steve . . . ah, Joey!" He would always make this mistake of starting to call me Steven. A couple of weeks into my stay, he did that "Steve . . . ah, Joey" thing, and I said, "Will you please stop calling me Steven! Don't do that! That really annoys me!"

This big smile came across his face—he knew that I had finally caught on. It was then that he kind of took me under his wing.

When Father Bill first started asking me, "What does Steven have that you want?" I thought he was talking about the fact that Steven was always center stage, that he was the one who could always say "fuck you" to everyone else and still get his way.

After a point, I realized that all that ego stuff had nothing to do with where Father Bill was trying to point me. What Steven had that I wanted was sobriety. He had been at Chit Chat a year ahead of me, and now I wanted to get clean too. The difference was that, where drugs and booze were concerned, **I was so sick and tired of being sick and tired that I only wanted to go through this rehab once.** Steven and Joe had gone to maybe five or six different rehabs. But I was so motivated at this point to stop feeling the way I felt and to stop living my life the way I was living it that I went after sobriety the same way as I had always gone after the drugs and the alcohol—like a man on a mission.

I came after Father Bill, asking him, "Why?" I wanted him to explain to me why I got high the way I did. What was the reason?

He told me that knowing why is nothing but the booby prize. You don't need to know why—all you need to do is work on your issues and stay

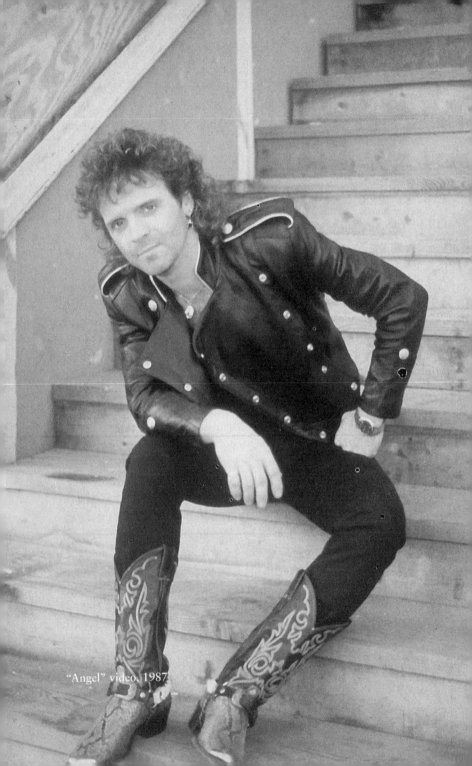

"Angel" video, 1987

sober. If you stay sober and work on your issues, then everything else will come to you.

That answer didn't satisfy me, and the question kept gnawing at me, but after a while I figured it out. Father Bill's point was that we all like to think we're so smart that if we can just get to the big answer intellectually, then we can get rid of the problem. He told me that, at least at first, my attempting to "know" all about the source of my problem was just another dodge. He said that if I thought I knew all the reasons why, then maybe I'd think I could get ahead of the game and not have to go through the pain of feeling all the feelings I was going to have to feel. Which is the part of getting sober that takes guts, and patience, and scares the shit out of everybody. But facing all my shit was the only way I could get past it. The road is through, not around. And that's where having a really good therapist would make all the difference, somebody to guide me a bit and make me feel safe enough to get down to what's real, to face down the demons and know that I'm going to be okay once I get to the other side.

Father Bill and I talked a lot about authority figures, about boundaries, about love and abuse, and about demons bearing gifts. He starting giving me a new vocabulary, and one of the key words he underlined and kept coming back to was codependency. That was my deeper addiction—the dependence on other people to feel good about myself. He also began talking to me about post-traumatic stress disorder.

According to Father Bill, you don't have to be a wounded soldier, like my father, or a rape victim to have PTSD; you just have to experience really powerful stuff that you don't acknowledge and that you don't deal with at the time. We talked about the way I was treated as a kid, of course, and my anger and my denial about the anger—that I couldn't accept it and couldn't acknowledge that these past experiences were affecting me. My reaction to abuse in my childhood was to just bury the emotions and keep on putting one foot in front of the other. I reacted the same way when my house burned down—just get the job done and don't really react. I'd been doing the same thing for the past twenty years in putting up with the relentless criticism I got from Steven.

Near the end of my stay, Steven and his wife, Teresa, came to visit me, which was really great of them, especially since Steven had been at the

same place as a patient not that long before. *Permanent Vacation* was just about to come out, and he brought me the album cover. April came down to Wernersville with them, and we ducked out to my room for about five minutes—after three weeks of celibacy, it didn't take long to get to the point of this conjugal visit. The four of us then strolled around the grounds and had lunch, and it was pretty relaxed. Steven and I were psyched, talking about how great Aerosmith was going to be now that we were all clean and sober.

Later, April came back for the Family Program, which has the intended purpose of helping the patient. But while she was there, she realized that she was just as much an addict as I was. A couple of weeks later, she was back for her own twenty-eight-day recovery program.

Being a member of Aerosmith had always meant being on call 24/7. So when I checked out of Chit Chat, I flew directly from Pennsylvania to California to start working on our first real video, which we were doing to promote "Dude Looks Like a Lady." I really didn't give it much thought at the time, but here again I was going to simply leap right back into the middle of everything, on a soundstage at A&M, after I'd just spent twenty-eight days in rehab. I had no time to ease back into normal life. Most significantly, I had no time to really feel all the emotions involved in going through this huge change in my life. I had just gone through emotional surgery. Jumping right back into work left me no room and no time to heal.

When I'd first gone to AA back in Marshfield, I did the usual thing—claiming I was there just to check things out for "a friend" who had a problem. But by the time I got to L.A., that was behind me. I found a meeting at a place that was mostly musicians, producers, A&R guys—entertainment industry folks showing up every day at seven o'clock to stay with the program.

At one of these meetings an older lady got up and said, "I'm grateful for my pain." I was a little confused at first, but after a while I figured out what she meant. What she was describing was what I was beginning to experience, which is that **when you're sober, you can begin to actually feel your feelings again— the bad as well as the good. Even if what I'm**

feeling is pain, at least that means I'm feeling, that I'm living my life instead of numbing out to most of it. What she was saying, really, was that she was grateful that she had the willingness to feel.

Toward the end of that summer, in August 1987, *Permanent Vacation* hit the stores. We had our work cut out for us. We had pissed off just about everybody in the record business. We were good at not showing up for scheduled and heavily promoted radio interviews, which made the radio station program directors pissed at the record-label reps for not delivering us and, not to mention, pissed at us. In one fell swoop we would alienate a radio network and the national label reps. Everything is connected in this industry, so the radio stations would get pissed at the label and then refuse to play any records (not just Aerosmith records) from our label as punishment for the fact that we, an artist on their label, fucked the radio station. Then the label would get ripshit at us because we caused this whole thing to happen.

And we didn't just alienate radio and record people—everyone around us got caught up in our insanity. I remember this one time we had a big band meeting with our lawyers and accountants—kind of a once-a-year review of everything. It was an important meeting with people who were looking out for our best interests. I had been on a binge for the last four days, so I was completely fucked up and out of it when I got there. About ten minutes in I fell asleep. Then I felt our business manager give me a little shove, which woke me up. I was like "what the fuck, man?" Like *he* should be apologizing for *my* falling asleep in his meeting. Then he said, "Joey, I think you should go find the bathroom—now." It took me a minute or two to realize that after I had fallen asleep, I shit in my pants and didn't even know it. Not a real high point for me, and this is just one example.

We had a lot to make up for. So we put on a full-court press, sending out personal notes and personalized videos to disk jockeys and other movers and shakers and tastemakers in the industry.

The album went on to sell five million copies—definitely a comeback. The "Dude" video—with our bearded A&R man, John Kalodner, in a wedding dress—got big play on MTV, and both "Dude" and "Rag Doll" made the top twenty. We went on tour and did 160 shows. We pulled

65,000 fans into Giants Stadium, then did three sold-out performances at Great Woods amphitheater outside Boston. **Our wives printed up T-shirts that had the names of our rehabs printed on them instead of the tour dates.** Guns N' Roses was opening for us. But what was even a bigger change was that now there was this optimism thing going around, and it wasn't just that we were back on the upswing in the music business. We all felt good physically. We were actually exercising and getting rest instead of staying up all night doping our brains out. There were some strict rules put in place initially, created to provide a protective environment. Crew were not allowed to drink in front of us, and now we had security—our tour manager, a former Arizona state trooper named Bob Dowd—to keep the dealers away. He'd go into our hotel rooms and empty the minibars before we arrived.

I'd been doing drum solos at most every performance since 1976, but now there was a special kind of joy to it. For maybe fifteen minutes the other guys would just clear the stage and leave it to me. There's usually a ramp up on the back of the stage, and they could hide underneath it and chill, and I could glance down at them through a grill.

For every tour I'd do something different, and this time out I put together this electronic package that could sample drum sounds just through the motion of the sticks—no need for them to actually connect with the drums. This setup included a neoprene belt with transformers, and my tech would put that on me while I was still playing. The sticks each had a vein routed out down the length and a pick-up wire running through it and up my sleeve and down into the belt pack that I wore around my waist in the back. I would get up from the drum riser and start banging the sticks on my body. Then I would walk around the stage where there were kick drums set up at various stations, and eventually I would work my way down to the edge of the stage. I'd start shouting out to everybody, dividing the audience into right side versus left side to see who could make the most noise. Then I'd play with the crowd a little more, standing over the security guy who'd always be there to keep people from jumping up onto the stage. I'd sort of pantomime out, "You want me to drum on his head?" And everybody would scream and

On stage, March 1988

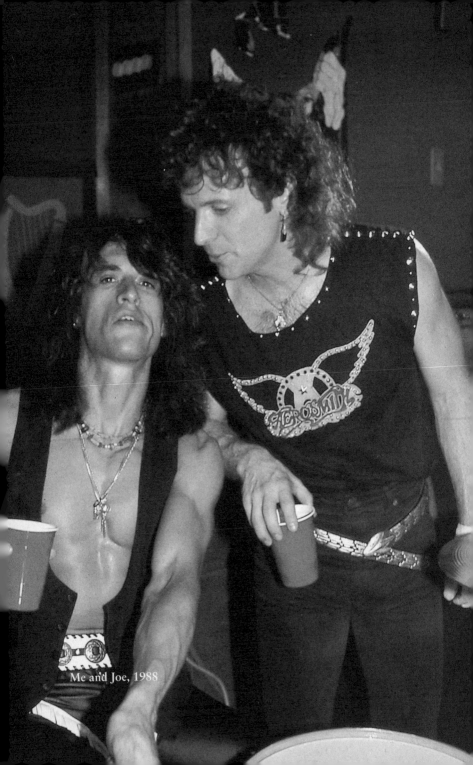
Me and Joe, 1988

holler "YESS!!" And then they'd go crazy with my tapping lightly on his cap but putting off this huge sound. I'd play on his head for a while, then work my way back around to my drum riser. I'd get rid of the belt thing, then go back to playing on my regular drum set, only with just my hands. I'd start working out on the skins like they were bongos, going faster and faster and faster until it was as fast as I could go, and then I would stop cold—and the crowd would go nuts. Then I would do one more thing, going back and forth between the cymbals with sticks, and I would bring it up again as fast as I could possibly go, and the crowd would be yelling with me, and then I'd stop cold again and throw my drum sticks out into the audience, and that was it.

We had an applause meter to measure crowd reaction to this or that, and the drum solo was always the thing that got people fired up the most.

I was feeling good on this tour, but I also knew that you don't just do twenty-eight days in rehab and leave it at that, good to go, no more problems. The transition from being an active addict to not being an addict is a big deal, and it took me awhile to even discover all the things that were going to be different. And there were other aspects of life that were new as well: I was still getting used to being out of the hole financially, to having a new house, to having a new point of view. For the first time I didn't have to deal with sneaking around and lying and scheming—all the bullshit that went along with being a drug-addicted alcoholic who was as sick as his secrets.

I'd been "Joey Kramer, the drummer" since seventh grade, and that's who I was. Even in my own mind I was the drummer from Aerosmith, and pretty much that was that. I guess I saw myself as being a decent person. But my whole adult life had been so wrapped up in the band and drugs and constant excess that I'd excluded and neglected other dimensions. Coming into sobriety and starting to see a shrink regularly was all a pretty big transition, so I was a little overwhelmed, and I think it made me kind of withdrawn. In a way, I was like one of those coma patients who wakes up after twenty years and has to get reacquainted with life. **For the first time, I had some inkling of what it meant to be fully conscious, and being conscious included reflecting back**

on my life and seeing things with increasing clarity—all the passion and all the pain. In my case, I found myself working through some doubts as to whether or not I had made the right moves, the right choices, or gone in the right directions.

A lot of marriages break up within a year after people get clean because, for the first time, they start looking clearly at their lives and their relationships without the distortions from all the chemicals. I've seen people who've been together for twenty years, and then all of a sudden they get sober and look at each other and say, "Wow, what the fuck am I doing with you?"

For the first eight years that April and I had been together, we had been actively using, so those years really didn't count much as an indication of how we would be together on our own—meaning without the drugs. I was using when we met, I was using when we fell in love, I was using when we got married, and I was using when our son was born.

It's also said that when you start using drugs, you stop maturing emotionally, so according to that calculation, I was emotionally about fifteen when the calendar said I was thirty-seven. On top of that, **I made my living in a rock 'n' roll band, which meant I was a complete fucking emotional retard. It's simply next to impossible to be balanced and normal when your job is playing music in front of 60,000 people at a time.**

With the fog beginning to clear, I kept thinking about that Billy Joel song "Honesty," which was the song that April and I had danced to at our wedding. One day she looked at me and asked if I still loved her, and I said I didn't know. That was a very honest answer, even though it was definitely not the answer she was looking for. I didn't know about loving April because I didn't even know me.

Of course, April was just getting sober as well, and her self-esteem wasn't that great, so she made an assumption—that my uncertainty had something to do with her, that maybe I thought there was something "wrong" with her. One of the things we'd just begun to learn was that

if we were going to be in a healthy relationship, we really had to detach somewhat from the other person's opinion of ourself. I was learning to recognize that the minute I assumed something about what someone else was thinking or feeling about me and I got into defending against that assumption, not only was I giving life to a committee of enemies in my head, but I was the "chairman" of that committee. Maybe most important, I began to hear the concept that we are not what other people feel about us or think about us. It started to make sense to me that other people see me not the *way I am* but the *way they are* and vice versa. This was an extremely difficult concept for me to integrate into my life day to day because up until that point my whole life had been based on pleasing other people and conforming to their expectations and needs.

"I can't hear you!" drum solo, 1984

I gave the people around me the power to define who I was—for me— whether they wanted that power or not. And when they did want that power, I was in even bigger trouble.

At that time, April and I committed to working on our relationship, but the first question we faced was, is this thing worth the work? We decided that it was, and we started trying to relearn how to communicate

"Janie's Got a Gun" video, 1991

with each other about how we felt, which was not easy for either of us. Neither of us had experienced that kind of open and honest communication in our families growing up. It was a welcome way of doing things, but just being welcome didn't make it easy.

We just kept doing it, though, and inch by inch we moved it along. It's like when you're trying to lose weight, and instead of looking in the mirror every day, you learn to look at yourself only once a week or once a month. You see the progress more easily that way. The more we worked at it, the easier it became, and the better our relationship became.

But April wasn't the only person I had to relearn how to be with. After Chit Chat, Lou Cox became my therapist, and I worked with him sometimes alone, sometimes with the whole band, and sometimes with him and just two of the band members, one on one.

As an individual, I had to get clean and sober in order to start addressing underlying issues that, for me, led to depression. For the band, getting clean and sober meant that we could start addressing the underlying issues that had plagued our band family for so many years.

My first one-on-one sessions were with Steven and me. Lou mentioned to both of us that he was very impressed with not only our commitment to working to make things better but also with our seeming to care about each other.

Lou asked me, "How do you feel when Steven comes into the room? How do you feel when you're relating on a level when it's really purposeful and productive?"

I told him that Steven was such a creative spark for me that it was exciting just to know that we were going to get together. Steven told him the same thing. So I really believed there was this love and respect we had for each other. But there was also the criticism, which felt abusive. And there was so much more of that than the creative excitement and respect I felt from Steven.

The fireworks could start out simply, with Steven reacting to something I'd played. "Are you kidding with that?" he'd say. He'd give me a look, and I'd say, "Why don't you just sing and let me play the drums," and after that all bets were off. With that little prompt, Steven could start roaming back and forth across our whole relationship, and then

MODERN DRUMMER™

The World's First International Magazine For Drummers

AUGUST
1988
$2.95
CANADA $3.95
UK £2.95

Joey Kramer

WIN A
SET OF
EVANS
HEADS

SUZANNE VEGA'S
Steve Ferrera

John Dittrich
OF RESTLESS HEART

Neil Peart
ON DRUM PARTS

Plus: The World Of Drum Corps ●
Playing Loud—Staying Healthy! ●
Drum Machines And Odd Time ●
Drumset Options

0 72246 00799 0 06

One year clean and sober

ONE DISEASE, TWO DISEASE, THREE DISEASE MORE

my upbringing, my sexual history or whatever, piling on everything he knew about me as evidence for whatever claim he was making about what was wrong with me and why I simply couldn't face up to it. The other guys would stand there, holding their guitars, getting bored, and then one by one they'd simply peel off and leave the room.

The trouble was that I gave Steven all that power. I believe he was genuinely frustrated that I wasn't doing or getting what it was he wanted me to, but at the same time I think he had an idea that I would find what he said and the way he said it hurtful and demeaning, and I don't think he knew how to stop himself. Looking back, I think he felt shitty about treating me that way and ashamed of his abusive behavior. I didn't know it then, but I have come to learn that that was the kind of behavior therapists call an expression of self-loathing. It's about the person delivering the message—Steven—and not about the recipient—me—but I swallowed it hook, line, and sinker. I made it about me, and I resented Steven, and I couldn't process any of it. So I stuffed it all down inside. Sure, I could see that Steven wanted to make things as good as they could be, but I felt so twisted that I could only tell him to go fuck himself, or I'd just shut down—which is what I mostly did.

That said, although it was a little scary, I was happy to work on our personal relationship as just that—a personal relationship—but I also thought we might find a way to improve our collaboration musically. We needed to find a way to get beyond the pathology of his always yelling at me, "Play it this way," or, "Play it that way," and my either yelling back at him because his "suggestions" always sounded like put-downs—or my shutting down.

We were all very good at gravitating back toward the original positions we held in the families we grew up in. That was home base, and we were always heading for home. **In my case, Steven's being a mentor to me—sort of like a father figure—got twisted into my giving over my power to him and letting him beat me with it. It was the same old confusion of love and abuse I'd had with my dad.** For Steven, I think I was like the younger brother he'd always beat up on, so much so that he didn't even realize he was doing it.

Steven was an inventively bright, extremely creative, hyperactive kid with an extra added rebellious streak that propelled him to be the superstar he is today. As a kid, his curiosity and passion about whatever was important to him was met with ridicule and punishment by a world that didn't understand him and confused his intensity with his being a bad kid—a world that would try to shut him up rather than hear, understand, accept, and appreciate him for what he had to offer. But Steven would do whatever was necessary to make sure HE WOULD BE HEARD. We were a perfect match for each other's dysfunctional, codependent behavior. Working on our relationship, we were all very vulnerable. I needed all the help I could get.

During the first few years of our sobriety, Tim created a kind of twelve-step recovery cult, and we all drank the Kool-Aid. He monitored everything, and just about any behavior could trigger the call for more therapy, including residential treatment. But he was also good-hearted about it. He'd say not only, "you have to go," but, "I'll pay for it."

One day Steven said to me, "Tim and I think you should go to this place called Sierra Tucson for this thirty-day codependency program." Steven had gone through the same program a few months earlier.

A little later, Lou said, "Who the fuck are these guys to tell you to go away for some thirty-day therapy program? Are you supposed to do it just because they tell you to?" His point, of course, was that going off to a codependency program because my partners tell me to is about as codependent as you can get.

I went back and forth about it, and I finally decided, partly owing to the fact that I kept going back and forth about it, that I would go. To not do something just because a particular person suggested it would also be pretty sick. So I took their advice, and the program helped me a lot, but the fact that I went still felt kind of suspect.

Maybe some of my willingness to go along with them had to do with codependency, but there was also my openness to learning more about myself and improving myself.

Lou Cox, the band's therapist, told me that codependency is all about not knowing where you stop and start and where the other people in your life begin. But it also comes up in terms of having your own will

Comin' back—August 1988

and recognizing what belongs to you—and what is the other person's shit. In other words, having healthy boundaries.

When I got down to Arizona to start the program, they began working me over about sex addiction, probably assuming I had to be a sex addict because I was in Aerosmith, but I wasn't a sex addict. When I showed up, they said, "Well, you're in a band with Steven Tyler, so you must have the same problem." This is when I had to say to them, "Hey, you got a lot of balls to lay this on me. Fuck you."

It turned out that this is what they wanted me to do. They were pushing for me to fight back. It had been amply demonstrated that standing up for myself in the face of authority figures had always been one of my big issues, and they wanted to see if I could do it. So I passed the test this time.

My mother came out to Arizona for Family Week, and part of the deal during those times was to have what they call "When you . . . , I feel . . ." sessions. She had come there to support me, and in this supervised setting it was amazing how open and insightful she was. She also told me some things that she said she'd always wanted me to know—experiences from my early childhood, like the story about my catching hell for playing in my dad's desk when I was two. She helped me bring my memories of these experiences, such as they were, up to the surface. She also apologized to me for letting those things happen.

But most importantly, she gave me a clearer picture of my dad than I'd ever had before. She told me about his childhood—about how he'd never been allowed to have pets, how there were never any hugs or even kind words as part of his upbringing. Apparently, my dad had grown up with the knowledge that his mother had tried to abort him. She jumped off a table again and again. So it wasn't just D-day, being badly wounded, and all his dead buddies that had come between him and me. He was an angry guy, with a lot to be angry about.

The thing that surprised me most was when she said she believed he was actually jealous of me. This was hard for me to figure, but then she mentioned times when I was little and I'd skin my knee or whatever and she'd try to comfort me. He'd always try to get her to knock it off. He always told her she was babying me. But she felt that witnessing that kind of mothering just upset him because he'd never gotten any tenderness

himself as a kid. He was able to indulge the girls, but never me. She said that, although he would never admit it in a million years, there was this edge of envy and resentment and sadness to it.

She also said I'd grown up jealous of my sisters. I'd never thought about my sisters one way or another, but she said that I knew I was being treated differently and that it pissed me off and confused me that much more. **The point is—what goes around comes around, and I know I have these ingrained, irrational hurts. The trick is to find some way to feel them, identify them for what they are, express them and resolve them in the moment. Most of all, the trick is to not pass the damage along to the next generation.**

After Sierra Tucson, we were up in Vancouver at Little Mountain again, and everybody was excited and psyched about what we were producing. This was the first time we'd ever recorded with all five of us clean and sober. It was amazing how fast we got things done, and how well. Kalodner said it was going to be the best record of our careers.

But I was still second-guessing myself. Had I played as well as I thought I had? Was the record as good as everybody thought it was? Early on, the people involved in a project are always too close to it to have much judgment. So you always have these grandiose thoughts that it's the best ever, but then you pull away a bit and go to the other extreme, thinking that it's all shit. But my self-consciousness was complicated by the fact that this was the first record I'd done with any "consciousness" at all.

Tom and I wrapped up first, as usual, and as I was getting into the car to begin the trip home, he handed me an envelope and said, "Don't open this till you get on the plane."

It's about a forty-five-minute ride to the Vancouver airport, and the whole time I was thinking, *What's up with Tom? What's this letter all about?* He and I were the last two to get sober, so there was this special bond, and I was dying to know what he had to say, but I'd given my word.

So I waited until I was in my seat on the plane, and as soon as I settled in, I ripped open that envelope. The note he'd written said: "I'm proud

to be a soldier in the same army fighting alongside another soldier of your quality. I'd do it all again in a minute."

That really meant a lot to me, because we had gone up against the odds. It wasn't just hanging in through all the bullshit for nearly twenty years, toiling in the background to make the music work and never getting much credit for it, but also just this week, facing down the pressure of a recording session, newly sober, and then coming shining through.

Aerosmith released *Pump* in September 1989. "Love in an Elevator" reached number 5; "Janie's Got a Gun" reached number 4. But the job wasn't over. For the next eighteen months we were on the road, pumping up *Pump* to keep it on the charts for 110 weeks.

That November we went to England. When we played the Hammersmith Odeon in London, I got to talking backstage with Robert Plant. I mentioned how I felt a huge loss that John Bonham, one of my drum heroes, was already long gone and that I'd never been able to see him play. Bonham had been the same sort of abuser that I'd been, but I was still alive and he was dead. I told Plant that there were things I'd like to say to Bonham if I could—that he was one of my mentors and that it was ironic that he was under the ground and I wasn't there with him after all of the abuse. Plant said, "Well, I can tell you where his grave is." The next day I hired a car and drove for three hours into the English Midlands. I found an old weathered church with these crooked headstones, and I found Bonham's grave and stood there in the drizzly gray English November weather and said my piece. Then I got in the car and went back to London.

By this time, my dad was in a pretty serious state of decline. Parkinson's had robbed him of more and more of his abilities, and once he started to get sick, he really didn't have any interest in anything. First he couldn't play tennis, and then he couldn't drive, and then he had trouble talking. Finally he reached the point where his whole body was frozen, and he pretty much lived in a chair in our living room back in Eastchester.

The little bit of understanding we'd gained of each other during that summer of '78 in L.A. had never really come to anything and didn't provide the breakthrough in our relationship that I needed to heal. I'd gone back on the road—and back to the drugs—and he'd gone back to being a hard-driving businessman. But clean and sober now, and after all the work I'd done with Lou Cox and April and Steven, I realized I did not want to be angry anymore, not at anything or anyone, not even my father. To free myself of that burden, I made a commitment to go to my father's house, to be in his presence, and to forgive him in my own words. I'd heard from Lou that resentments destroy the container they're kept in, and I was starting to believe it. Talking with my mother in Sierra Tucson had given me a new perspective, and I wanted to let my dad know that I understood what he'd been through and that I no longer held him responsible. I wanted to tell him that I forgave him. And maybe then I could begin to forgive myself for playing the role of the victim for so long.

April and I got in my car and drove south, heading down I-95 toward Eastchester. All the way down I was still thinking about my dad and about what I was going to say. I was also thinking about all the waste, about how much he loved music, but that we never talked about music. He'd never even seen me play. I had carried this huge block in my chest and in my gut for over forty years, and all the way down I felt it choking me. How was I going to put this huge *thing* into words and then get rid of it? I didn't really know. I couldn't just lay it on him, especially with his being so sick with Parkinson's. But I was sick too, sick in my heart. After a while I had to pull over and get April to drive.

We got to the house, my mom was there, and my dad was sitting in the living room in the chair that by now was pretty much his whole world. April took my mom into the kitchen, and now it was just me and Mickey, my dad. Immediately my eyes started to well up—just to see him

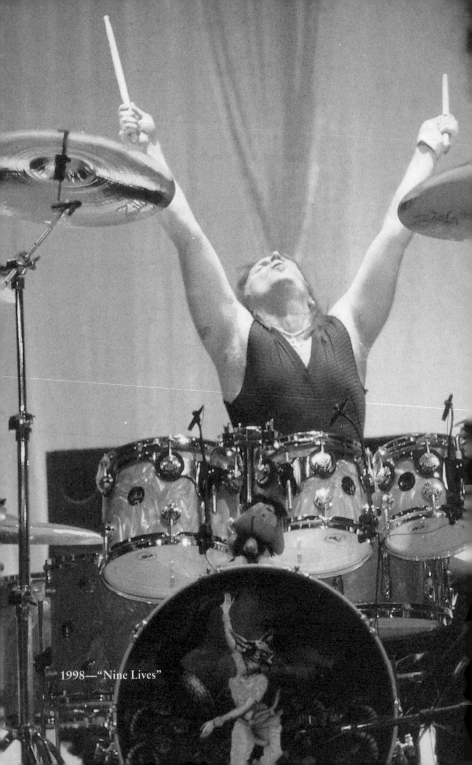

1998—"Nine Lives"

like that. His face was like a mask. The disease had taken everything, even his ability to smile or talk. This big strong guy, this soldier who had stormed the beaches at Normandy to fight the Nazis was now helpless, stiff and hunched over, his muscles wasted away from not being used. It broke my heart, and I thought, *This is the raging monster who had terrorized me when I was growing up?*

I sat down in a chair in front of him and pulled in close. His head was tilted forward. He couldn't move it to look at me, so I had to get down on my knees to look up at him. I positioned myself so that my eyes met his; tears were rolling down my face.

I said, **"Dad, you know why I came here today? The reason is that I want you to know in your heart that I forgive you, Dad—that I forgive you for everything that happened when I was a kid."**

Through the tears I said, "I know that you feel bad and you've probably beaten yourself up for that, haven't you?"

He could hardly move. He sat there, staring back at me. But after a few seconds I realized that he was whimpering, trying to respond.

I said, "And you carry that around with you all the time, don't you?"

His body trembled, and he whimpered again, trying to make his mouth form the words.

I told him, "Dad, you don't have to carry that anymore. Because I forgive you from the bottom of my heart. I love you, Dad."

I took his arms in my hands and put them around my shoulders. I knew he was too weak to do anything, but I told him, "Come on, Mickey, give me a hug."

He could barely summon the strength to squeeze his arms around me, but I could feel him trying with everything he had, and he was crying, but the disease had taken so much from him he just couldn't speak. This was the best he could do to let me know what he would never be able to put into words.

By 1992 we'd all been sober for five or six years, and we were back in L.A. to record *Get a Grip*. The record company had set us up in these residential suites at Sunset Plaza, and **for the first time my partners and I were spending a lot of time together. It was sort of like it was back at the beginning when we shared an apartment on Commonwealth avenue, only we didn't have to live on brown rice and carrots.** And, of course, none of us were drinking or using.

We were now a bunch of forty-year-old guys, settled in to the good life, which in some cases meant new marriages with new little kids on the way. For April and me, this brought up a lot of emotional stuff that we didn't even know we had going on.

During my active addiction, two years after Jesse was born, I underwent a vasectomy. The decision to have that procedure really wasn't about drugs or life being out of control. It was simply that we had Jesse and Asia and things were good, and having another kid just wasn't part of the program. The fact is, of course, with my being so out of control at the time, it would've been a disaster to have another kid.

But now that things were settled and pretty mellow, it was difficult to sort out my feelings when I saw these bulging bellies and proud papas-to-be. I found myself noodling it around—wouldn't it be amazing to have a two-year-old? Especially now that I had my head together and knew what I was doing. Or wouldn't it be amazing to have a four-year-old? And then wouldn't it be amazing to have a six-year-old or an eight-year-old or a ten-year-old? I was even to the point where I was thinking about asking April if she'd consider adopting a kid.

All the various forms of therapy we'd been through included some further codependency work for April and me at Sierra Tucson. Once when she and I were in a group session, we were each supposed to bring up something about our self that our spouse didn't know. I mentioned kids, and this bit of second-guessing that had been going on in my head, and one of the therapists picked up on it. "Well, Joey, are you so sure you didn't want to have more children?" she said. I told her, "Well, you know, I'm not sure. I think maybe I would have."

Right then and there April broke down in tears. She said she'd been feeling the same way. We both knew that, physically, it just wasn't going to happen, but obviously neither of us had resolved this, so we had to take a moment to let it go.

The therapist asked us to write a letter to our unborn child. We were to tell him why he wasn't born, what kind of life he would have had, and what kind of father and mother he would have had. And we were to tell him that we were sorry, and then we were to say good-bye.

We wrote the letter, and then we had to sit in the middle of the group and read it aloud. When we were done, everyone in the room was yelling and clapping for us. The therapist hadn't admitted it beforehand, but this was the first time she'd ever tried doing something like that. For me, writing that letter brought an incredible amount of closure. Even

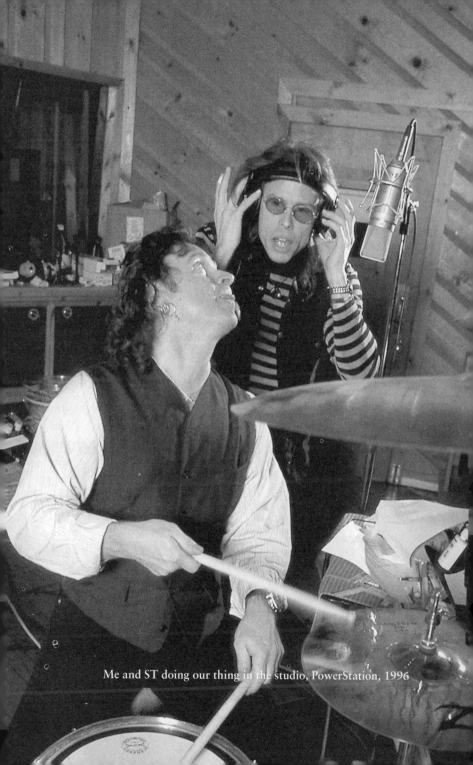

Me and ST doing our thing in the studio, PowerStation, 1996

though we had made the "no more kids" decision during the course of our active addictions, we made it very consciously, and we gave ourselves credit for that. I had already fathered one son, and I knew what that was about. And writing that letter allowed me to get a lot of mixed feelings out and manageable.

A few years later, when all my partners were in their mid-forties and had three-year-olds crawling around on the coffee table, April and I were saying to each other, "Hey, not bad!" In other words, we realized that there was something to be said for having our kids further along and for having our lives back after the diaper and daycare phase.

While *Get a Grip* was still in the can, I was back on Pudding Hill Lane in Marshfield, in the house that we built on the site of the one that burned down. It was now eight or nine years since the fire, and the Aerosmith paychecks were considerably bigger, so April and I were thinking about putting an addition onto the house. A real estate guy we talked to said we'd be better off just buying a new one and moving on. So we started to look around, and then we saw this new place that we fell in love with. It sounds pretentious, but I have to admit this was like "an estate." The band was back on top, so I felt pretty confident that the money would be there. But the fact is, I had inherited a good deal

Somewhere in Europe

of financial insecurity from my father, and I didn't want to commit to something that I might not to be able to afford. Then again, my reluctance was also just another instance of insecurity in general. Even so, I made a deal with the owner of the big place with a handshake and a check. I gave him $100,000 and said that if I bought the house, he was to apply the money toward the purchase price. If I didn't buy the house within a year's time, he could keep the money for his troubles.

Before the year was out, *Get a Grip* was released, and we were on the road. The tour was a huge success, and the record sold 14 million copies, so I bought the house. And yet I remember, when we were getting ready to move, sitting out on the dock by the pond at the old place, the smaller house at 282 Pudding Hill Lane, looking at the water and saying to myself, "Why am I doing this? Why is this house not good enough anymore? Why do I have to move up and on and into a bigger place that is going to keep my nose to the grindstone to make the bigger payments?"

I talked to April about it, and she told me, "Well, you know, this is part of what happens when you allow yourself to indulge in what you've worked so hard for." And that answer was fine for me at the time. What she was saying was that I deserved it even though in order to pay for it, "deserving it" would mean being on the road more than I was home. So was I really going to enjoy it? Was I really going to get to experience it as much as I wanted to? Not really.

In the spring of 1994, right in the middle of the Get a Grip tour, we had a ten-day rest back home before going to Japan, and it was on the second or third day of that rest that the phone rang. I picked it up; it was my sister Amy.

"Joey," she said, "I'm at the hospital."

Right then I knew what was coming.

"Daddy passed about an hour ago," she said.

I let the news settle over me for a second. When I was able to speak, I thanked Amy for letting me know, told her I'd see her the next day. Then I hung up the phone.

I walked back into the room where April and I had been watching TV, and when she looked up, she could tell by my face that something big had happened.

The Foundation Room

"What's wrong?" she said.

"My father just died," I said. Then I burst into tears.

April tried to comfort me, but I needed to be by myself, so I went out into the laundry room, got a coat, and went outside.

Parkinson's had been taking down my dad for years, so we knew this was going to happen, but we still hadn't expected it to happen quite so soon. And even though I knew it was coming, when it actually did, I felt really empty and alone. This was late winter/early spring in New England, and on the coast where we lived, the marshes that time of year have this dead, matted straw look to them. I walked down across the lawn a little bit, and with the night air cold in my face, I could see the river that ran just below our property down to where it opened into the ocean. It was an amazing view in the moonlight, but somehow the beauty of it meant nothing to me at that moment. The thing that kept coming to mind for me was how I had never connected with my dad the way I'd wanted to, and now that chance was gone. I'd forgiven him for all the things he'd done to me when I was young, but that feeling of resolution was bittersweet. I still felt like I'd been sold

short, especially in that the Parkinson's had begun to take him away ten years earlier, and we never had a chance to be the kind of father and son I had wanted us to be.

That night I couldn't sleep. I kept reflecting on what it would have been like if we'd had the kind of relationship I'd always dreamed about—and especially his telling me he was proud of me. I tried to focus on some of the good stuff, like when he came out to L.A. during *Sgt. Pepper*, but the finality of death left me reeling.

The next day, April and I drove down to New York with Jesse. My mom had a burial plot that they bought years before, but nothing else was set up for the funeral. I had to do all that with her in just a couple of days.

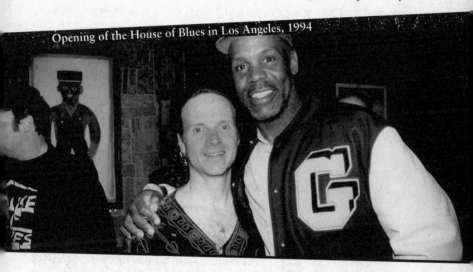

Opening of the House of Blues in Los Angeles, 1994

We picked out the casket and made the arrangements, and the morning of the service, my mom and I had to go in and legally identify the body.

I felt good that so many of my friends came to support me that day. **When I gave the eulogy, I focused on the main lesson my father taught me, which was that the most important things in life were family and friends. Take care of your friends and be a friend, he'd always said.**

Afterward the family stood around talking, and a lot of people came up to me. They all described how my father had told them that if there was one thing he was ever sorry for, it was the way he treated me when I was younger.

I appreciated the words of support, and while I knew they were said out of care and love, in a way hearing them just made me feel sadder.

We went to the cemetery, and the whole band was there, along with Tim, our manager. We put my father's casket into the ground, and I've never cried that hard in my whole life. I cried so hard for so long that I couldn't even see. By the time it was over, I was physically wrung out from crying. I just really was at a loss for how to handle all my feelings, because I was losing something that I never really had to begin with. There was love, and there was anger, and guilt about the anger, and over all just a huge feeling of emptiness and loss.

After the funeral, my mom and my sisters and I were together for a few days, but then I had to get back to work, which meant heading off to Japan. I had commitments to the band and to the big house and to all the rest of it, so I didn't really have time to mourn my father's death the way I might have.

At the time, I was also responding with some of the old habits—just get on with it, put your head down, and stay busy. It wasn't that I was consciously denying the grief, it was just that I wasn't really dealing with it the way it deserved to be dealt with. What I didn't realize was that, even after all the therapy and rehab, and even though I wasn't on drugs, I was still pretty numbed out. By shutting down and going right to work, not allowing the process of grieving to run its course, I was just postponing the real confrontation with all my contradictions and conflicted feelings. I was also feeding the inevitable showdown with myself making what was soon to come much more intense.

Get a Grip had put us safely back in the game, bigger than ever. So being on the road was even more pressurized than before. Which also meant pressure for us to get back into the studio. Steven and Joe went down to Miami for preproduction, and Tom and Brad and I stayed up in Boston rehearsing.

Meanwhile, April was getting ready to set out on her spiritual journey to see Sai Baba in India. She and Isaac Tigrett had been talking about this trip for many months, and she made it official around maybe October or November.

The band always took time off during Christmas and New Year's, so when the holidays came, there was a lot of family, and a lot of presents, and a lot of socializing going on. April and I had a New Year's Eve party, not for the band, but for buddies like Jack Scarangella, David Brega,

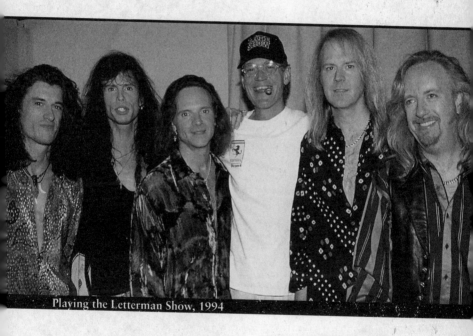

Playing the Letterman Show, 1994

Richard Guberti, Frank Gangi, David Hinkleman, and Donny Wightman. I have a picture of all of us together, and I look really bad. I remember them saying to me at the time that my face was really long and drawn. People were asking me, "Are you okay?" "What's wrong?" or saying, "You don't look happy." I think they were trying to get me to go someplace to get some help, but frankly, I didn't want any more of that kind of help. I just wanted to be home, living my life—or so I thought.

April could see the kind of condition I was in, too, but I knew she really wanted to go on this trip to India to see Sai Baba. So when she asked me about it, I said, "I'll be fine. You go ahead and take your trip. I've got to work this out on my own."

Tom and Brad and I started drilling again in January, and I thought I

Figuring it out

was kind of okay for a while. But within just a few weeks I started feeling a little strange, and I started getting depressed, only I didn't know that I was depressed. All I knew was that I was feeling a lot of pain and deep, unexplainable sadness. It was starting to crush me.

One day Tom and Brad were with me, rehearsing the arrangements we were getting ready to record down in Florida, and I just put down my sticks. This horrible despair suddenly hit me, and I started talking about how I was feeling and how long I'd been feeling it, and I said that if I had to go on feeling this way for a prolonged period of time . . . well, I could understand how someone could start thinking about suicide. I wasn't saying that I was going to kill myself. I was saying that I had some new insight into what's going on when people do kill themselves.

Tom and Brad took that statement and ran with it to Tim, who was still like a nervous nanny as far as our behavior was concerned, though not necessarily without reason. I immediately became the designated patient, and Tim wanted me to go into suicide-prevention treatment. But I knew there was no way I was going to kill myself. Like that lady I'd heard at the AA meeting in L.A., I knew that I'd rather feel the pain than not feel anything at all. It's just something in the core of me, some determination from my parents that makes me love life too much. But by being so down, I could see how people get there. And **it's a scary place when you're thinking, This fuckin' sucks. I can't stand it anymore. I'm done.**

The nearer we got to April's departure day, and the more I realized she was really going to India, the more I became agitated. This was a big deal for her, and she seemed so sure it was the right thing for her to do, so I thought I was wrong to not want her to go, but it was hard. Jack B., my AA sponsor, was with me to drive her to the airport, but when the moment came for me to actually say good-bye to my wife, I just broke down in tears. I had told her to go ahead and go, and that I would be okay, but the truth was, I felt totally abandoned.

Reflecting back now on my relationship with April, I realize it wasn't the first time I felt April either physically or emotionally abandoned me; the reality was that this had been going on for years, and if any of my friends or family tried to make me see that and do something about it, I would always rationalize and justify April's behavior. I was afraid to acknowledge anything might be wrong with our relationship. I was not equipped to stand up to what I was certain would be April's insistence that what I was saying was wrong or, worse, that my bringing it up would

piss her off. So when April was leaving this time, even though it didn't add up for me that, once again, she would not be there with me, and for me, everywhere I turned, things seemed to make less and less sense, so I didn't know how I felt about anything. It would take nearly a decade before I felt strong enough with myself to confront the issue and say to April that some things needed to change between us.

After she got on board and the plane took off, Jack and I drove back to my house, and I remember his telling me, "We're having fun; we're in training now," but I didn't see it as fun at all. Jack was a marine, and while he was a great advocate for AA, he just wasn't the kind of guy I needed to help me through this. I didn't need somebody to coach me to tough it out. I needed somebody just to be there, and maybe to listen if I ever felt like I had something I needed to say.

After Jack left, I called Frank Gangi. Frank was an amateur pilot I'd met years before when we were trying to line up a couple of planes for a trip. We became great friends over the years, and he could tell just by my voice that something was really wrong.

"So, bro, you want me to come over there?"

I said, "Yeah, Frank. That's really what I need."

So Frank pretty much abandoned his business and dropped everything for maybe ten days. This was an amazing act of friendship, and I will be eternally grateful to the guy. He moved into my house and camped out and looked after me. I so didn't want to be by myself, and Frank was being such a prince, but once he got there, I really didn't have much to say. It was just the presence of somebody else close by that I needed. If Frank hadn't been there with me, I don't know what would've happened. I couldn't even drive a car.

After a while, I decided that even with Frank's help this was just not working. I said to myself, *I gotta get out of here*, and I booked a flight to Florida to go record with my partners who were all down there in the studio. I thought that if I could really get going on the record, together with the sunshine and the change of scene, then all this pain and shit would go away. Which meant that I was still in denial about what was really going on—I was starting to dive into the full-scale breakdown that would land me in California two days later. When Steve Chatoff came

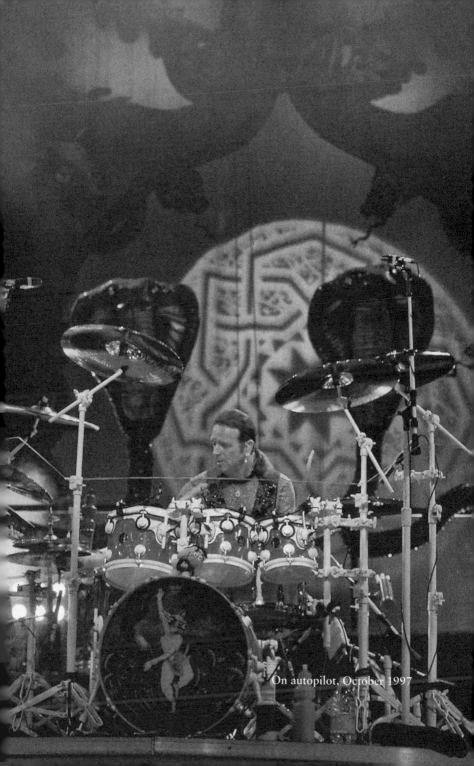
On autopilot, October 1997

in to see me that first morning at Steps, he was with his wife, a beautiful redhead named Charnay. She's a psychologist and he's a registered nurse, and their specialty is dealing with people in the music industry. That was the first time I heard the term *flooding* used to describe my condition. They agreed that I was too deep into that to get any real work done, but over time, I began to see Charnay as my therapist every day.

Eventually I became okay with staying in the room by myself instead of in a bed by the nurses' station, although, a lot of times, as I look back on it now, the isolation really bothered me. At the same time, it forced me to deal with a lot of my shit. I would lie in bed at night, and my real solace at the time was talking to Baba, the spirit guru that April had gone off to see in India. It would be ten o'clock at night, and I'd be saying: "Baba, please help me to help myself."

I never felt like eating, and I didn't want to talk to anybody. I just wanted to hide in my room, back in bed. I used to kind of just gaze out onto the patio, and I would see people either taking a smoke break or having their morning coffee and moaning about not being able to have real coffee. All they could have was decaf, because Steps wouldn't let you

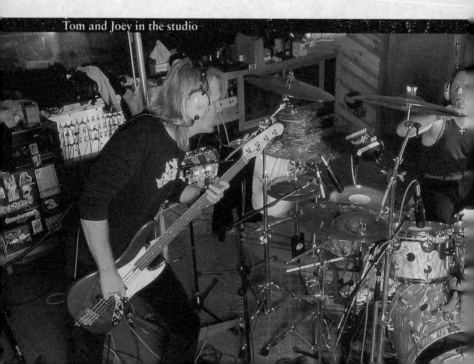

Tom and Joey in the studio

have any kind of stimulant at all. It kind of made me glad that at least I didn't smoke. At least that was one addiction I had avoided.

The clinic gave you this rolling series of wake-up calls leading up to seven thirty. They would call you at a quarter to seven, seven o'clock, quarter past seven, and then at seven thirty you really had to be up. I would wait until the last possible minute to put my feet on the floor. I was so anxiety ridden and depressed and emotionally distraught that sometimes I'd just have to take it from hour to hour . . . sometimes from minute to minute. There were times, I remember, when I sat in my room, watching the second hand tick by on my watch.

But mostly what I did was cry and ask myself, *Where the fuck is this coming from?* The biggest mystery to me was that I had this overwhelming pain in my gut. I didn't know why I was feeling it or even what it was. All I knew was that it hurt—worse than anything I could even imagine. **I didn't know emotional pain like that could create such physical pain.**

After about five days they said they wanted me to start on antidepressants, but I had never taken any before, and I didn't want to take them now. **I figured I could deal with the depression without medication. But this depression was just one big hole, and I was right at the edge, looking down into the darkness, and the darkness had a gravitational pull all its own. I didn't want to go down there, and yet I couldn't pull away. I was really stuck, and it was scary. So I had to give myself time.** I had to be really patient, spend the time in a controlled atmosphere, and calm down so I could learn what the depression was all about. I needed to get more educated about myself and about why I was feeling the way I was. Ultimately, I started taking the antidepressants; they became part of the regimen and, eventually, part of the ultimate solution.

After a while I started going to classes. I went to classes about child abuse, sexual abuse, codependency—you name it. Sometimes I participated a little bit, being patient with myself, because at first I was so anxiety ridden that I couldn't even sit and listen. And even more so, I was not

able to take instruction to try and learn about what was going on with me. But I did my sessions with Charnay. I saw her every day, and I did my group therapy. Going down to the depths of all this pain changed me in many ways, and after a while I really got into the process. I learned to feel happy and experienced joy from realizing that I had the kind of strength I needed to actually come through something like this.

I had done the work to get clean and sober, and now that I was, I could feel the pain, which meant that classroom-like blackboard sessions had purpose. Understanding what was going on intellectually wouldn't be just the booby prize anymore, a way of avoidance and denial. Steps wasn't just "tell me about your pain," it was also "let me explain to you how this usually works." The "what's going on" helped me get to the "why," which helped reinforce the goal and set the course for making some real changes.

They told me at Steps that a common denominator with so much personal turmoil is people being hurt, and the hurt causes them to shut down. So I was able to relate to what they were talking about in the blackboard sessions. Every once in a while, the light bulb would go on.

I had done all these forms of therapy—sometimes on my own, sometimes initiated by Tim—only to realize that I'd only been dealing with this stuff on a surface level, which at this stage of the game meant I wasn't really dealing. Until my system of defenses and denial began to break down, I wouldn't be able to absorb the real lesson.

One of the ideas that became a lot more powerful for me at Steps was this concept of post-traumatic stress. Father Bill and I had talked about it at Chit Chat, but now I was in a better position to connect the dots. I remembered a time April and I were coming up the Hutchinson River Parkway in New York, going into Connecticut after visiting one of my sisters. We were in a new Porsche Turbo, and I had slowed down from about 120 to around 80. I was cruising along next to this guy in a Lamborghini, and suddenly a deer hopped out in front of us from out of the woods. He hit the front of my car, flattened against the side of it, then came apart. April completely flipped out. I simply pulled over to the side of the road and took care of business. I asked her if she was okay,

went out and examined what happened to the deer, made sure there was nothing I could do, then got back in and drove home.

It wasn't until about forty-eight hours later that I started to react. I had taken the deer's life and was feeling really bad about it. Remembering that delayed reaction, I now realized that this was the way I always processed—or didn't process—big emotions. You do what needs to be done; you react later. It can come in handy in emergencies, and with me, I could see that this was how I dealt with everything. But sooner or later, it takes a toll.

Alone in a crowd

What I was coming to see was that all those emotions that I never really processed had waited thirty or forty years to bubble up to the surface. That buried pain affected how I dealt with any authority figure throughout my life, whether it was my father, Steven Tyler, Tim Collins, April, or now Steve Chatoff, the shrink. **Whenever I was around an authority figure, I had a deep, unconscious fear that was tantamount to the fear of being beaten. As a result, I'd go overboard trying to please, even when it meant denying my own emotional reality or my own boundaries.**

One thing that became very clear was that by not completing the grieving with my father's passing, then and there, I had exceeded the limit of what I could contain. That was the pain that finally insisted I stop and pay attention. When I didn't, it built up and built up until it all came flooding out. That and everything that I'd stuffed in, packed down, and kept inside for forty-five years.

When I was at Chit Chat, I wrote a good-bye letter to cocaine. At Steps I wrote a good-bye letter to my father. That one letter provided a great deal of relief for me, like a pressure valve being opened. It started a process for me of recognizing a lot of the shit I was going through—I finally got it that I needed to acknowledge that I *had* feelings, become aware of what those feelings were, accept my feelings, and take the action to express them—if I was ever going to really heal emotionally.

I accessed the feelings I had about my dad, organized them, and wrote him this letter; then I read the letter aloud to a group of human beings—and so the process of healing began . . .

Dear Dad,

I'm writing this letter to honor and cherish the good in our relationship,

and the positive and constructive things that you taught me about life— how to fight for what I want, how to work hard and earn what you get, and most of all to be honest in all endeavors.

I honor that you worked hard for all that you have, which was a lot. I only regret that you weren't able to enjoy it when the time came. O In my heart, I feel forgiveness for you for many things. I have forgiven you for being the disciplinarian you were when I was young, and for abusing me physically so many times. I forgive you for not being there when I needed you to be. I understand that you were the best father that you knew how to be at the time. I now can forgive you for dying, when I really wanted you in my life. But you know what? You'll always be in my life, and I'll always love you. I choose to

remember you as the bustling young businessman who struggled to make Jumbo Advertising Company what it was. Your spirit will always be with me. It's next to me as I write this letter. I can feel you here now.

Well, Dad—it's really time for me to say good-bye. So I bid you farewell. Know that you'll always be in my heart. Know that God is with me and that you are with God.

Good-bye, Dad, and I love you.

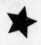

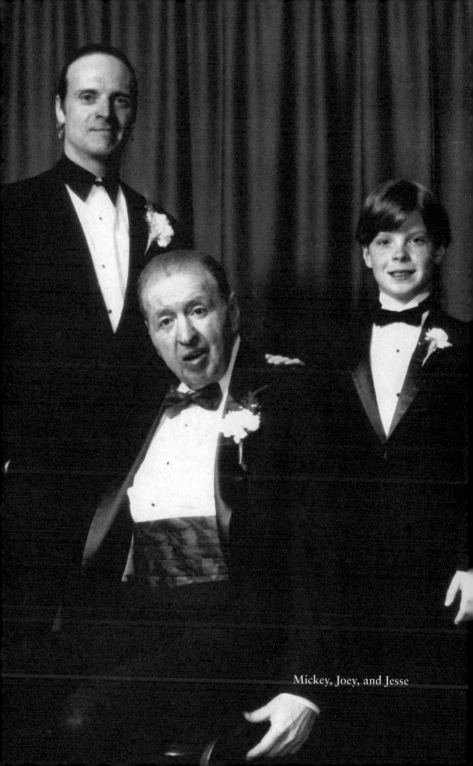
Mickey, Joey, and Jesse

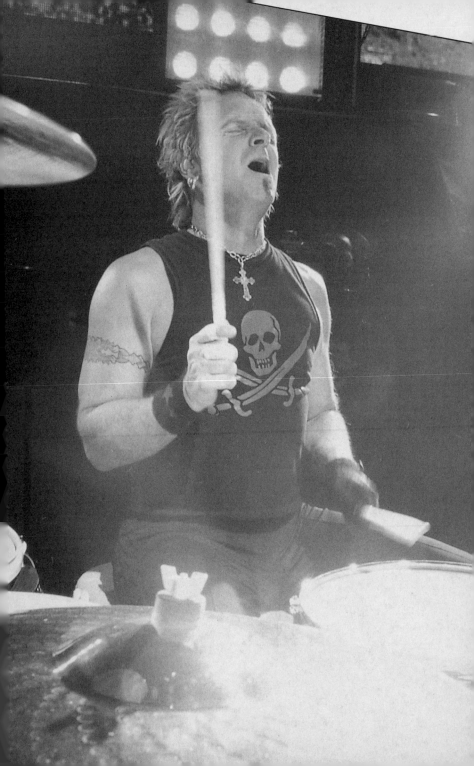

NOTHING SO BAD
THERE AIN'T SOME GOOD IN IT

While I was at Steps in 1995, only a few people came to see me. One was Jimmy Eyers, our road manager, whom I love dearly. Another was my friend Sandy Jossen, my best man and my buddy from Hebrew school. But then two guys showed up to take me out for a meal and fuckin' make my ass laugh—Rick Dufay, who had been in the band for a little while, and Jack Douglas, our producer on four albums.

As much as I enjoyed these visits, something was missing. After a while I spoke to Tim, our manager, saying, "Wow, man, you know I can't believe none of my partners have called me."

Tim said, "You see? What'd I tell you, man. They don't care about you. They're scumbags. They're really not your friends."

Something about that just didn't feel right. Maybe I should have been a little more perceptive, but I still had a long way to go on this idea of being fully conscious and aware of the interactions around me.

As a manager, Tim's initial idea had been to get Joe Perry back on his feet, which he achieved by reuniting Joe and Steven and then by getting Joe clean and sober. Once he helped engineer the "kiss and make up" between Joe and Steven, his highest aspiration after Joe was back in the band was to remain as Joe's manager. When he got control of the whole megillah, I think he couldn't believe his good luck—he'd really hit the jackpot. We all had our own version of the same kind of insanity, Tim included. In all fairness, I say with compassion and understanding, Tim had good reason to be haunted by his own special demons. As Tim had described it, he was the youngest son of a big, alcoholic, Irish family from a New England working-class town, and a mama's boy with a weight problem. I figure it's likely that he must have taken a lot of shit at home from his alcoholic father, a lawyer, and his older brothers and had a tough time in the schoolyard on a fairly regular basis. Then there was the whole Catholic punishing God and the rigid, shaming, and physically abusive nun thing that he had to deal with growing up. And as if that wasn't enough to fuck him up, he had to bear the shame and the guilt he must have felt as a guy growing up in the sixties with an ambiguous sexual identity.

Like the rest of us, Tim's insecurities ran deep. My read—he compensated with a vengeance by protecting himself with money, food, sex, drugs, and a sense of self-importance that hung on and was inflated by his relationship with Aerosmith. Tim was also a control addict with an insatiable appetite for ruling the world and people around him, using fear, shame, and what felt like a twisted version of the principles of twelve-step recovery as his tools for manipulation. The band had become not just a major source of his identity but was tantamount to having turned into his drug of choice. There was also what I believed to be his attraction to Joe and Steven—sort of like Brian Epstein being in love with John and Paul.

"There's nothing so good, there ain't some bad in it; and there's nothing so bad, there ain't some good in it," a friend of mine once

told me. Tim had been an invaluable force in our lives, and also very generous. The folks at Chit Chat, the Caron Foundation, loved him, not just for raising their profile as "the place where Aerosmith goes to get clean," but for also making substantial financial contributions that supported a lot of therapy and recovery for a lot of people over a very meaningful period of time. We owed him a lot for getting us clean and sober and for keeping the pressure on us to stay with the program and, it has to be said, for putting together an amazing team that helped to bring us back and drive our career to an unprecedented level of success. All the same, this first inkling of his driving a wedge between me and the other guys stuck with me—a little red flag lodged somewhere in my brain.

A few days later, after April came back from her trip to India, she came to Steps for Family Week. I remember sitting with her out in the courtyard at one of those picnic tables when Chatoff dropped by to tell me the news. My partners were going ahead down in Miami. They were going to record the basic tracks without me.

Tim had the ability to convince the band to do lots of weird things, but this really freaked me out. I couldn't believe it. I was trying to figure out—given that I was already in treatment for depression—if they ever thought about how that decision was going to affect me. Maybe they didn't realize how bad off I was. Had anybody told them, "he's already got enough to deal with, and now we're going to lay this on him?"

It was only later that I fully realized how Tim's mind worked, which was like this: a band needs a new record in order to have a successful tour. A successful tour means more money, all commissionable by Tim Collins. Tim would let nothing stand in the way of achieving that healthy percentage for himself. It was feeling more and more as though we were just tools for Tim to achieve his brand of "success," and for Tim I was a replaceable tool.

The net result was that, **just as I was finally dealing with all the emotional problems that had built up over a lifetime, somebody else was going to come in and take my place and do my job.**

But for once I didn't just numb out and roll along. The whole thing really set me back, but I got pissed off—enough so that I decided that once I got out of treatment, I was going to tell my partners that I wasn't going to play in the band anymore. If they were going to record without me, fuck them, they can be Aerosmith without me.

Down in Miami, Ballard had brought in Steve Ferrone, a really top session drummer, and they were letting him do my tracks. Ferrone was an English soul guy and a great drummer but not a rock 'n' roll guy.

But sitting a few thousand miles away in California, I didn't have any say in the matter. I also didn't have any place to go with my anger and sadness, other than to the community that I was a part of at the time, which was the other patients at Steps. So I brought it up in group therapy, and that's when the therapist asked me the big ones: **"What or who are you without Aerosmith? Who is just Joey? Who is Joey without being the drummer in Aerosmith?** How much of a part of that is you? How much of a part of that is your ego? How much of that are you banking on to be who you are, instead of just being your own man for yourself?"

I really had to think hard about all that, and then as I worked it through my mind, I became even angrier. I hated those questions because they forced me to doubt what I'd been doing for the past twenty-five years. I realized just how much I had allowed my identity to be tied up with the band, and with that realization I felt angry at myself. But I was so eager to just get down to being myself that I also found it kind of exciting to face up to it that way—the all or nothing proposition—the idea of really doing the unthinkable and saying "fuck Aerosmith."

What I didn't fully appreciate at that time, and what would take me probably the next five or eight years to figure out, was that my job in life was to be able to be in the band and also be separate from it. **What I really wanted was to be the drummer in Aerosmith, and also my own person, and they were not mutually exclusive.**

Get a grip

I remember sitting in a chair, rocking back and forth because the anxiety was crawling all over me. I had this urgency and anxiety to just get normal, but by virtue of being in the band, I wouldn't know normal if it bit me in the ass. Then the agitation gave way to a bit of a calm, because it was gradually dawning on me that I didn't have to make being Aerosmith's drummer so important. It was like somebody yanked the chain and a light bulb went on. It was sort of dim at first, but as I did more work, it became brighter. Eventually, I was in a place where I could say, "Holy shit. Maybe I don't have to do that anymore. I'm as good as I am, and as healthy as I am, and everything else that I am, without considering what I do for a living. I'm all that other stuff first and foremost."

And when I reached that point, it was amazing for me. I could begin the process of letting go of a lot of what I had made so all-important but which had, in reality, become a very powerful trap for me. Being the drummer in Aerosmith was incredible, but it was not the only thing in my life. I remembered reading in one of the books they gave me: "Fame and fortune are the two greatest barriers to self actualization." **After this point I knew that being the drummer in Aerosmith is what I do and that I'd have to do a lot of work to balance that within the greater context of who I am.**

The most important thing in my life was getting well, getting emotionally healthy, and making my life come together the way it could. Having an unusually exciting and lucrative career made me a lucky guy. Now I was beginning to understand I wasn't supposed to be living my life in order to be the drummer in Aerosmith.

I came to realize that, no matter what happens, I have to be present and solid with myself—all the time. If I can do that, everything else around me is going to fall into place. But I'd let the foundation crack, and that's why I was at Steps. I didn't need a bucket of cement and a trowel to mend that crack. What I needed was to rip out all the old stuff, make sure the dirt was all nice and smooth, put in new gravel, and build a new foundation. It took forty-five years of abuse, much of it self-inflicted,

to get to this point. So it would still take a lot of time and a lot of work to heal to the point of being healthy.

Seriously thinking about letting go of the band helped me start to realize who I really was. And when I started to see that guy, I started to believe he deserved better from me. Suddenly I realized that I needed to think differently about some of the energy that this guy Joey could bring to being a friend, a husband, a father, a brother, a partner, and a son. I had been misdirecting a lot of that energy because I was focused and anxiety ridden in the effort to be what I thought I had to be in order to be in the band, and to be the "right" guy to people I let intimidate me. I was always having to be that guy in order to feel like I fit, so much so that it was hard for me to realize that I was paying a huge price for the return on the investment—especially in emotional terms. I was a tool in Aerosmith, and in that environment there's not a lot to provide the kind of emotional support I—or anyone in and/or close to the band—might need as a human being. So I would have to change the way I saw myself in order to ensure that I got that support I deserved.

When I came out of Steps, I knew I had to learn to live and give in a new way that was more balanced, where there would be more positive emotional "give and take" for me. If I could do that, it could also work to shift and better balance my internal chemistry, and maybe I could begin to be an example for the band so that there was a little more "give" to go around. But that was for another day. I had my own situation to get straight first.

Having begun to realize all this, I was feeling like I had started to truly heal and that maybe I was ready to go home. I mentioned this to Steps director, Steve Chatoff, and he was immediately against it. Then on a conference call with the band Tom Hamilton said something to the effect of, "Man, you'll do what we tell you to do, and that's it!" Which felt really fucked up to me coming from Tom, because he's very laid back. And that's when it dawned on me that none of them, including Chatoff, were taking me seriously. I was the designated patient, which meant that other people felt entitled to take control of my life. But worse, Chatoff wouldn't even listen to me. He wasn't sizing me up on the basis of what he saw in front of him. He was following Tim's lead and listening to what some of my bandmates were telling him, which is to say he was

listening to Tim Collins. He was still taking direction from Tim, taking Tim's word for everything, including the comment I made to Brad and Tom that I'd been ready to kill myself, which Tim blew way out of

Chicago, 1998

proportion. Tim was manipulating Chatoff about my therapy just like he had manipulated all of us for years to be in therapy.

I went to see Chatoff and said, "Don't do this. You've got to realize this guy is manipulating you. He doesn't know what the fuck he's talking about." I even had the wherewithal to ask Kathleen Price, one of the counselors who worked there, to come with me so she could bear

witness to what I was saying. "I may be the designated patient," I said, "but that doesn't mean my judgment is completely fucked up. You're listening to this guy and keeping me here and ignoring the reality and what I'm trying to tell you from my heart."

MTV Icons, 2002

I think I displayed a pretty clear grasp of the situation when I said, "It's very difficult for me during this process to come and stick up for myself in front of you because that's one of my big issues. That's part of the reason I'm here, because doing this is such a hard thing for me. But it's what I need to do."

Of course, this was a challenge to Chatoff and his professional expertise. He didn't like what I was saying, but after thinking about it, he realized that the way I was describing the situation was, in fact, the case. Instead of going into denial and resisting it, he came back to make amends. He actually apologized to me, admitting that he had, in fact, been letting Tim influence what should have been his own professional judgment. And from that moment on, our relationship shifted into one based on mutual respect.

"You know, you taught me a lesson," he said. And after that, we got to be really good friends.

Chatoff then suggested that we all do a ten-day session, the whole band and with Tim, to clear up all the power issues and the intrusions and the overstepping of boundaries.

It was dawning on me now that Tim had held sway over every other psychologist or therapist who had dealt with us. He always had the power to insist that they did what he told them to do largely because he was the gatekeeper who could grace them with the "honor" of working with the world-renowned Aerosmith—or not. And if they had Tim's blessing, they also had a client who would pay them a great deal of money. Tim had a lot of power, so much so that some of the therapists would routinely share our personal, confidential information with Tim under the guise that he had to have this information to be sure to continue to do that which was in our best interests. If they didn't follow the rules, Tim would give us some reason why they were "dangerous" to have around, and they'd be gone. Some split, but the ones who stayed did so because they caved in and played along. After I clued Chatoff in, he didn't play Tim's game anymore. It wouldn't be long before that shit hit the fan.

Chatoff and I agreed that it was time for me to go home. April came out to California to pick me up, and we were driving away in a rental car when the phone rang. This was before cell phones—this phone came with the car. I answered, and it was Tim, yelling at me that I was leaving AMA—Against Medical Advice—and that I had to go back and finish my process.

This pissed me off so much that I couldn't even see straight. What kind of power—what kind of insane need to control—did this guy have that he could weasel my car-phone number from the rental company?

And then to try to tell me what I needed, when really all he was doing was a bullshit manipulation engineered to get what he needed. It was the same old story all over again—something offered as loving concern that was actually intrusion and bullying. All my life, every time I'd tried to fight back against that kind of abuse, I'd been bowled over until finally the pressure had just gotten too much and I'd cracked and caved in. But now I had some clarity and was able to call "bullshit" for what I believed it to be. I was getting an education on all this shit and was

Just push play, Japan, 2001

being told that in order to take care of myself, it was my responsibility to recognize what I was feeling, understand it, and act accordingly, and I wasn't willing to go backward.

So I told him right on the phone, I said, "Listen, man, you know, this is really difficult for me, because what I've just been dealing with in therapy is exactly what you're doing to me right now. And I have to tell you—this is totally fucked."

I was ripshit all afternoon, and when we got to L.A. that evening, I sat up in bed in our hotel room just shaking because I was so upset. That fuckin' phone call meant that I was still in that "one down" position with Tim, just like I'd always felt with Steven and with my dad and teachers and everyone else along the way who pulled some sort of power play with me, so Tim's telling me what to do in a situation like this that was none of his fucking business infuriated me.

When Tim had first come on board as our manager, I needed somebody I could trust and depend on; Tim presented himself to me as that person. I never really questioned anything he did because whenever he made a case for something, he seemed to be able to back it up. He would say that we're doing X because Y is going to be the result of it, and it usually worked out exactly as he'd predicted.

Looking back on it, I realized I mostly surrendered a lot of judgment to him simply because I wanted his approval, and, after all was said and done, I just wanted to play the drums. I wanted somebody else to worry about the fine print. But my codependent issues were so entangled with his that he could play me like a violin. This contributed to my blindly trusting him, even more so after all he did to get us sober and rebuild our career.

Tim had gone from running the band to running our whole lives. He had the same talent for rage that my father and Steven had. I had been afraid of confronting them, but with Tim, that fear was compounded by my sense of financial insecurity. Tim had built up his power over us like a cult leader. Aerosmithland was a culture of fear. All five of us in the band lived in fear. Each of us, in his own way, believed that if we slipped up on any little thing—boom! We would pay a price one way or another. Even our wives had to toe the line, and he was really crude about it. I remember

his talking to the suits at the record company and referring to the wives as "the cunts," as in, "we need to get the cunts under control."

We never could differentiate between management and meddling because everything ran into everything else. Our need to find sobriety opened us up to what looked liked love and concern, which encouraged the trust, which extended into his actual job of managing the band, which overlapped with being friends.

Shortly after I got back to Boston, Tim called a meeting, freaked out about rumors that Steven and Joe were back drinking and doing drugs. All our band meetings had become these intervention-style confrontations and accusations. Tim even called Steven's wife, Theresa, telling her that Steven had been sleeping around with a couple of girls in Miami. Then Tim insisted on creating a confrontational letter from all of us to Steven, telling him that he had to change or we wouldn't be in the band with him anymore. At this point we were all still weak enough to go along with this bit of insanity. The call to his wife was way over the line, but it was this letter that really froze Steven out. **Tim had been so worried about losing control of the band that he actually came close to breaking it up altogether.** For a long time Tim maintained a precarious balance: he'd keep us separate and mistrusting of one another, all the while reassuring us that he had the back of whichever one of us he was talking to at any given moment. He created drama and urgency and then would be the hero who would keep it all together—like the arsonist who comes back as the fireman. Even with his brilliance at manipulation and control, Tim's magic curtain was starting to fray. Trying to hold it all together, I think Tim himself was starting to fray.

By July all of us were back at Steps in Oxnard to have the group sessions Chatoff had suggested, sitting down to talk about just these kinds of boundary issues. Tim had agreed to let us meet as a band and then for him to come in later, but the band members started comparing notes and discovering contradictions.

When I said, "You guys never fuckin' called me when I was here," they came back with, "Tim told us you needed to be left alone. He told us not to bother you!" Divide, control, and conquer. Tim did the one

thing I could never tolerate. He betrayed me as a friend. The more we talked, the more we uncovered. He'd been trashing April to Joe, then trashing Joe's wife, Billie, to me. He'd robbed us of our brotherhood, but the truth was we'd made the dysfunction function simply by not knowing what it meant to take responsibility for ourselves and understand that we had the power to do so.

Chatoff listened, and then he sized up Tim perfectly: "He's the one who's been pushing all of you to get healthy," he said, "and he's the sickest dog of all."

Tim must have feared that after spending five days with Chatoff and comparing notes, we were likely to get wise to him. When it was time for him to come join the discussion as we'd agreed, he refused. In Chatoff's mind, that locked it in. He knew what our manager was all about and, now, so did we.

Tim understood a great deal about the band but ultimately underestimated what the band meant to itself and what made it function the way it did. He didn't see that the relationship among these five guys was the foundation for everything. I mean, how many bands are still on top, with the same five guys, after so many years? It ain't easy, and those relationships have to be nurtured—not exploited. But Tim proved to have become the show-biz cliché manager who would use any one of us as needed to keep a dollar from going unearned or uncollected. It felt as though we had become a commodity to Tim.

I think all of us, separately from one another, had looked at Tim's cult-leader behavior—to the extent that we recognized it—as the price of doing business. This is what we had to endure to get the job done. The crazy irony was that we were so fucked up that Tim's working to keep us isolated from one another actually helped keep the band together. Each of us was working so hard to conform, to stay "in," that none of us thought of walking away. Trouble is, other than to make money, I don't think any of us had a consistently clear idea of why we wanted to stay together and what it was we wanted to accomplish. These discussions

helped us realize that, if making money was all there was to Aerosmith, maybe it was time to fold. But everyone was willing to make the necessary changes. I think Joe was the first to cut to the chase. Tim had said that Joe and his wife, Billie, were not close because they were in love but because they were entangled in an unhealthy, codependent relationship. Tim warned they had to go to therapy to deal with it, or it would deal with them and become a serious problem for the band. This clued Joe in enough to really question and doubt the stuff that Tim had been saying about—and manipulated us to say to—Steven.

I felt bad that I had gone along with Tim's shit, that I cosigned his behavior so willingly. I have made amends to Steven about that. I for one have to own that I (and I dare say we all) agreed to this sort of un-

NOTHING SO BAD THERE AIN'T SOME GOOD IN IT

spoken deal that Tim would be the one who took care of each of our day-to-day bullshit, which meant that none of us had to deal with it band member to band member. In return, we gave up our power to Tim and accepted his judgment far too much of the time. **It wasn't the first time Aerosmith had sold its soul to this kind of devil.**

After the sessions with Chatoff, we went back East and called a meeting at the Four Seasons in Boston. We were very civilized, and Tim was too. We reclaimed Aerosmith, and we made a commitment to take back ownership of our own lives. When we told Tim "thanks, it's been a good run," he immediately went out and told the press that we were back on drugs. We started having meetings with Wendy Laister and Burt Goldstein, who had been with us for years, about taking over managing the band.

And then on top of everything else, I found out that John Kalodner wasn't happy with the sound that had come out of those sessions with Glen Ballard down in Miami. They had worked digitally, and after listening, everybody said the record sounded too homogenized—it didn't sound rock enough. When we *re*recorded in New York in the fall of 1996, everybody was pussyfooting around me, wondering if it was okay to say this, or wondering if it was okay to act this way or that way. I hung in, and by doing that, I proved a couple of important things to myself, one of which was that I could bear down and do what needed to be done (which also provided an opportunity to reclaim my turf). But, more important, I gave myself the opportunity to sit back and begin appreciating the strength I exercised in doing it.

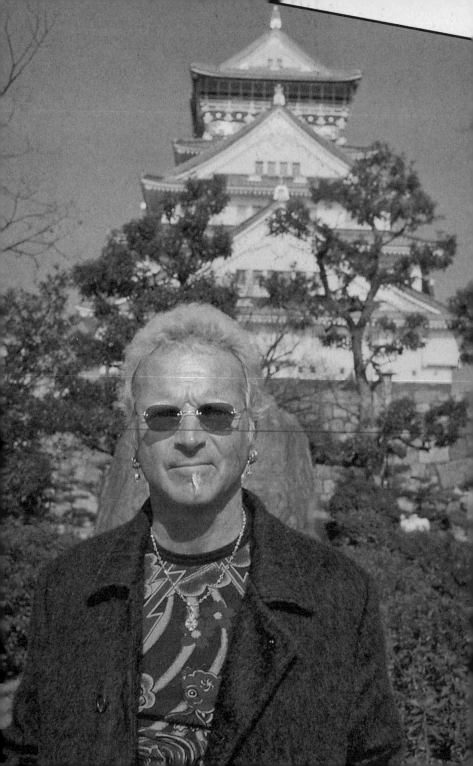

I was cruising along Route 3 just south of Boston, going to meet April for dinner. It was the middle of July in 1998 and a beautiful, hot, summer day. I actually had some time to chill that summer because while we were on the road a few months earlier at a show in Alaska, Steven broke his knee on stage, which meant the interruption of our tour. I was almost to the city when I realized I didn't have any gas, so I pulled into a Sunoco station and up to the pump. The kid opened up my gas tank, put the nozzle in, then walked away to fill up another car. It was hotter than hell, and I was sitting there with the top down fumbling through my wallet to get out my credit card. Which is why I didn't notice when the nozzle fell out of the tank. Or when it hit the ground and didn't stop pumping. Or when it continued to pour gasoline onto the ground—maybe ten or twelve gallons—creating this little lake

of gasoline underneath my car. I was in my Ferrari, which sits so low to the ground that the heat coming off the bottom of the car was only a couple of inches above the gas.

When I looked up from my wallet, the flames were maybe fifteen feet high. They were licking up to the gas-station overhang. The car was engulfed, and I had to get out. I took off my seatbelt and opened the door, but the only way out was through the flames. I put my forearm over my eyes and just leaned into the flames. I was wearing shorts and a tank top, and my forearm caught fire. I burnt my leg from my thigh right down to my ankle, and my hand and arm from my fingernails right back to my shoulder. The skin there had melted and was just hanging off.

It took maybe twenty minutes before the ambulance came. They wrapped me in an ice pack, but that was like a joke up against the kind of pain I was in. About halfway to the hospital they pulled over, put in an intravenous line, and started pumping me with morphine.

As soon as we got to the hospital and the doors of the ambulance opened, I could see April standing there waiting for us. But by now the pain was even worse, and the medics had to get it under control before they could clean up the wounds. In the ER, the nurses kept giving me more morphine and kept asking me, "Mr. Kramer, is the pain under control yet?" But it wasn't. It was the most excruciating physical thing I've ever felt in my life. God only knows how much narcotic they pumped into me, but eventually the pain subsided enough that they could clean the burns and bandage me up.

The doctors wanted me to spend a couple of nights in the hospital, but I just wanted to go home. I'd had enough pain and enough clinical settings, so we hired private nurses to come and take care of me down in Marshfield.

The band had been gearing up to go back on the road, but now my accident meant that we had to postpone the rest of the tour for maybe another month and a half. Nobody was too happy about that, and I was just angry at the whole thing. I was angry at the kid who left the pump

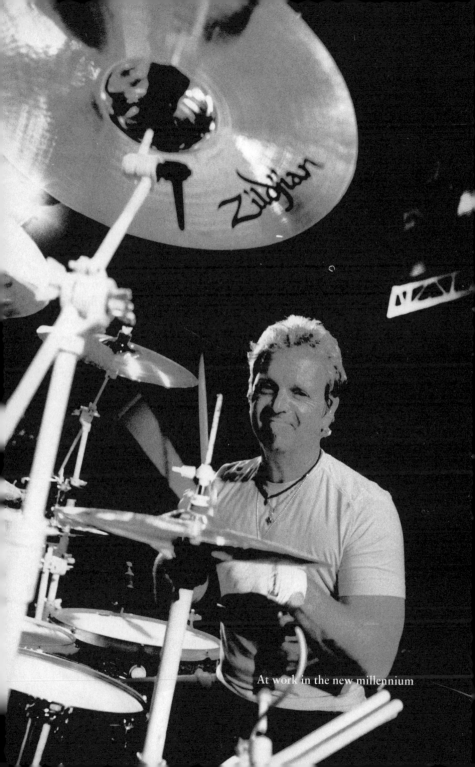

At work in the new millennium

unattended. I was angry at the owner of the gas station who never showed the kid where the main stops were so he could shut off the pump.

But once I got past the anger and the pain, I found a lesson in all this. **Even when I think I've hit cruising speed and I seem to have life figured out, I never know what's waiting just around the bend. I can be in the thick of it, living large, and in the blink of an eye it's over.**

Being nearly burned to death woke me up to just how precious life is, which includes being alive to my own emotions every second. I can have a yacht and six Ferraris and a house the size of Wellesley College and none of it can take the place of simply feeling okay when I wake up in the morning and being okay with the person who wakes up next to me.

After everything I've been through, I'm better about smelling the flowers. I'm even more aware of the crunch of my cereal in the morning. Which of course doesn't mean that the old demons of fear and anxiety and uncertainty don't make a visit from time to time.

Back in the nineties, I had needed some serious prodding before I was ready to buy our first really big house. In 2002 April wanted to tear that place down and rebuild something even bigger. In fact, she was so insistent that I just let it go. I acquiesced, and in August of that year the bulldozers came and flattened the place, which was kind of tough for me to watch. I had gone through enough anguish just deciding to buy that big house in the first place—also at April's insistence. But there I was watching them tear it down. And then I left to go on the road and took my anxiety about the whole process with me.

I had been off antidepressants for over a year, but with the anxiety I felt after the house experience and having to face going back out on tour, I started taking them again. Only they didn't kick in right away. Four or five weeks went by with no results, until we were out in California for a show. The hotel doctor there, Dr. Shapiro, turned me on to a psychiatrist out there, Todd Sadow, who got the mix of meds just right.

During this time, from August until early spring 2003, April traveled with me, along with our dog, Harry. We were all on the bus together, but I wasn't really bringing much to the table as far as our relationship went. I had all I

could do just to get on stage and play every night. When I left my drums at the end of a show, I would come back for the encore to find a different note taped to my snare. One of those notes said, "J.K., I'm right here loving you. Your April." Maybe it should have, but it didn't always make me feel better. What I still needed work on, of course, was learning to feel better without a crutch. I needed to be better at feeling okay without anything from outside my own skin—drugs, booze, toys, or fame. I was working on it, but even with going to meetings, something still wasn't right.

I had learned that being healthy means being able to recognize my emotions and not freak out because I'm experiencing them. The better I am in feeling fundamentally okay—not the greatest or the worst but just okay—the less any of the other shit that comes along is going to bother me. And that okay feeling has to be independent of how others might try to make me feel. Which is not to say I should be a narcissistic asshole, thinking I'm so fine when in reality I'm being a shit to everyone else, or so self-absorbed that I lack compassion for how anybody else feels. The trick for me is having the right kind of boundaries—knowing which feelings belong to me and which are yours.

I also was able to understand that I couldn't be there for other people, or for myself, if my whole life is about hiding, whether that means hiding in drugs or in denial. Being an addict is both. As an addict, I convinced myself that nobody knew what I was doing—as if, when I used to go out and spend $1000 on blow, come back home, and not answer the phone for a couple of days, nobody was going to figure it out. And even if other people didn't know what I was up to, I knew. And that secret life kept me away from other people. It kept all my pain bottled up, which made and kept me sick.

After I came out of Steps, I spent a year or a year and a half on my own with Steve Weinstein, a therapist just north of Boston. I would describe something to him, and he would look at me and say, "And, Joey, how did you feel about that?"

I would look at him with this blank expression on my face, not knowing what the fuck he was talking about. And he would look at me and say, "Man, you were angry. That's anger, man." This was after my time at Chit Chat, getting clean and sober, after my time at Sierra Tucson,

working on codependency and family-of-origin issues, and after my stint at Steps, dealing with major depression. So this business of reconnecting your head and your heart when they've been disconnected since age two is no easy thing.

Weinstein not only helped me recognize the anger I'd always had going on inside, but he also gave me an education about what anger does and how anger can destroy a person when it's turned inward. Weinstein helped me realize that my anger was not something to be afraid of and that by naming it and facing it, I could handle it. Some people turn it outward, taking it out on other people—raging, being condescending, just being difficult in general. And then there are other people like me who are too afraid of their anger to name it for what it is, who think it would destroy the whole world if they ever felt it and let it loose. I lost the ability to express anger directly. When I swallowed my anger instead, when I turned it inward, the emotion became resentment, and as I learned from Lou Cox, resentment destroys the container it's kept in. My hidden and festering resentment became depression. Untreated, that depression turned into an emotional breakdown.

With Weinstein's help, I learned to identify my feelings and begin to differentiate them: anger from sadness, fear from shame and guilt. This process helped me to understand which emotional response would lead me into self-loathing—which is a big part of depression.

All my work in therapy has helped me move forward to achieve balance in real life. When I get angry now, I can identify the feeling and name it, and because I know what it is, I can talk about it. I can express it in a healthy way. I don't necessarily have to flip out and have steam coming out of my ears, but I don't have to internalize it either. Just being able to say that something makes me angry is a whole new thing for me, and it feels really good. It's also a whole lot healthier than swallowing the emotion and carrying it around with me until it makes me sick.

If I'm angry at somebody now, sometimes I let myself really get into a froth, because that shows right out front what I'm feeling. I have to push it sometimes because it's too easy for me to just talk about it very matter-of-factly, which is almost the same thing as not expressing it at all. To get excited is to really get it out for me. I don't do that very

often, because the fact is, I get angry less and less now that I see myself differently in the world.

Along with all this work on learning to feel my own emotions, I've also learned how not to take on other people's shit, not to make their shit my shit. This means that I don't have to take their shit personally. At the same time, I've worked on being man enough—human enough—to own up to

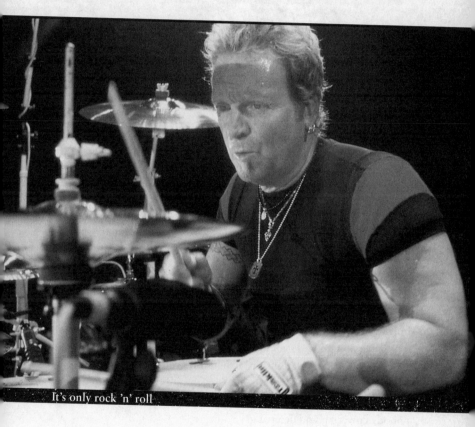

It's only rock 'n' roll

my own shit and apologize when I'm wrong. That's the only way both the other person and I can move on. It's still a continuing battle, of course. I like to be close to people, and I like to be friendly and take care of people. So I have to be very astute about finding the proper balance between being aloof—setting too rigid a boundary—and getting sucked in.

Doin' it for "The Rugrats"

It wasn't until I'd been clean and sober for nine years and had a nervous breakdown that I actually realized I was a pretty decent guy with a lot of compassion and a lot of love for a lot of people. When I'm in what they call a healthy relationship, I should be getting some of that love back. It's a give and take, with compassion on both sides, and nobody running roughshod over the other person, bossing and bullying, and nobody cowering and deferring.

And while I'm not denying that I can still feel angry, I've come a long way in dealing with my father issues and my father figures, so I don't have to hold on to the anger any more. Which means I'm getting unstuck. Letting go of the anger allows me to be more selective about where I focus, as with my dad, when I try to remember the pleasant im-

ages, as opposed to the ones from later on when he was miserably sick, fragile, and dying.

One of the memories I choose to revisit is from 1955—September. I was five years old, and we were living in the Bronx. My dad came home from work early one day, and he had a pair of roller skates for me. We sat down in the living room in our apartment on Davidson Ave., and he helped me put on those skates. And then we made it out to the front hall and out the front door, and he held my little body to keep me balanced, guiding me through the lobby of the building. We went outside, and he held my hand and helped me skate down the street.

I said to my father, "Dad, can we go look in the windows, in the store windows?" And my father looked at me and said, "You know, Joey, you don't have to call me Dad. You can call me Mickey if you want." And I remember looking at my dad and saying, "Okay, Mickey."

And when I think back to that moment and let myself feel his love for me, I get to be his little buddy. We're back there together, looking in the store windows, with me on the skates and him holding me up every time I start to fall.

I now know that, for Mickey, expressing love was showing discipline, so for me, love and abuse became two confused elements of what it meant to have a connection. Hitting me was his way of disciplining me, and disciplining me was his way of showing love. At his core, that's all he knew how to do—but I don't believe that deep down that's the way he wanted to be with me.

My pal Scott Sobel, the guy who was painting my apartment when my girlfriend, Cindy, had her epileptic seizure, worked for my parents for a while. He was just a kid out of high school, on the outs with his own parents, and he did so many odd jobs around my parents' house that sometimes he'd just spend the night. He told me recently that he felt as if they wanted to adopt him as a kind of surrogate son, as if "we sort of blew it with Joey, so maybe we can get a second chance with Scott."

He also told me a story about my dad. It was on that same Father's Day when I showed up with the Cadillac. Scott said that, just a few days before that, Mickey had pulled him aside and, out of nowhere, told him about the time he'd beat the crap out of me for coming home late. "I

thought he'd never forgive me," Mickey told him. Scott's comment to Mickey when he saw the Cadillac was "I guess he forgave you." Then Scott described the huge smile on my father's face. Today, that story puts a smile on my heart—with my dad's name on it.

With my mother, we're still working on it. I still have issues about the way she stood by and let my father beat me up. I'm still angry, but I'm trying to "let it go and let God," as the saying goes.

I believe that when I was a young kid, my mother lived her social insecurities through me. She insisted that I line up with them and that I measure up according to those insecurities and those values. I could never identify the feeling or understand it until much later, but the way she assigned priorities made me feel like she loved those standards more than she loved me.

Now that I'm an adult, I can see that she was simply a product of her own upbringing. She didn't choose to have those insecurities—they were foisted on her by her own circumstances growing up, and those circumstances weren't easy. That's why compassion has to be the name of the game. Unfortunately, while my mother and I were living all that high drama, neither one of us had the skills that would have allowed us to talk about it and understand each other's point of view. With my mother, it was always a monologue, never a dialogue.

Steven and I have also made a lot of progress—or maybe I am just better now at understanding that whatever Steven's issues are, they are his issues, not mine. **I used to be afraid of his anger and how he would react if I played something he didn't like. Now I play what I play, and if Steven likes it, that's great. If he doesn't like it, and it's something we can work on, that's great too. But I'm learning more and more how to own myself.** I'm learning how not to be dependent on what Steven or anyone else thinks about me in order to feel good about myself. I'm also learning to treat myself with respect each day, which means not showing up everywhere as a victim in the world I see. Treating myself better and not inviting abuse has actually allowed me to renew the joy in working with Steven. He's a brilliant, obsessive

perfectionist. If Steven starts getting intensely intense, I don't need to make it about me. It doesn't get to me the same way it used to, because I am no longer an unwitting participant in the same old song and dance. For him to get to me, I have to take what's being said negatively, and I do that less and less as time goes by. I recognize his intensity as his and have no need to own it myself. However imperfectly, I don't obsess about other people or their issues. I've come to believe that Eleanor Roosevelt was right when she said, "No one can make you feel inferior without your permission."

The whole story of my adult life has been about peeling back the layers to get down to what's real. I didn't realize it at first, but in the past five years or so, I had slipped back into denial about some basic unhappiness. I was numbing out on my lifestyle—the *stuff*—using the money that rock 'n' roll brought me as a drug. If I felt lousy, I could go buy a new Lamborghini, or I could go buy another house. I've never thought

of myself as that kind of person, but when it came to my attention that that's how I was living, well, I wanted to do something about it. But first I had to peel back one more layer to get down to the root cause.

April and I were in the kitchen one evening, and she started reaming me out and yelling at me in a demeaning and condescending way, and

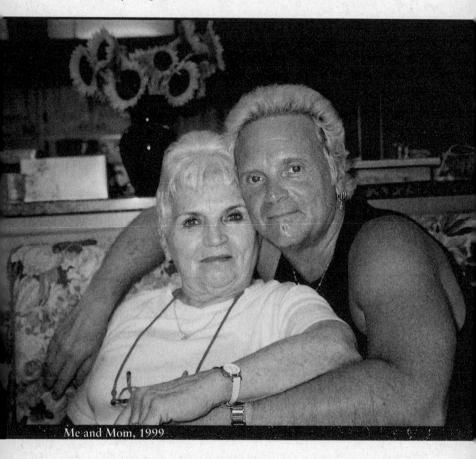

Me and Mom, 1999

then she walked out of the room. I didn't even take any special notice. Once again, I accepted this kind of behavior, which had become a fairly common occurrence in our relationship, as the price of doing business. It

NOW THAT THAT'S OVER...

had become such a regular pattern, so familiar to me, that I didn't even know I was doing it. *Oh, am I being bullied and demeaned? Really? Isn't that just the way it is in a marriage? Happy? I guess I'm happy. April says we're happy.*

But our daughter, Asia, was sitting there, and after a bit of stunned silence she looked at me and said, "Wow, how can you let her talk to you that way?"

Asia just put it into words, and suddenly my eyes were opened.

Up until that moment, I had never consciously acknowledged the way April talked to me, because, just as unconsciously, I had never believed I deserved anything better. "Jesus, Joey," Asia went on. "She's been going at you like that for as long as I can remember. That sucks, Joey, and you shouldn't put up with it."

With all the work I'd been doing, and with all the levels of awareness I'd passed through, I was right up against the wall of my shell, ready to bust out. Asia's comments were like the last stage in the chemical reaction that gets the chick to stick its head through the shell and up into the open air. What she was saying was, "This is not okay."

The pattern in my childhood was so well established that the relationships I entered into as an adult just naturally followed the same blueprint. My father and mother, Steven and Tim . . . my role in relationships with them was to be the accommodating victim. It's like a lock and key, the two parts to the same puzzle.

With April it was the same way. She was another powerful personality with issues of her own. Those issues pushed April into some pretty intense behaviors—demanding, controlling, and judgmental. But even given the slow way I'd become aware of the basic pattern, it still amazes me that it took me so many years to catch on.

In 2007 I walked out of my big estate in Marshfield, and I've never looked back. The breakup was my idea, and April was none too happy about it. The fractured relationship was something we both had to take responsibility for. We tried to work out the rough edges, but after a while I realized that the problem was so deeply embedded that it really couldn't be reconciled. The path to my near destruction was so long and

convoluted, and the road back toward health so demanding, that I knew I could never get where I needed to be if I were limited to working from inside an abusive marriage.

I've taken a lot of heat for leaving—from myself, from others—but tough as it's been, I know it was the right thing to do. I've had to ask myself if this was some "middle-aged crazy," superficial decision, but I know that it wasn't. This was a very painful part of a remedy for a lifelong problem.

I know that each of us contributed to my misery. For years, April complained that I was shut down, but of course I *was* shut down. I'd been shutting down since the age of two! The task before me was to complete the process of opening up.

In the past, whether it was Mickey or my mother or Steven or Tim or April, I gave these people power over me, in part because I allowed the pain that they themselves were carrying to penetrate my boundaries and reinforce the negative things I felt about myself. What I needed to do was build up stronger personal boundaries, first and foremost by building a healthier sense of self. Then I could allow those people to simply be who they are and to see them with compassion for whatever pain they felt. I needed to stop looking at the way my father behaved or the way Steven behaved or the way April behaved and change the way I behaved in response to them. I needed to find new ways of guiding my own life, changing the kind of relationships I participated in. I had to stop offering up my own sense of inadequacy, which merely encouraged their willingness to harp on those same inadequacies. I needed to stop buying in to the abuse, which meant getting out of my role as willing and enabling recipient. That's the only way it could become clear that the behaviors of these people were about them, and not about me.

The change I'm trying to make in my life is not about saying fuck you, but about finding a way to look out for myself (as well as for other people) and to have compassion for myself (as well as for other people), and the first step is to say that I deserve love, and that I do not deserve abuse. To accomplish that, I need to see these other people not as tormentors, but as individuals who have their own shit to deal with. Looking at it that way allows me to be compassionate toward them as well.

What I'm working toward is to have a continuing awareness of the principles of emotional well-being so that I don't need a therapist—or my stepdaughter at the kitchen table—to reflect things back to me in order for me to see them. It's sort of like when I go to a drum lesson and I want to pick up some ways of seeing and thinking that I can then use on my own. It is about learning, and I always want to learn, whether it is about the drums or about myself. The learning process involves opening myself up and sharing more of myself with other people, people who are just as willing and who are also going along the same path in trying to increase their awareness and their compassion.

Relationships change, but things really line up differently for me only when I achieve a different relationship with myself. A lot of the drama comes from trying to be right and trying to prove somebody else wrong. But my experience tells me that such a desire merely prolongs the pain. I have love and compassion for April, but I need to be in relationships where love and compassion are matched by respect, understanding, and support. April and I lost those latter three too long ago.

I experienced a great sense of loss when my marriage broke up, but as for the material things that went with the breakup—I couldn't care less. When I first had the opportunity to have finer things like cars and stereos and cameras, it was really nice. It was also novel, because I'd never had that kind of financial freedom before. But as I moved along in life and started to grow up, I realized that all the "stuff" and the comfortable life were part of the trap I was in. I was as anesthetized by money and the "stuff" it could buy as I had ever been by drugs and alcohol. Money and "things" put a beautiful wrapper around my wreckage. I needed to let myself do some unwrapping in order to see things for what they really were.

In the house April and I shared, we had a piano that cost $30,000, and neither one of us plays the fuckin' piano. I have an appreciation for the beauty of the instrument and for how it was made, and so I enjoyed having it. But in order for me to move on, I had to let it go. The same for all the other luxury items I left behind. It took me awhile to realize just how much the big house and the grand lifestyle were not important to me. Nobody put a gun to my head to get me to buy into it, and I could enjoy it, but it wasn't really what sustained me.

On our way to the stage

It's amazing now how letting go of "stuff" has also eased my fear of financial insecurity. I would get stuck in that trap by thinking that whatever I had was never enough. I have to have more faith in myself and maybe more faith in life. To some extent, this means putting it all in the hands of a higher power, letting it go, knowing that everything will be whatever it will be. For me, that's also called a huge step in the direction of being healthy and happy.

In June 2008, just before the launch of the Aerosmith version of Guitar Hero, there was a surprise birthday party for me, and I was really moved

to share in the realization that there are a lot of people who really love me. Steven was there, and we got to talking about the next tour and how great it was going to be, and it was like we were still twenty years old, brothers in arms, revved up to go out and take over the world.

I'm lucky that I personally still find so much that is rewarding and fulfilling in the music. That's what it's always been about for me—not the money or the fame. I just love to play the drums. After ten or twenty years with a band, a lot of guys are burned out. After thirty-nine years with Aerosmith, I know I still have a lot to learn, which is why, whenever

we perform, I always go out and listen to the act that's opening for us, to keep up with what the young guys are doing.

I have my passion for cars, so I'm experimenting with new ways of enjoying that passion, of finding new challenges that have to do with cars. For one, I'm part owner of a dealership on the South Shore of Massachusetts called Corvette Mike. I've also talked to some other dealers in the area about partnering with them to sell high-end imports. It's great if we can make some money, but I wouldn't bother if it were just about the money. **Cars are simply a source of beauty that really speaks to me.** A love of cars was one of the things that was a bond for Tom and Brad and me, and its something where I have real expertise. It's a way I can express myself and share the experience with people I love.

I've taken down a lot of the barriers I put up with family and, really, the barriers I put up in life in general. I feel pretty solid in my new outlook, and one thing I know for sure is that, given the amount of drugs and chemicals I put into my body, I'm lucky to be here at all. Embracing that helps to allow me to experience real joy now in ways that were impossible back then; and there are a lot of people who bring a lot of joy to me. My son, Jesse, is a miracle and a gift. He's now a drummer, too, with his own band called Destruments in San Francisco. Asia is doing great, living in Canada with her husband, Tom. They're raising their daughter, Sophie, who is very smart and strong-willed like her mother. And just as I was finishing this book, Asia gave birth to a baby boy they named August.

I am finding so many rewards that come with committing to heal myself. I have had to go through a lot of things, like lack of self-awareness, an enduring victim role, and suppressed anger. But I am willing to do the work, and now I'm in an infinitely better place and finally feel deserving and capable of relationships in which I am the best version of myself. Much in the way, as I said earlier in the book, that when the student is ready, the master appears, I have experienced what can happen as a result of being truly "ready" for an open, loving connection with another human being. The "appearance" of Linda in my life, not as master but as loving companion, could not have happened without all of the work I have been doing. Work that has readied me

This is what it's all about

for a relationship to which I can commit authentically with honesty, compassion, nurturing, respect, and love—deeply grounded in the openness, kindness, and generosity of spirit that is Linda. Our relationship is something I've never experienced before, and it's a treasure. I've found companionship that amazes me. But looked at another way, it's the most logical thing in the world, and I, like Linda, like everyone else, deserve to be genuinely happy and to experience love the way it was meant to be—but we had to be ready.

In order to get my head and heart clear, I first had to allow myself to feel the pain and sink to the depths of an emotional bottom so low that the only way back was to learn to deal with the lows instead of numbing out to them, and then to move through them to get beyond them. But once I got to the other side, the job still wasn't over. In fact, the job is never over. I have to keep it fresh, and I have to be aware, which means working at it every day. Every day I learn something, I put it to use the next day. I have to keep digging back in the box and putting a little oil on the tools to keep them in good working order.

Looking back at that day in the Marlin Hotel, barely able to see through my tears, I know that I was lucky to have my breakdown. Seems strange to say that, I know, but I was given the gift of desperation, which left me with a clear choice—and I chose to get beyond that desperation. I was forced to strip down all my defenses and my ego right to the bone so that, with a lot of help, I could look at myself from the inside out. For me, this was the only way I could build myself back up and truly heal.

In March of 1997 the album *Nine Lives* debuted at #1. We started touring like mad all over again, and word of my troubles got out into the press. Even though it was recommended to me that I play it down, to describe my experience as just this big blue funk, **I wanted to be completely open about it. I felt strongly that someone might benefit from my willingness to reveal the truth, and more than that, I believed it was important to make the statement that depression and other mental-health issues were nothing to be ashamed of. Sharing my experience, strength, and hope openly and honestly, an essential part of my healing process, is a way for me to give back and help others who might be dealing with the same kinds of issues. It's that belief that motivated me to write this book and tell my story.**

Thanks to all the love from our fans and everyone along the way for helping me accept, embrace, and truly feel the world around me. After all, I'm a feel player and right about now, I feel pretty good.

EPILOGUE:
FROM TEN 'TIL NOW

The road to peace and sanity is always under construction and the challenges of life on life's terms keep rolling my way... I've been keeping notes. The ride continues on **JoeyKramer.com**

INTERIOR:

The photographs on pages 176 and 200 appear by courtesy of George Chin.

Photographs on pages 5, 7, 10, 14, 194, 204, 206,215, 219, 220, 223, 228–229, and 232 appear by courtesy of Ross Halfin.

Photographs on pages 170 and 210 appear by courtesy of William Hames.

The photograph on page 77 appears by courtesy of Terry Hamilton.

Photographs on pages 168 and 203 appear by courtesy of Todd Kaplan.

Photographs on pages 127, 135, 146–147, 150, 155, 156, 160, 165, 172, 182, 185, 197, and 212 appear by courtesy of Gene Kirkland.

The photograph on page 189 appears by courtesy of Wayne Mazer.

Photographs on pages 175, 181, and 186 appear by courtesy of Kevin Mazur.

The illustration on page 162 appears by courtesy of Modern Drummer.

The photograph on page 231 appears by courtesy of Michelle Munday.

Photographs on pages 80, 84, 89, 90, 99, 102, 107, 109, 112, 118–119, 122, 124, 140–141, and 159 appear by courtesy of Ron Pownall.

Photographs on pages 234–235 appear by courtesy of Jim Survis.

All other photographs appear by courtesy of Doris or Joey Kramer.

SPECIAL THANKS:

David Hinkelman
Linda Kramer
Sandy Jossen
Donny and Debbie Wightman
Jimi Ricci
Tori and David Brega
Carmen
Bob Henry
De De Iasandro
Artie De Iasandro
Phil Hannegan
John Good at DW
Scott Garrison at DW
John DeChristopher at Zildjian
Stephan Adelson
Kevin "Chappy" Chapman
Dennis Chambers
Keith Garde
Liz Liao
Joe and Billie Perry
Tom and Terry Hamilton
Brad and Kim Whitford
Steven T and Erin Brady
Doris and Mickey Kramer
Amy and Bill Olin
Annabelle London
Suzy and Michael Sammarco
Nancy Sobel and Robert Acio
Scott Sobel

Frank Gangi
Jesse Sky Kramer
Asia, Tom, Sophie,
and August Tenkoff
Jack Scarengella
Trudy Green
Howard Kaufman
Todd Sadow
Greg Read
Karen Whitford
John and Julie Rota
Jerry Elliot
Frank Cimler
Nikki Sixx
Mike and Gail Milian
Dr. A.C. and the Girls
The Mann Family
Rick and Judy Chasin
The Gonzalez Family
Rusty and Dena Pedersen
Dr. Rau
Richie Supa
Rich Guberti
Richie Dandry
Bill Patrick
Brad Allen
Charlie Nichols
John Nichols
Diane Dreibelbis
Don Bernstine

Gary Walsh
Skip Portney
John Bionelli
Paul Santo
Gianluca Siciliano
Rick Dufey
Jim and Sandy Schumacher
Scott and Mindy Gordon
Marti Frederiksen
MaGee
Patty Bourdon
Mitch Weinberg
Nicholas Brown
Peppy Castro
Ray and Lorraine Tabano
The Gang at Corvette Mike's
New England
Saul Shockett
Steve Chatoff
Steve Stein
Mel Bucholtz
Bill Hultberg
Mark DiRico
Howie Brooks
Ralph and Florence Simon
Ralph Simon Jr.
Mark "Marco" Hudson
Paul Householder
Jill Kneerim
Teresa T.

Jim Survis
The Gang at Champion Porsche
Ike Williams
Michelle Munday
Rich and Greg Rotman and the
Gang at PAID
Danielle Friedman
Kelly Franke
John Kalodner John Kalodner
Darryl "DMC" McDaniels
Andy Gilman
Eric Rothenberg
Karen Langford
Steve Weinstein
Jack Douglas
Gene Kirkland
Dr. Lou Cox
Jimmy Eyers
Marty Callner
Russ Irwin
Ross Halfin
John Branca
Kazuyo Horie
Casey Tebo
Dr. Alan Curtis